Francis Bacon

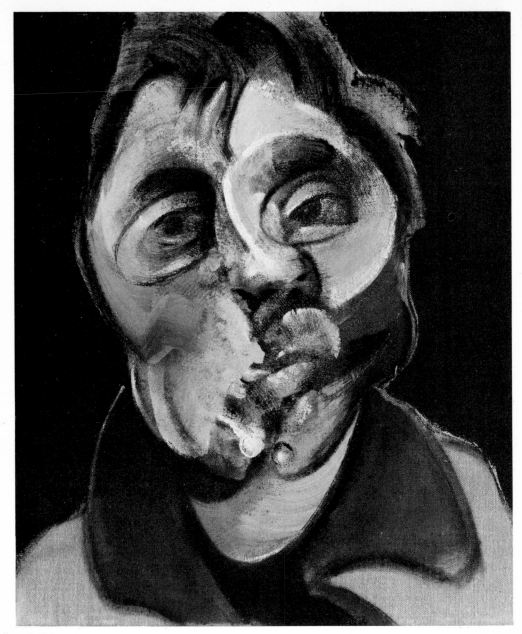

1 *Self-portrait* 1969

Francis Bacon

JOHN RUSSELL

NEW YORK AND TORONTO

OXFORD UNIVERSITY PRESS

To Suzi Gablik

© 1971 and 1979 John Russell
Revised edition published in the
World of Art series in 1979

Library of Congress Cataloging in Publication Data
Russell, John, 1919–
 Francis Bacon.
 (World of art series)
 Bibliography: p. 153
 Includes index.
 I. Bacon, Francis, 1909– II. Painters—Great
Britain—Biography.
ND497.B16R8 1979 759.9415 [B] 78–13075
ISBN 0–19–520113–2
ISBN 0–19–520114–0 pbk.

Printed in Great Britain by
Jarrold and Sons Ltd, Norwich

Contents

Preface

This book is not the work of a detached observer. Whatever authenticity it may have derives from the fact that for more than thirty years I lived within a mile or two of Francis Bacon and was aware of him, and of what he was doing, as phenomena as to which posterity would be curious. Simply to be there, and to keep one's eyes and ears open, can be a public service in such a context. Contemporaneity cannot be counterfeited. If Hazlitt were to come back to earth in fifty years from now and write a sequel to his essay on 'Persons One Would Wish To Have Seen' it might well be to Francis Bacon that he would turn first; for Hazlitt loved painting, and he knew a great original when he saw one, and he liked it very much when men were what he called 'persons' or 'characters', quite independently of what they had had to give to the world.

In that particular class Francis Bacon ranks very high. He has never finished a bad book, he has never entertained a dull thought and he has never made a commonplace remark. Of how many of us can that be said? In life, he has set his own standards; and neither as a beginner nor as the most sought-after of living European painters has he fallen below them. As to whether his work will occupy this place or that in the history of art, those who come after us can decide. The purpose of this book is to say how it seemed at the time to someone who was much in Bacon's company and prized every moment of it.

Le hasard est le plus grand artiste.

HONORÉ DE BALZAC

We are moving into a totally non-religious age in which men as they are will no longer be able to take religion seriously.

DIETRICH BONHOEFFER

Educated privately

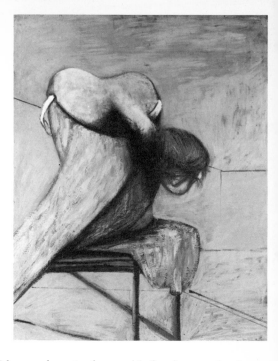

2 *Three Studies for Figures
at the Base of a Crucifixion*
1944

There was not much to be said, anywhere in the world, for the month of April 1945. A six years' war brings with it a loss of moral energy which may be forgotten in the exhilarations of victory but is there none the less. Dullness, passivity and acquiescence result from it; decisions taken at such a time may result, and in this case did result, in the perpetuation of precisely those things which they sought to abolish.

Peace itself is misleading, in today's conditions. What has been looked forward to as the white-ribboned reward of six years' exertion may turn out to attract human misery as bad meat attracts bluebottles. That is what underlay the meeting of Russians and Americans on the Elbe, and the hanging of Mussolini head downwards, and the euphoric speeches at the United Nations conference in San Francisco, and the suicide of Hitler.

Those events have in common that they happened in April 1945, together with the death of Roosevelt, the taking of Okinawa, and the abrogation by the USSR of its non-aggression pact with Japan. Few months in the history of our world have been more crucial to its continuance, and it was difficult at the time for any one human being to take in, let alone to process and master, all that was going forward. War digs a deep and narrow channel through the mind: visibility therefrom is both poor and intermittent. In our English case there was the further factor of isolation: the life of the imagination had not quite gone to sleep, but it had fixed on visions, more or less idiosyncratic, of a

8

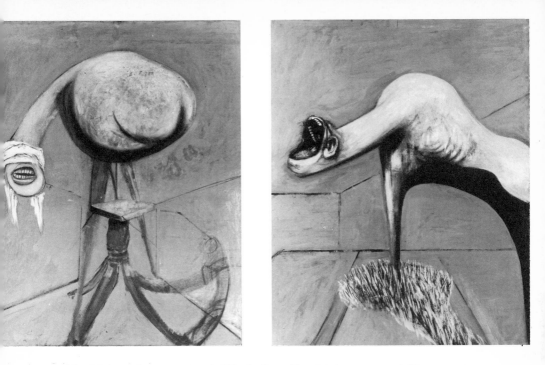

world which no longer existed. Eliot's *Four Quartets* in 1944, and Henry Green's *Loving*, Cyril Connolly's *The Unquiet Grave* and Evelyn Waugh's *Brideshead Revisited* in 1945, were all in different ways acts of homage to the past. The voice was rare and unwelcome which said, as George Orwell's did in *Animal Farm*, that when peace came the favourite phrase of 1940, 'Business as Usual', would not apply to society as a whole.

It was precisely then, in the first week of April 1945, with the end of the war in Europe only a month away, that Francis Bacon's *Three Studies for Figures at the Base of a Crucifixion* were put on view at the Lefevre Gallery, which then occupied rooms on the first floor of a building on the west side of New Bond Street. I well remember the look of the show, which was made up primarily of artists whose work had stood high among the consolations of wartime: Henry Moore, Matthew Smith, and Graham Sutherland. Moore in 1941 had dealt with the predicament of those who night after night, in underground shelters, were being borne into the future like captives, as he himself said later, in the hold of a slave ship. But now, in April 1945, that ship was reaching port, and it would soon be known whether freedom, or some subtler form of bondage, was waiting for them at the quayside.

Moore himself, in this particular exhibition, was manifesting a robust confidence in the continuity of normal life. In this, he was at one with most English people. All over the country the phrase 'After the war' was being

2

taken down from the shelf and dusted off. Something of the magnanimity of Winston Churchill had been passed on to the nation which he had so often had to take into his confidence. Nobody wanted to believe that there was in human nature an element that was irreducibly evil. People had been relieved to find, for instance, that rumours of 'werewolf' activity in Germany – continued resistance, that is to say, by underground groups – had no foundation. All that was needed to bring Germany back to normal was a little planned re-education; with this in mind, a book called *The Free State* had been commissioned from D. W. Brogan. Everything was going to be all right, and visitors went into the Lefevre Gallery in a spirit of thanksgiving for perils honourably surmounted.

Some of them came out pretty fast. For immediately to the right of the door were images so unrelievedly awful that the mind shut snap at the sight of them. Their anatomy was half-human, half-animal, and they were confined in a low-ceilinged, windowless and oddly proportioned space. They could bite, probe, and suck, and they had very long eel-like necks, but their functioning in other respects was mysterious. Ears and mouths they had, but two at least of them were sightless. One was unpleasantly bandaged.

The left-hand figure had the hairstyle of a female jailbird (or jailer). At shoulder-level it had what might have been mutilated wing-stumps. An inch or two below these there was drawn tight what might have been either a shower-curtain or a pair of outsized pyjama trousers. Set down on what looked like a metal stool, the figure was thrashing round as if to savage whatever came within biting distance. The central figure, anatomically somewhat like a dis-feathered ostrich, had a human mouth, heavily bandaged, set at the end of its long, thick tubular neck.

What that neck would have looked like without the bandage was indicated by the right-hand figure. It had big ears at the corner of its mouth, and was able to open that mouth to an angle of almost ninety degrees. Like the central figure, it was in a mysterious way almost as much a piece of furniture as a living creature. Its one visible leg was as much a sofa-leg as an animal leg, and the patch of grass on which it stood was nearer to a bed of nails than to the shaven lawns of Oxford and Cambridge. Common to all three figures was a mindless voracity, an automatic unregulated gluttony, a ravening undifferentiated capacity for hatred. Each was as if cornered, and only waiting for the chance to drag the observer down to its own level.

They caused a total consternation. We had no name for them, and no name for what we felt about them. They were regarded as freaks, monsters irrelevant to the concerns of the day, and the product of an imagination so eccentric as not to count in any possible permanent way. They were spectres at what we all hoped was going to be a feast, and most people hoped that

they would just quietly be put away. In this, the title should have helped; for Bacon made it clear that these were not spectators at 'the Crucifixion' but at '*a* crucifixion'. They were the creatures who gather as ghouls round any scene of human degradation: April 1945 was to see a whole parade of them before the body of Mussolini as it hung from a butcher's hook in the suburbs of Milan. Hitler's bunker had its share of them in May, and with the liberation of Belsen and Dachau in June they were revealed as what they really are — not 'monsters' in the old fancy-dress sense, but uniformed respecters of the law, champions of order and due form, servants of Power, and Interest, and Things As They Are. They were all over the place in 1945: at Roosevelt's funeral, in the ruins of Nuremberg and Dresden and Berlin, and wherever those who had made their peace with Pétain were making their peace with Pétain's successors. We in England were slow to believe that there could be quite so many of them. We tried to think of other things, and *The Times* did its best to help: there was a sympathetic editorial, for instance, on the destruction of Goethe's birthplace; and at the time when the news of the camps was getting out, our religious leaders gave their attention to the undesirability of knock-out cricket. The fall of Brunswick was seen in terms of 'the loss of numerous picturesque medieval buildings'; but the Baconian note, the true tocsin of the month, was sounded in Ohrdorf, south of Gotha, where the Burgomaster and his wife first slashed their wrists and then hanged themselves after they had been shown what had gone on within the periphery of their little town. 'Nothing will ever be the same' was what they were trying to say; and it was the message, also, of the *Three Studies for Figures at the Base of a Crucifixion*.

Bacon in April 1945 was thirty-five years old. He had never been to school, let alone to art-school, in any conventional sense. He had shown once before in Bond Street (at Agnew's, in 1937, in a mixed show of 'Young British Painters'), but his output as a painter had been small and infrequent, and he was known to very few people in the professional art-world. His *Three Studies* could have been the freak that many visitors supposed them to be: a phenomenon without precedent or succession, an incoherent cry of outrage which would die down as soon as peace had done its emollient work. 'Then may he delight, where now he dismays' was the classic reaction, and it would be a clairvoyant spirit which could claim never to have shared it.

In point of fact, the *Three Studies* relate to two at least of the paintings which Bacon had shown at Agnew's in 1937: what was new was the vastly more cogent, provocative and timely character of the image, and the abandonment of anything that could be called tentative or irrelevant. They could have come, even so, from a moment of divination and high energy, never to be repeated. Bacon's history had throughout been one of

improvisation, willed or involuntary; and he could have improvised his way out of painting just as quickly as he seemed, from outside, to have improvised his way back into it after several years away from the easel. He had been, and could be again, a classic case of what could be called Marginal Man. He had never stuck to any one thing – one school, one home, one office, one profession, one way of life, one country – and it seemed implausible that he would ever stop being what he had always been: one of Nature's unclassifiables.

Destiny had done its best in that direction. Bacon was born in Dublin, at 63 Lower Baggot Street, on 28 October 1909. He was one of five children. Nothing in his inheritance related him in any way to the practice of art. His father, Edward Anthony Mortimer Bacon, was nearly twenty years older than his mother. He had been in the army, but at the time of Bacon's birth, and intermittently ever afterwards, he earned his living as a horse-trainer. Horse-owners, trainers and fanciers tend to be individualistic and capricious people, much involved with hazards and reversals unforecasted in the book of form, and Bacon's family had, on both sides, more than its share of imperious instinct. Bacon remembers his father as a highly strung, intolerant, dictatorial and censorious character, much given to moralizing and to arguments that ended in lasting discord. This trait lost him a great many friends as he grew older, but at the time of Bacon's birth he had a considerable name in Ireland as a breeder and trainer of racehorses.

Bacon's mother, born Christine Winifred Firth, had a lively, untrained intelligence, an easy-going, gregarious nature, and the gift of getting on with a wide variety of people. When war broke out in 1914, Bacon's father took a job in the War Office and the family moved to London. Thereafter they moved back and forth between England and Ireland, changing houses every year or two and never making anything that could be called a permanent home. As Bacon suffered from asthma as a child, he never had a coherent schooling, except in so far as his whole upbringing could be called a school of adaptation. Tutored in nineteenth-century style by the local clergyman, and left to his own devices for long periods at a time, he developed an awareness of life that was quite independent of formal education. A nomadic life is a great precipitator in such matters, and Bacon had the further good fortune to spend much of his time with his grandmother, and with his great-grandmother, on his mother's side.

These were invaluable frequentations. His grandmother had a largish house in Ireland and enough money to indulge her greatest pleasure, which was to entertain in an open-handed way and see what came of it. (She had had three husbands and was about to take a fourth when she died.) Her mother, Bacon's great-grandmother, was partly French and had married a

Northumberland colliery-owner. As she had had seven children, and as Bacon's grandmother had had three, a great many ramifications were on hand for the student of behaviour, and the number of persons who could be on stage at any one moment was large enough for Drury Lane in the heyday of Sir Herbert Beerbohm Tree. (Bacon's aunts, in particular, were of an eccentricity which still stirs him to wonder.)

One of his great-aunts had married a Mitchell from Newcastle and lived in Jesmond Towers, a house not much smaller than the Palace of Westminster, which stood at the end of the tramway-line out of Newcastle. Among the Mitchells was Charles Mitchell, who was an enthusiast for the Pre-Raphaelites and himself painted in ways derived from their example: paintings by himself and his favourites filled the enormous ballroom at Jesmond Towers and were Bacon's first introduction to the idea of art as something that entered directly into the life around him. The Mitchells' life was indisputably rather grand, even by Edwardian standards. Mrs Mitchell was able, for instance, to rent Bamburgh Castle for the summer and to invite the entire family to stay with her in that strange fastness. Bacon also remembers her gutting a house in Hill Street, Mayfair, and doing it up from top to bottom in black marble. He was not conscious of this as being odd, or indeed of oddity as characterizing his mother's family in its entirety, though he does now remember it as being something rather out of the way when one of his aunts went to dinner at the Berkeley and found, on sitting down at the table, that she had her dress on back to front. The important thing is that throughout his childhood he had an experience of human strangeness which set the *tempo primo* for much of his later life.

With his father's family, on the other hand, he had very little to do. His father had about him certain elements of fallen grandeur. His collateral descent from Francis Bacon's great Elizabethan namesake is a matter of fact, not of legend, and Queen Victoria at one time urged Bacon's grandfather to take up the lapsed title of Lord Oxford. This he refused to do, on the grounds that he had not enough money to live up to it. Money and the lack of it were a source of recurrent anxiety to Bacon's father also. Bacon remembers that he gambled a good deal and that he himself was often sent down to the post office to place bets by telegram just before the 'off'. Bacon's father was no better at getting on with his son than he was at getting on with anyone else. In the house, he set rather a puritanical tone, and one that Bacon found it difficult to live up to. It was, in fact, for what seemed to his father a grave breach of that tone – trying on his mother's underwear, to be precise – that Bacon was sent away from home in 1926 and began the life of constructive drifting which took him even further from any idea of a regulated and conventional existence. When he was of school-age, Bacon's one idea was

'to do nothing'; when he was sixteen, his father involuntarily, in the very process of banishment, made it possible for him to go on doing just that.

What he learned in childhood was, in short, how to improvise a life of his own. His family offered him, again quite involuntarily, an education in aplomb. He developed a very sharp eye for human particularities. Most of his time was spent with people who were used to doing exactly what they wanted. Life was lived outwardly and without hesitation, it being taken for granted that the world would turn their way. In Ireland, especially, he met people who had the outrageousness, the downright extravagance, which the English public schoolboy knows mainly from Hogarth or Gillray. Among his Irish neighbours there were many for whom the dominion of drink was absolute. He remembers, for instance, a Master of Fox Hounds who, when far gone in drink, would string up cats, and cause his wife and daughter to lock themselves into cupboards at his approach. Behaviour, for such people, was a mode of fulfilment and not, as in England, a mode of self-protection and self-denial.

He also took it for granted that life was lived in a great many houses and not in just one. Visiting plays a great part in Irish life, and Irish houses, like the people who live in them, have a great deal of style. Bacon soon got into the way of looking at rooms, and at the outlook from rooms, as being in some way an extension of their owner's personality. In Queen's County, for instance, his grandmother at one time had a house with a semi-circular window in the drawing-room that overlooked a big tract of open country. This gave Bacon a sense of the desirability of sheer scale, in a house, that he has never forgotten: to this day his comments on big houses – Mereworth, for one – reveal a poetic feeling for space which is quite independent of conventional grandeur or the notion of 'importance'.

All these changes of scene made him very aware of the element of masquerade and dressing-up in grown-up life, and of the effect of environment upon human behaviour. Environment meant space, and it meant costume: Bacon's earliest memory dates from 1913 and is of the pride and delight which he took in parading up and down an avenue of cypresses while wearing his brother's bicycling cape. Not long after, when war was imminent, environment took another form as he lay in bed at Cannycourt, fifteen miles from the Curragh, and listened to the cavalry galloping up and down in the woods nearby: manœuvres meant gunfire – sometimes at night – and an atmosphere of violence on a human scale, man against discernible man, which still seems to him one of the prime ingredients of life. Though not himself Irish, he absorbed Ireland from his earliest conscious moments. Attempts to make him less Irish – attempts, for instance, to send him to a school near Cheltenham – were a complete failure: he always ran away. It

was a matter of inmost instinct with him that he should shift his ground, settling nowhere, identifying only with his own vagrant impulses.

A great deal has been made of the fact that a part of his youth was spent in Berlin, and many people have confused his Berlin with the Berlin of Christopher Isherwood. In point of fact, Bacon was there in 1928, several years before Isherwood, and for two months only, with an allowance of £3 a week. He does not at all accept the identification with the relatively cosy, twittery world of *Goodbye to Berlin*. The Berlin that he knew was that rarest of things: a capital city that was genuinely wide open, with no control of any kind upon the satisfactions of instinct. Bacon's stay there was short, in terms of measurable days and nights, but it gave him a standard of total freedom by which all other cities at all other times were to fall short. Whereas Isherwood wrote of a period in which Nazi power was already a reality and an independent human being could do no more than fight a retreating action, Bacon knew a Berlin that was laid out on its back and asked only to be pleasured over and over again. It was, in some degree, a continuation of Ireland: an Ireland Prussianized and de-Catholicized, with a more bracing climate and a complete lack of Irish waywardness in its pursuit of whatever seemed desirable. In Ireland he had been conscious at every turn of the restraining hand of the Church, so eloquently made evident in *Ulysses*. Berlin was something else again; given his lifelong inclination to push every experience to its farthest limit, it is legitimate to assume that the experience of Berlin has many times over been transposed in poetic terms in his work.

From Berlin he went to Paris. Paris has not been made much of in accounts of his career, but the truth is that as an enduring element in his life it means infinitely more to him than Berlin. He comes of almost the last generation of Englishmen for whom France and French life are of supreme importance and the life-style of an artist like Alberto Giacometti is an object of profound admiration. Artists who came of age in the 1950s and 60s find it difficult to realize to what an extent the naturalness, the open-mindedness and the refusal to run after success of a man like Giacometti could be taken for granted in the Paris of the late 1920s and 30s. Bacon did not, in point of fact, know Giacometti till the 1960s, but he was deeply affected by the Paris of the late 1920s, in which people were left alone to be themselves and life had a hand-made quality that has gradually been rubbed away in the interests of standardization.

Anyone who knows a few of the facts can trace the effect of Bacon's childhood and boyhood on the impulsive, open-handed and noctambular way of life which he led for many years afterwards. The generosity, the love of gambling, the acceptance of others' frailties and the ability to be at home in all societies: these are part of an Anglo-Irish inheritance. Berlin and Paris

gave him the notion of a big city as an erotic gymnasium in which spring-board, trampoline and a variety of cognate boosters were available for the paid-up member. But there is also, in Bacon's make-up, a paradoxical austerity which he traces directly to his father. It is this austerity, this power of saying 'No' in a voice to which none will demur, that makes his work possible.

One of the characteristics of a genuine artist is the instinct for pace: the innate knowledge of when to wait, when to push on, when to turn aside. In a novel or a film, young Bacon would be busy with his sketchbook in the transvestite bars of wide-open Berlin; and he would turn up again on summer evenings in Montparnasse where people were discussing a film, then quite new, called *Le Chien Andalou*. There were real-life examples of this sort in the 1920s: Christopher Wood, for one, who went to Paris, pushed his looks and his talent as far as they would go, and painted (as Cocteau said) 'like a puppy who hadn't had the distemper'. Bacon was the very opposite of this. He carefully and positively did not force himself forward as a painter; and when he returned to London in 1929 and took a studio – actually, a converted garage – in South Queensberry Mews, he was known, in so far as he was known at all, as a decorator and designer. In August 1930 an article headed 'The 1930 Look in British Decoration' appeared in *The Studio* magazine: from this it was clear that Bacon was deploying a gift, long since evaporated or pushed underground, for conscientious modernity. The windows of the studio were said to be 'curtained with white rubber sheeting that hangs in sculptural folds'. It is difficult to imagine him putting up, in later life, with the 'white faience seagull by Adnet' which *The Studio* remarked upon. But the steel-and-glass furniture and the modern-style or Art-Deco rugs, all of his own design, reappear in toughened and epigrammatic form in many of his paintings, as do the mirrors of black-and-white glass and the look of a general bareness: half studio, half condemned cell. Around this time he began to paint in oils, and not long afterwards he had a show, jointly with his friend Roy de Maistre, in which one or two paintings were allied to pieces of furniture.

Two paintings by Roy de Maistre fixed, once and for all, the look of the studio in the early 1930s. The floor is like a sheet of black glass. Glass, again, were the tops of the circular tables. Steel tubes served as drawer-handles, chair-legs, supports for wall-brackets. Paintings and rugs were often of an identical format – a tall, thin portrait-shape – and the images could be read, however loosely, as standing human figures. One rug, dated about 1929, is almost a straight paraphrase of a synthetic cubist painting by Picasso. Later, when painting got the upper hand of furniture-designing, the paintings stacked against the wall (and carefully, irreplaceably recorded by de Maistre)

had again a look of Picasso: the rearing pinhead and grossly enlarged feet, for example, of the bathers done a year or two before. Bacon regards all these paintings as worthless and irrelevant and discourages any discussion of them; but they have, at the very least, a negative significance, just as the earliest surviving paintings, which date from 1929, have a look, long since discarded, of English pastoral surrealism as it was practised by Paul Nash: stylized vegetation, multiple perspective, fragments of classical architecture, and floorboards that swoop up or away from the picture-plane. All that soon went, and went for ever, along with the dark London hat, the formal striped suit, the tall collar and the neatly tied tie in which Bacon was photographed in 1928 in the gardens of Schloss Nymphenburg.

In 1933 Bacon made, in one way and another, a distinct if small mark as a painter. One of several paintings by him of a crucifixion was reproduced by Herbert Read in his book *Art Now*; and this same picture was bought by telegram by Sir Michael Sadler when Freddy Mayor included it in a mixed show in his gallery in October 1933. Art-life at that time was a discreet, secluded affair and a matter of concern to very few people. For Bacon to engage the interest of Read, Mayor, and Sadler represented about as much as could be achieved in so short a time in the England of the early 1930s: Read was the critic most alive to new art, Mayor had a long record of discernment in his choice of exhibitors, and Sadler was a collector of quite outstanding accomplishments who had visited Kandinsky when hardly anyone in England had ever heard of him and had seen the point of Henry Moore when Moore was an unknown student just out of the army.

In February 1934 Bacon organized a show of his own work in the basement of a big London town-house, Sunderland House in Curzon Street, which had been taken by his friend Arundell Clarke. Once again, the work put on show has since been entirely discounted by the artist: with the exception, however, of one painting, *Wound for a Crucifixion*, which he still speaks of with great attachment and regrets having destroyed. This was set in a hospital ward, or corridor, with the wall painted dark green to waist-height and cream above, with a long, narrow, horizontal black line in between. On a sculptor's armature was a large section of human flesh: a specimen wound, and a 'very beautiful wound' according to Bacon's recollection.

There are, in point of fact, two surviving pictures, both dated 1933, which have a comparable background. It looks, at nearly forty years' distance, as if Bacon was already marked out as a painter of figures in rooms, and of rooms schematically divided. The sense of enclosure, of situations pushed to their extreme between four walls, is powerful enough to offset all shortcomings of assurance in the way those situations are handled. One or two people sensed

that he could become a painter of real consequence: Eric Hall, for one, who had bought a rug from Bacon in 1929 and followed his career closely right through to the late 1940s. Michael Sadler remained interested to the point of sending Bacon an X-ray photograph of his own skull with the request that he should paint a portrait of it. Bacon did as he was asked and incorporated the skull in a painting of 1933 called *Crucifixion* which is not, by any means, a favourite of his. But he now regards this whole period as, if not a false start, at any rate a misleading one; and he made no effort to consolidate his position among the two or three people who then stood for advanced opinion. With the exception of three paintings contributed to the 'Young British Painters' exhibition at Agnew's in 1937, he did not show again until 1945.

For a number of years he ceased, in fact, to be a painter in any practical sense. He was not one of those painters who need to go to the studio every day in order to preserve some sense of their own identity. Nor was he one of those painters, not uncommon in English art-history, who are born with great natural facility and spend their adult lives trying to think what to do with it. He was *sui generis*, in this as in everything else; and there was, in any case, too great a gap between his way of seeing the world and his ability to put it down on canvas. Some people, again, would have set themselves to study twelve or fourteen hours a day, seven days a week, like the young Matisse. Bacon 'did nothing', existed by odd jobs of a fugitive sort, gambled a lot, and seemed not to be pushing himself to go anywhere in particular.

In point of fact he had everything to learn and was going about it in his own way. Bacon today is quite exceptionally articulate and can take the heart out of a new book as fast as anyone at All Souls. But he remembers himself as having been, in the 1930s, an absolute beginner in such matters; and he remembers, above all, the salutary surprise of hearing his friend Edward Ashcroft say that 'Whatever is clearly thought can be clearly said'. It was not until much later that he mixed at all in what could be called the society of intellectuals; for the moment, he learned as many another powerful nature has learned: on his own.

In the pictorial sense, a new branch of education came into being in the 1930s. This was the news-photograph, and above all that formalization of disrespect which was then spoken of as 'the candid camera'. It was quite a new thing that public figures should be wrenched out of the standard attitudes of traditional portraiture and shown as they actually are: harassed, inconsequent, racked by tics, their faces distorted, their clothes in disorder, their bodies off balance. Many people at the time found all this an unwarranted intrusion upon the privacy of the subject. Others recognized it as a school of truth, and one not available to earlier ages.

Its arrival coincided, moreover, with that of a new class of monsters:

human beings ambitious and unscrupulous beyond all the norms of liberal democracy and bent on eliminating that mutual tolerance upon which democracy depends. When applied to the Nazi leaders, the procedures of candid camera and news-film gave a new and creepy dimension to our idea of what the human face will bear in the way of distortion. Photographs of the Russian Revolution had already shown that in moments of violent action the recordable image of the human body is stretched far beyond what we normally think acceptable. And now, just across the Rhine, the answer to the question 'What is a human being?' was being revised, and the image that went with that answer was being revised with it. Bacon had had almost no formal education and he was never to catch up with Middle English or the consequences of the Council of Trent; but in the prime object of education – the understanding, that is to say, of one's own time – he was ahead of the Prime Minister, and ahead of the Foreign Secretary, and ahead of the Editor of *The Times*.

He was, then as now, a great hand at not doing things unless he really wanted to do them. He had already the kind of weight, in conversation, which makes people say to themselves 'There's someone we must get hold of'. In the 1930s, for instance, he was invited by Rupert Doone to make the scenery for a new production of *The School for Scandal*; but he didn't want to do it, any more than he has wanted, quite enough, to take part in a number of more recent theatrical adventures for which people have sought his collaboration. He was very bright – everyone agreed on that – but the brightness was still unfocused; and in fact it did not come into focus until the last months of the war.

Bacon before 1939 was, as I have implied, Marginal Man personified. Taking no part in society's rituals, observing none of its canons and taboos, he was not involved in them even to the extent of denying or infringing them in any spectacular way. He just went on as if none of them existed. His existence was entirely private. Duty, obligation, observance, ambition – all slumbered in the dictionary. Not much of this was changed in wartime, though wartime had the effect of making other people more like him: nomadic, that is to say, and improvisatory, and given to sudden gusts of affection, and much preoccupied with the element of chance in life. Contrary to general belief, wartime is advantageous for Marginal Man. Not only does his own kind multiply, most mysteriously, but his status is envied, and his behaviour aped, by those whom the war has put nearer to the centre of things than is quite comfortable. London for much of the war was a shabby, slovenly, easy-going, relaxed and paradoxically undemanding sort of place. Foreigners abounded. Once the grand general obligation to King and Country was discharged (or put aside), people were left free to behave or

misbehave as they pleased. The city became one vast transit camp. More cosmopolitan, perhaps, than at any other time in its history, it welcomed into its tumbledown embrace a fugitive company of heroes and scroungers, charlatans and scallywags. Often these brought out in the resident population reserves of oddity which they had not known themselves to possess, together with whims and velleities for which peacetime had held only disapproval. The collapse of bourgeois society seemed imminent; every man was his own Harun al-Rashid.

Bacon's asthma had ruled him out of account as a soldier, but he did at one time enrol in the ARP rescue service, only to be discharged when it was clear that he was not well enough to continue. He gambled a good deal, at a time when life itself was one huge gamble of a rather undignified sort, and he had abundant scope for the observation of human oddities. 'We all need', he once said, 'to be aware of the potential disaster which stalks us at every moment of the day'; and he noticed at the time of the German air-raids on London that these did indeed provoke a most curious frenzy among those who sat them out. But the crucial fact about his wartime experience is that for some reason it suddenly turned him on to painting again, after several years' withdrawal. 'If I hadn't been asthmatic,' he once said, 'I might never have gone on painting at all.' But when he was discharged from his ARP post, he found, against all expectation, that painting had become an obsession for him. From that obsession came the group of paintings which he showed at the Lefevre in 1945. What happened after that is the subject of the rest of this book.

The fine-art context

Bacon's work bears looking at in four distinct and quite different ways. There is the fine-art context: the extent to which it continues the tradition of European figure-painting. There is the context of visual material that has nothing to do with art: the newspaper, the magazine, the medical photograph, the movie-still, the photographs which document the effects of psychological tension or stress. There is the context of what is irreducibly his own: the Bacon-note in the work. And there is the context of what has happened to art, and to society, since the *Three Studies* were first put on show; for what once looked entirely of the moment has turned out to be timeless, and what once rang out like an individual cry of pain has been taken up, all over the world, as the first oboe's A natural is taken up by the whole orchestra. On one level the pictures are physical objects, additions to a world which absorbs millions of new paintings every year and has its own system of refuse-disposal for getting rid of them; on another, they are moral-energy systems, constructed in the belief that, as Bacon once said, 'There is an area of the nervous system to which the texture of paint communicates more violently than anything else.'

If taxed with all this, Bacon is likely to attribute the break-through in 1945 very largely to the imperious character of the day-dreams which he had lately been having. Once away from the studio, he has an Irish openness, an easy conversability which persuades many people that they 'know' him after five minutes' conversation. But fundamentally few people are less gregarious. If his telephone goes out of order, he will say 'It's wonderful to be cut off from human contact'; and today, as much as ever, he spends a great part of his time day-dreaming, like a big cat in a cage. With his sleeves pulled up to his elbows, he sits or half-lies, most often with one leg bent, drawn up beneath him, and held firmly with a large, dry hand that is particularly full and broad in the palm. No one age could be ascribed to his face. When he gets up and crosses the room, it is with an incisive, spring-heeled tread and a quick glance to left and to right, as if the walls were as transparent as those of a cage, and something, somewhere outside, were about to come within reach of the big cat's claws.

The big-cat metaphor is incomplete, of course; but it is right enough as regards the combustibility and state of animal readiness which are part of

Bacon's equipment as a painter. The idea of the trap is a favourite with him, and he sees the painter – his kind of painter, at any rate – as lying in wait for the image in the way that a hunter in equatorial Africa will lie in wait above the baited trap that he has set hours, if not days, before. We know nothing of the big cat's thought-processes as he, too, lies in wait; but we know enough about what is traditionally called 'day-dreaming' to be quite sure that in Bacon's case it is a working-name for something purposed and constructive. Long before Anton Ehrenzweig published his *The Hidden Order of Art* in 1967, Bacon was a master of the 'unconscious scanning' which was one of Ehrenzweig's main contributions to our notion of creativity.

'Unconscious scanning' is the name which Ehrenzweig gave to the active but unfocused attention as a result of which we make discoveries and establish correspondences which are denied to 'normal', concentrated, focused attention. It is a common and universal experience of everyday life that if we momentarily forget something, we cannot recapture it by knitting our brows and concentrating; but if, on the contrary, we relax our attention and let the mind go limp, the missing fact will find its way back of its own accord. Ehrenzweig suggested that what was formerly known as 'the chaos of the unconscious' is, in reality, a serial structure of supreme beauty and complexity; and that it is accessible only to unconscious vision.

'What matters', he said, 'is that the undifferentiated structure of unconscious (subliminal) vision, far from being weakly structured or chaotic, as first impressions suggest, displays scanning powers that are superior to conscious vision.' And, later: 'It can be stated as a general psychological law that any creative search involves holding before the inner eye a multitude of possible choices that totally defeat conscious comprehension.' To this multitude of possible choices, our conscious faculties can react with a 'defensive rigidity', an anxious tightness that lets in the possibilities one at a time, and a conviction that their very profusion is an act of malice on Nature's part. The closed system, the finite and limited order, the notion of a definable beauty – all are examples of this defensive rigidity. Its antithesis is the decision not to force, not to anticipate, not to tighten. The 'undifferentiated structure of unconscious vision' is what the artist needs, and 'day-dreaming' is its nursery-name.

It was not part of Ehrenzweig's purpose to say exactly what should be scanned, or what is available for scanning, or whether the serial structures of one man's unconscious may be richer or more meaningful than those of another, or whether some people's scanning apparatus is innately more efficacious than others'. But it is quite certain that the disintegration of western society over the last hundred years, and the profound and ever-accelerating changes in the nature and function of art over that same period,

have between them placed at the disposal of the artist a material quite simply prodigious in its richness and complexity. If we consider that it can be argued that the end of painting is at hand, and that the end of painting may in any case be merely incidental to the end of human life on earth, it follows that Ehrenzweig's 'defensive rigidity' could very well be taken up by almost anyone whose identity, as a human being, depends on the continuance of old-style fine art. The alternative is to embrace a whole new family of desperate extremes; and it is because Bacon has done this that his day-dreaming, and its outcome, are worth closer investigation.

'The great images of the past', he once said, 'are precise in ways that are no longer either possible or "actual".' This is not a problem that can be tackled frontally: old-fashioned vertical thinking will get nowhere. Vertical thinking has been defined by Edward de Bono as knowing how to dig an already-existing hole deeper. Its antithesis is lateral thinking: digging a hole somewhere else, and knowing where to begin. Vertical thinking can be taught, and is the basis and object of formal education. Lateral thinking is something quite different. De Bono suggests that its principles can be considered under four headings: recognition of dominant or polarizing ideas; the search for different ways of looking at things; relaxation of the rigid control of vertical thinking; and the use of chance.

Among these, the third principle is related, quite clearly, to Ehrenzweig's theory of unconscious scanning. But, more generally, the lateral thinker is the one who comes upon Ehrenzweig's serial structures and reads them in ways that would never have occurred to a vertical thinker. A vertical thinker who addressed himself to the problem 'What should a picture be in the year 1945?' would never have come up with Bacon's *Three Studies for Figures at the Base of a Crucifixion*; the *Studies* were so remote from current ideas about painting that they were regarded as the product of a wayward, invalidish fancy that had no general authority. I propose to argue that they were, on the contrary, an objective, accurate and verifiable account of society in certain of its aspects, and that they were arrived at by a process to which both unconscious scanning and lateral thinking contributed.

To establish this, we must know something of what was scanned, something of what had been thought about, laterally or otherwise, and something of the general situation of art at the time. The precise timing of the *Three Studies* in Bacon's career is important, and the reader should also realize to what an extent that career is a matter of intelligent adjustment to circumstances and of a refusal, in all circumstances, to fall back on 'defensive rigidity'. Among Edward de Bono's four principles, the fourth, 'the use of chance', has been stressed by Bacon himself on many occasions; but there is a difference in this context between what is loosely called 'pure chance'

2

and what is, rather, a reliance on involuntary prompting from within.

Bacon has in his studio a physical stock of images: pictures that he has taken from books and catalogues and newspapers and magazines for many years, in the knowledge that sooner or later one of them will rise to the top of the heap at the appropriate time. Much in the *Three Studies* now seems to him, for instance, to be a relatively direct and primitive adaptation of strange forms that he had memorized while poring over photographs of animals. Animals in movement fascinate him especially; the instantaneity of the photograph yields an alphabet of forms, neither wholly animal nor wholly human, which somehow extends the alphabet of human forms. Anyone can invent spooky animals: the difficult thing is to use animal form in such a way that it returns the observer to human form and gives him a heightened understanding of it.

The *Three Studies* are the natural point of departure for any study of Bacon, but they stand a little apart from the main body of his work. The references are uncharacteristically direct, for one thing. The pictures have a one-to-one relationship with definable sources or inspirations, which is rarely the case with Bacon's paintings. When he quotes, in conversation, a phrase from Aeschylus about 'the reek of human blood smiling out', or when he describes the colour-plates of wounds, and of rare skin diseases, which he had examined in medical bookshops, the *Three Studies* seem already half-way made. This does not diminish their importance: it is still true that there was painting in England before the *Three Studies*, and painting in England after them, and that no one can confuse the two.

Judged by the standard of Bacon's later work, the paint in the *Three Studies* has, even so, a tight, seamless, unresonant quality: Bacon is here sticking very closely and quietly to the fact which he wishes to record. Perhaps that fact was too strange to bear manipulation? At any rate, other paintings of this same period are nearer, in terms of execution, to his paintings of the 1950s and 60s. They have, once again, an element of day-dreaming, but they also have something that comes near to the surrealist practice of automatic writing. Bacon would begin, that is to say, with one intention and would then be led by the nature of the mark on the canvas to end up with quite another. The classic instance of this is the big *Painting 1946* which Alfred Barr bought, on behalf of the Museum of Modern Art, from Erica Brausen in 1948. Bacon began by painting what he thought would be a chimpanzee in long grass, went on to try his hand at a bird of prey landing in a field, and almost involuntarily ended up with a monumental painting – one of the few in which he came near to realizing his full intentions – in which three of his preoccupations are mysteriously conjugated: war, meat, and the dictator. The picture also pioneered other recurrent elements in his later

3

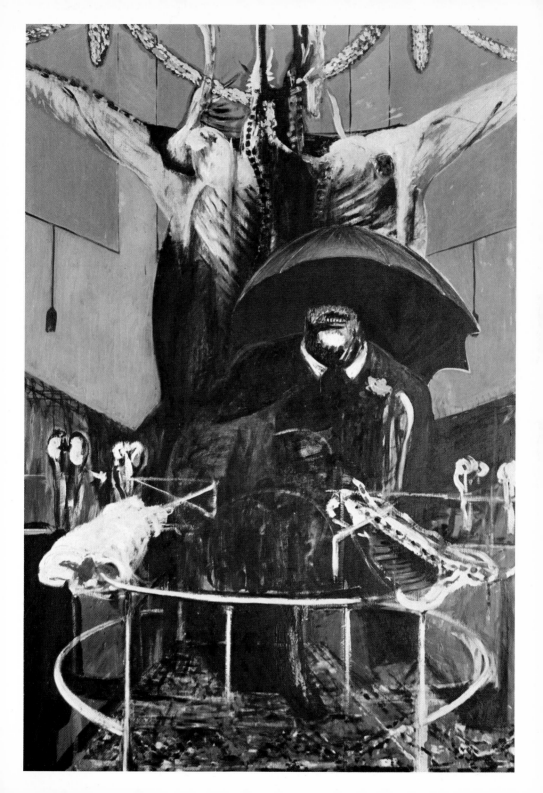

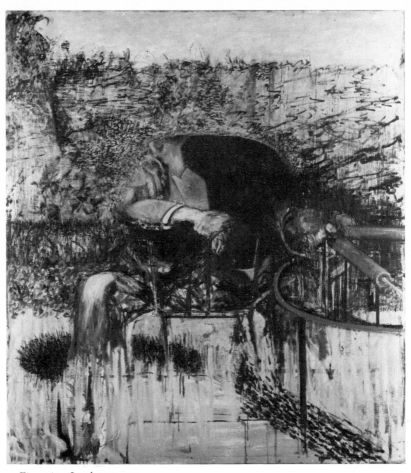

4 *Figure in a Landscape* 1945

work: tubular furniture, for one, and what looks like a hot red Turkey carpet, for another, and the blinds with their dangling cords for a third. The two sides of beef form up as a crucified figure, and the umbrella is a classic surrealist property. The faceless mouth will be familiar to anyone who in childhood saw news-photographs of Mussolini.

Bacon in later years was to take up all these things, singly or in combination, and often to more unified effect; but *Painting 1946* gives, uniquely, the impression of a powerful nature struggling to reach complete

3

5 *Figure Study I* 1945–46

expression – adding, embellishing, continually raising the stakes, risking chaos, throwing in enough ideas for half a dozen pictures. By the 1960s he could make us feel the nearness of the charnel-house without actually showing us the meat; but in 1946 all was spelt out, right down to the dictator's yellow button-hole and the dingy white collar which has been forced open by the monstrous proportions of his neck. At a time when many European cities were being decorated to mark the end of the war, there was something peculiarly lurid about the festooning of the upper part of the

27

picture with what could have been paper-chains but looked more like the innards of some huge beast unknown in Smithfield Market; and the seated figure itself had a disquieting likeness, though a distant one, to the official photographs taken at Yalta – above all, perhaps, to Roosevelt with his big cape fastened high at the neck. (In 1971 Bacon painted a variant of this image against a tulip-yellow background; what he called 'the armchair of meat' then took on a strikingly succulent appearance.)

The seated figure turns up in another important picture of this period: the Tate's *Figure in a Landscape*, which Bacon painted early in 1945. This was prompted by a photograph of his friend Eric Hall dozing in a canvas chair in Hyde Park; but the day-dream principle soon took over and the picture ended up as – what? A civilian machine-gunner, outgunned and headless? A strange and fortuitous echo of Magritte's *Therapeutist* of 1937? Neither description will do. A man-Madonna, a transvestite throwback to a great European tradition, enthroned among a Nature that is not pretty in a Florentine way but hostile? That won't quite do, either, though all these possible descriptions suggest something of the complexity of the final image. The year 1945 counts for much, once again. Violence at first hand was integral at that time to European life, and the strange juxtapositions of which surrealism made so much had become a part of ordinary life. What seemed to many people the gratuitous oddity of Bacon's imagery was outdone a thousand times over – turned, in fact, to a down-to-earth ordinariness – by what was actually happening in Europe as one city after another was fought over and fought through. *Figure Study I* and *Figure Study II* of 1945–46 are other examples of this: the background of No. II is as severe as that of Poussin's Louvre self-portrait, and the strange drama of the middle-ground could have been paralleled many times over in cities where half-dressed people were caught by disaster and a shriek as elemental as that portrayed by Munch in the 1890s rang out on every hand.

Even at that early date (the two *Figure Studies* were shown at the Lefevre in February 1946), it got through to many people that Bacon was trying not merely to record some startling facts but to put them down with a sumptuosity of statement that was quite foreign to 'modern English' painting at that time. Passages like the overcoat in the *Figure Studies* were pushed as far as he could then push them in the direction of voluptuous expression. At the same time he was going all out for monumentality. The gamble was for high stakes in the old European tradition, and the pictures were to deserve either the National Gallery or the dustbin, with nothing in between.

All this was in line with his attitude to earlier art, and with his ideas of what, ideally, people should do with their lives. Bacon will not, in anything,

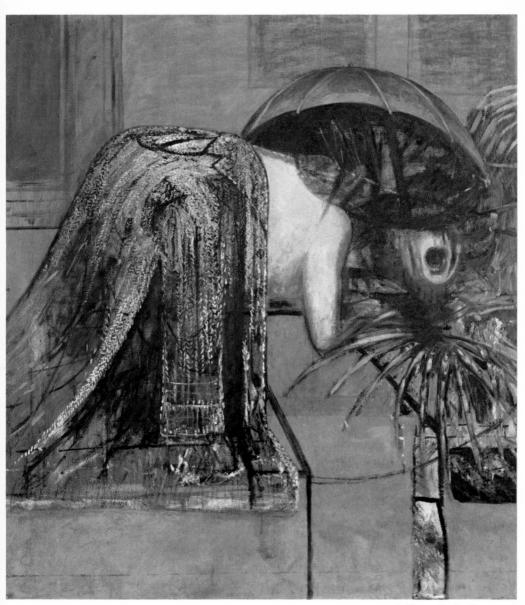

6 *Figure Study II* 1945–46

settle for the second-rate. He has an aristocratic preference for private statements that are made in a very grand, plain way. Hence his admiration for Baudelaire: 'Baudelaire is as intimate as it is possible for a human being to be, when he writes about behaviour, and yet it remains very grand – in "Les Petites Vieilles", for instance, when he spreads all Paris before you.' Baudelaire made some of his most memorable effects by adapting the stately utterance of the seventeenth century to things which were quintessentially 'modern' and could never have been written before; and, in the same way, Bacon's ambition is to take 'shocking' or 'unheard-of' material and deliver it in the European grand manner. People frequently imagine that any recrudescence of that manner must be accompanied by a certain rigidity, a defensive keeping-out of subject-matter that is too much of our own time. Francis Bacon's own point of view is the opposite of this: 'If only people were free enough to let *everything* in, something extraordinary might come of it.'

3 The New York *Painting 1946* is, on one reading, an example of 'letting *everything* in'. Surrealism, certainly, had let more in, in that sense, than most earlier kinds of painting; and the accumulation of material in *Painting 1946* has, as I said earlier, its surrealist side. Anyone who had read Lautréamont, and read Breton's Surrealist Manifestos, would know how to feel his way around it. The Surrealists felt free to disperse the interest, knowing that somewhere, somehow, the facts would bite all the harder. But by 1948 Bacon was no longer dispersing the interest: he was concentrating on one single image that had been dragged round the dark side of reality and brought back – transformed and re-presented – into the light again. There is no doubt as to which of the two ambitions was the more difficult. Any fearless researcher in the heart's rag-and-bone shop could at that time come up with debris strange enough, in almost any arrangement, to impress us. The difficult thing was to perfect the single image.

Samuel Beckett in his book on Proust speaks of 'those rare miracles of coincidence when the calendar of facts runs parallel to the calendar of feelings': Bacon's ambition is to bring about those miracles by a combination of extreme vigilance with the will to 'let everything in'. 'Letting everything in' was only a part of Proust's method, but it was an essential part, and its essentialness is well characterized by Beckett: 'Voluntary memory (Proust repeats it *ad nauseam*) is of no value as an instrument of evocation, and provides an image as far removed from the real as the myth of our imagination or the caricature furnished by direct perception.' That myth, and that caricature, are quite foreign to Bacon's painting. 'There is only one real impression', Beckett goes on, 'and one adequate mode of evocation. Over neither have we the least control.'

Involuntary memory is the prime factor in all this; and the material with which it can deal is 'stored' (Beckett again) 'in that ultimate and inaccessible dungeon of our being to which Habit does not possess the key, and does not need to, because it contains none of the hideous and useful paraphernalia of war. But here, in that "gouffre interdit à nos sondes", is stored the essence of ourselves, the best of our many selves and their concretions that simplists call the world, the best because accumulated slyly and painfully and patiently under the nose of our vulgarity, the fine essence of a smothered divinity whose whispered "disfazione" is drowned in the healthy bawling of an all-embracing appetite, the pearl that may give the lie to our carapace of paste and pewter . . . From this deep source Proust hoisted his world.' (*Proust, and three dialogues with Georges Duthuit*, London 1965.)

This is, of course, an earlier and less scientific-seeming version of Ehrenzweig's 'unconscious scanning'. What is Beckett's 'mysterious element of inattention that colours our most commonplace experiences' if not the 1930s' notion of unconscious scanning? What was unusual about Bacon's situation in the late 1940s was that as a man then forty years old he had as yet made no sustained effort to dredge for the pearl that might 'give the lie to our carapace of paste and pewter'. In particular, he had not tried to do it in the many-levelled way which seems to him to characterize the major achievements of the twentieth century. Certain lost or abandoned paintings of the early 1940s show the repertory of later paintings in an unmixed or inchoate way: isolated mouths, open black roadsters such as the Nazis used, fragments of uniform, tubular constructs, far pencilled horizons. What was missing was the realization that, although a given event may be on one level only, our knowledge of it exists on many levels at once. Bacon had read *Ulysses* in 1930 or thereabouts, and been enormously impressed by the extent to which Joyce had reinvented naturalism: had invented, that is to say, a way of recording fact which, although remote from traditional novelizing, none the less ended by giving the reader a far stronger dose of fact than had been offered to him before. That fact came on many levels: sentence after sentence was a tiered construct, a many-jawed trap for sensation. When *Ulysses* was filmed, no amount of reverence could overcome the fundamental absurdity of the endeavour: the fact that although sight and sound between them should have been able to present an experience of great complexity, they turned out to be outclassed at every point by the printed page: invention became illustration, and illustration was too stiff at the joints.

This is the context in which one should look at the Belfast *Head II* (1949), 10 which seems to me the most successful of Bacon's early attempts at the single image. Paste and pewter have no part in it: the pearl, a black one, is out on its own. 'One of the problems', he remarked at the time to a reporter from *Time*

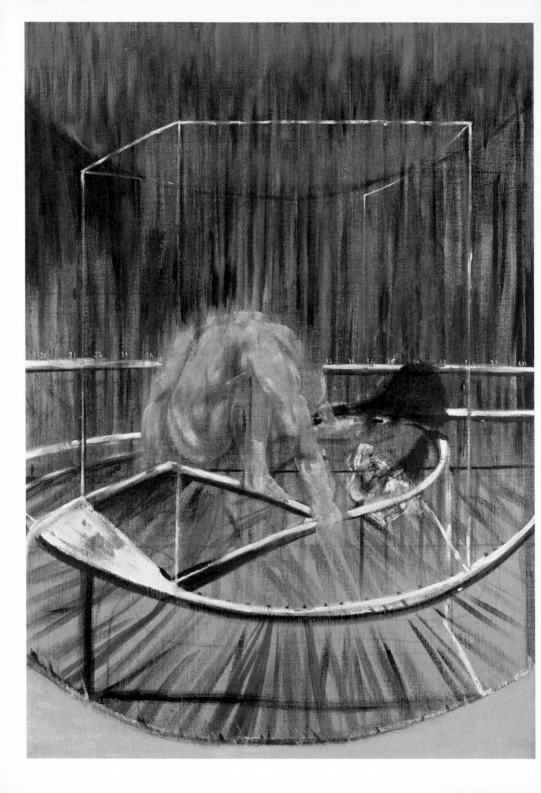

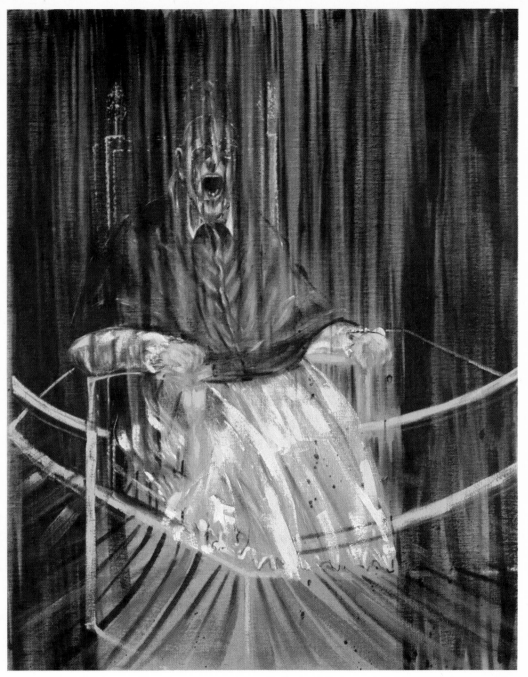

8 *Study after Velazquez's Portrait of Pope Innocent X* 1953

7 *Study for Crouching Nude* 1952

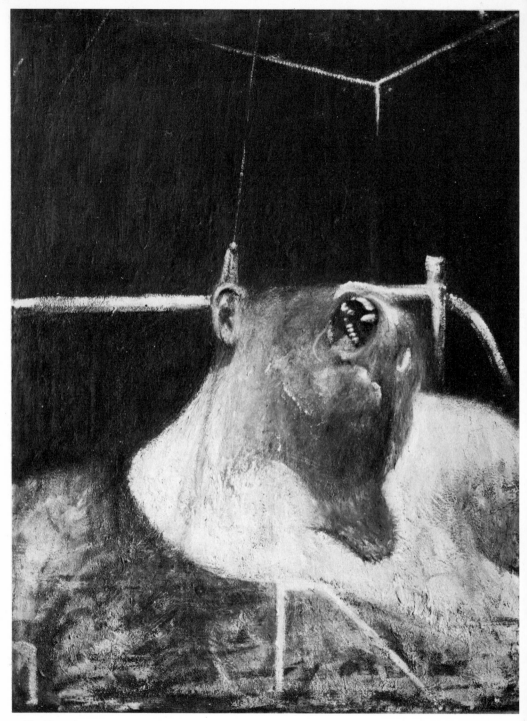

9 *Head I* 1948

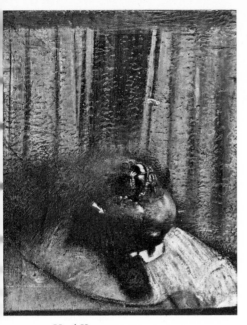

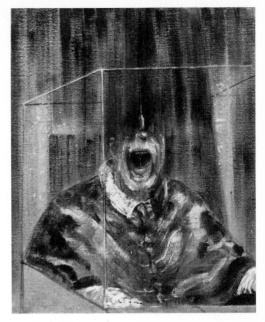

10 *Head II* 1949 11 *Head VI* 1949

magazine, 'is to paint like Velazquez but with the texture of a hippopotamus skin'; and *Head II* does have, over much of its surface, a dense, weathered, leathery texture that reminds us of another remark of his: 'Painting has nothing to do with colouring surfaces.'

Head II has to do with a shallow, curtained space. 'I've always wanted to paint curtains', Bacon said many years later. 'I love rooms that are hung all round with just curtains hung in even folds.' But the curtains in *Head II* could also be the walls of a prison, an execution dock in which an unnamed creature was confined. They could be curtains stiffened by the fifty years' *crasse* of a tenth-rate lodging-house; or they could be sliding shutters that had been pulled apart to admit a new victim. Safety-pin and arrow have no rational function, but they do most mysteriously enhance the atmosphere of the painting (which would also, from a spatial point of view, look flatter and vaguer without them).

As for the head itself, it can bear many interpretations. It can be localized in time: pinned, that is to say, to the view of the human condition which was current at the time. The late 1940s were the heyday of the 'extreme situation'. Camus with *L'Etranger*, Sartre with *Huis Clos*, Koestler with *Darkness at Noon*, had all seen the small, enclosed, windowless space as a metaphor for our general predicament; and since a great many Europeans

35

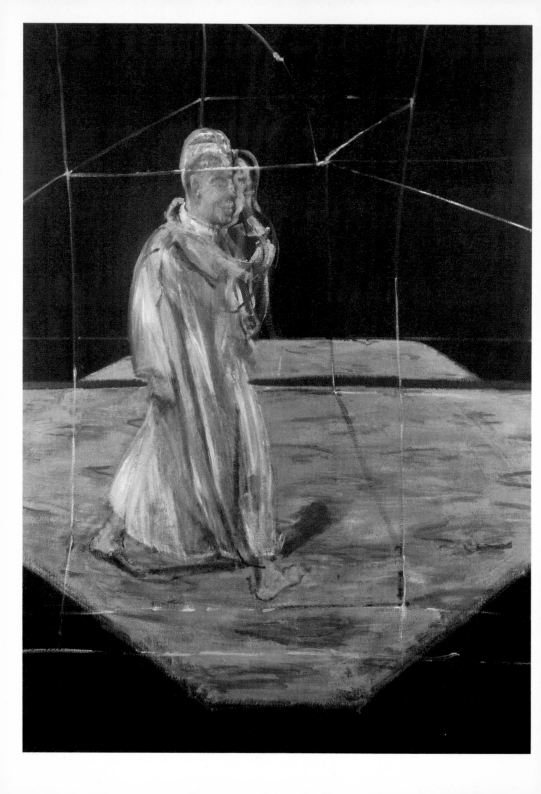

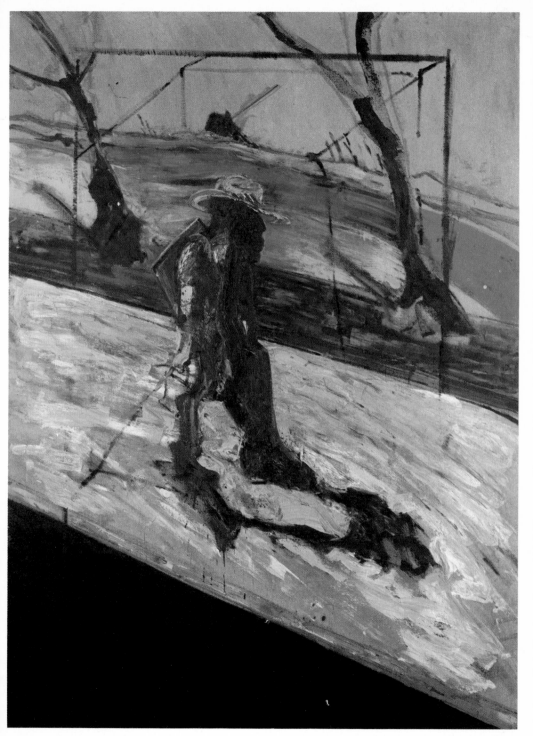

12 *Man Carrying Child* 1956 13 *Study for Portrait of van Gogh II* 1957

had lately been in captivity of one sort or another, the view had a certain circumstantial validity, quite apart from its metaphorical interest. *Head II* can also be read as an evocation of some kind of *Untermensch*: a discarded trial run for a human being, grunting and slavering in its pen. It can be related to Picasso's reinvented heads, but with the difference that in them Picasso really is just 'colouring surfaces' or filling in a drawing with paint.

But perhaps we don't need to go so far, or so fancifully, for an interpretation. Perhaps the six *Heads* that formed part of Bacon's first show at the Hanover Gallery in November 1949 are simply statements about what it feels like to be alone in a room. Looking at them, we realize that although European painting includes a great many portraits of individuals in rooms, they are never about what it feels like to be alone in a room: the painter always makes two. Not merely is the subject not alone in a portrait by Titian or Ingres, but he is not-alone in the highest possible degree: he is under inspection, that is to say, and more searchingly so than in almost any other of life's possible situations. The garbage of the psyche has been put out at the back door; all buttons are done up. The sitter is busy: busy posing, admittedly, but busy none the less. What painting had never shown before is the disintegration of the social being which takes place when one is alone in a room which has no looking-glass. We may well feel at such times that the accepted hierarchy of our features is collapsing, and that we are by turns all teeth, all eye, all ear, all nose. The view out front ceases to be the only one, and our person is suddenly adrift, fragmented, and subject to strange mutation. That is the kind of situation with which *Head VI* could have to do.

It is not, in any case, a piece of deliberate moralizing. Bacon has known some very odd people in his time, but he never judges them on moral grounds and he certainly does not mean to bring out the Mr Hyde in his imagined subjects and leave Dr Jekyll to dine by himself at the Athenaeum. If we try to read *Head VI* naturalistically, we get something like a cross between an alligator shorn of its jaws and an accountant in pince-nez who has come to a bad end. What is animal is charged with human overtones, and vice versa: we are neither quite in the world as we know it, nor quite out of it. It is as I said earlier: certain facts about human nature have been dragged round the dark side of reality and brought back into the light. If the effect is horrific, it is not due to any ghoulish emphasis. Bacon likes, in this context, to quote not from any modish recent source but from Madame du Deffand: 'Il n'y a qu'un malheur, celui d'être né.'

Taken out of context, that remark carries with it overtones of self-pity which are foreign to Madame du Deffand and, even more so, to Bacon. What she meant was that birth is the mishap after which nothing can ever be quite as bad again. But life does, even so, have in store for most of us a

repertory of misfortunes, some self-invited, others not: and it is in respect of these that the big artist takes up a distinctive stance. When I wrote earlier that Bacon's ambition was the National Gallery or the dustbin, with nothing in between, I meant it literally; middling fortunes and the middle way mean nothing to him, and where fine art is concerned he likes it to exist unbeatably or not at all. In this he is at the farthest possible remove from those younger artists who think that the concept of the masterpiece is irrelevant and anachronistic. Such talk is, in my view, mere dressed-up incapacity: rationalized impotence. The great artists are, and will always be, the ones who paint the great single pictures.

Bacon knows this, and tries to live by it, but in his attitude to the great painters of the past he is unlike anyone who came before him. He is not, for instance, at all like the French masters of this century who educated themselves in the Louvre. Even less is he like the English painters of earlier generations who went round Europe, cap in hand and forelock tugged, in the hope that they could somehow justify their existence. He sees painting as an activity in which (to quote a key-phrase from the heyday of existentialism) 'on joue perdant'; and in which the rare great successes of the past discourage as much as they incite.

Nor is he the kind of painter who sees first-hand contact with a favourite painting as the equivalent of a laying-on of hands. He loves cave-paintings, but has never seen one. He has worked repeatedly from the idea of Velazquez's *Pope Innocent X*, but did not care to see the original when he was momentarily in Rome. So far from putting 'the Old Masters' in a category of their own, and the rest of visual experience on the other side of the sticks, he is likely to get as much pleasure from an out-of-key colour photograph as from many an accepted 'masterpiece'. An ideal democracy is the characteristic of his attitude to visual material: every image is the equal, in potential, of every other image, and a tattered page from *Picture Post* for 1939 may well say more to him than anything by Fuseli, with whom he is often and so wrongly associated.

What grips his attention in older paintings is very often an inspired solution to a problem that he has himself been struggling with. And, just as he will keep a page or two from a book and throw away the rest, so will he fix on one or two paintings by a big artist and leave the rest out of account. In Degas, for instance, he prizes especially the passages in the National Gallery's pastel nude which distort the structure of the upper spine and yet somehow return the observer to the *fact* of the subject as if he had never before seen a woman's body as it really is. And since Degas was a great student of people in rooms, it is natural that Bacon should often have studied the paintings in which Degas brought off just that element of psychological ambiguity

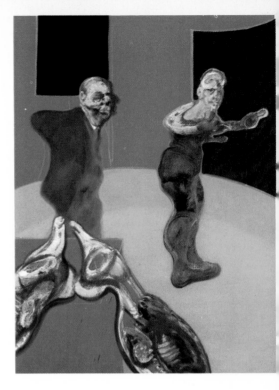

14 *Three Studies*
for a Crucifixion 1962

which Bacon himself often strives for: a capital example of this is the so-
called *Interior (The Rape)* of *c.* 1874 in the McIlhenny collection. (One could
also compare the portrait, in the National Gallery in Washington, of Degas's
sister-in-law Madame René de Gas, where the sitter's blindness is so subtly
evoked by the scuttery, off-centre composition, often paralleled in Bacon's
seated-figure paintings.)

Another thing that has preoccupied him is the question of how to paint
grass. The great painter, for him, is the one who can paint grass the way
Velazquez paints hair. Hair and head, grass and earth, must be made to grow
together in ways that very, very few painters can bring off. Seurat in the
National Gallery *Baignade* comes nearest to doing it with grass, in Bacon's
opinion: something about the shortness, the walked-on look, the suggestion
that every year the town will encroach a little more – all this adds up to near-
perfection in the portrayal of fact. Another favourite of his, in this context, is
Constable's full-size sketch for *The Leaping Horse* in the Victoria and Albert
Museum. The passage to which he returns over and over again is the one in
which Constable defines precisely the degree of uncertainty and agitation
with which the horse almost, but not quite, loses control of the situation.

40

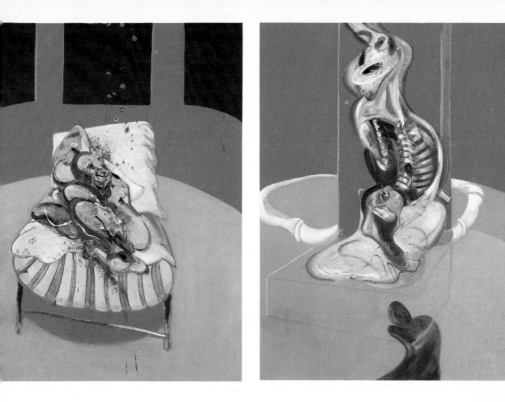

What could have been just an evocative commotion in the paint returns us to fact in just the way that Bacon prizes most.

The incident of the leaping horse is one in which the violence of the image is directly equivalent to the violence of the thing portrayed: a heavy animal kicking and pulling at a slippery river-bank. It is, however, a great mistake to think that Bacon is attracted necessarily to paintings which have violence as their subject-matter – or, for that matter, that violence of subject-matter is fundamental to his own art. If anything, his preferred works of older art are those in which a monumental stillness is combined with ambiguity, or with a leaving-open of some fundamental question about human affairs. People sometimes think, for instance, that he must like Goya, because Goya dealt so often with extreme situations of horror and cruelty. But the Goya whom Bacon admires most is, on the contrary, the Goya of the formal portraits.

Bacon's admiration for Velazquez became generally evident in 1951, when the first series of *Popes* was painted. But in point of fact it was already clear in the Museum of Modern Art's painting of 1946: and what it amounted to, quite apart from considerations of paint-quality and truthfulness to observable fact, was an acknowledgment of Velazquez's

15

3

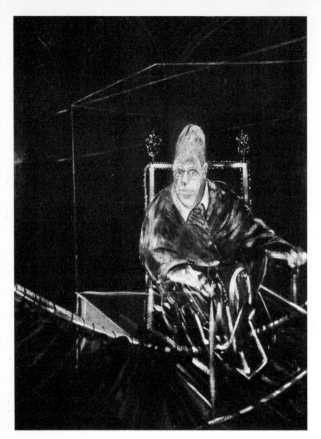

15 *Pope I* 1951

supremacy as a painter of the dressed–up human being: the human being surrounded, moreover, by attributes of power and importance. Pope Innocent X, in Velazquez's portrait, is perceptibly just about the most powerful man in the world. Everything points to it: the throne, the robes, the ring, the state paper held in the left hand, and the note of perfectly balanced and incorruptible authority which is set by the relaxed way in which the Pope's arms rest lightly on the throne.

But to someone who had grown up in the 1920s and 30s this painting also had quite different overtones. The Pope's lace-trimmed white skirts are those, for instance, of an archetypal man in drag – and also, perhaps, of someone who has gladly reverted to infant-state and presents to the world the image of a grown man in swaddling-clothes. In the late 1930s and early 40s, Innocent X was just another man in uniform: a licensed dissembler, like nearly all of us, for whom a uniform was a second self, to be put on and off at will. That second self conferred immunity, as often as not: the uniformed

42

man can lie and cheat and be applauded for it, where an un-uniformed man will be arrested for doing the same things. The Pope in 1650 was top man in life's masquerade; someone who lived all his days in drag and was revered for doing it.

When Bacon painted the Museum of Modern Art's picture, he produced, as if in an echo-chamber, a scene which was many things in one. It was painted at a time in which Europe was one vast charnel-house. France, Germany and Italy were like the field in front of Troy at the end of *Troilus and Cressida*: desolate places in which corpses were towed away like bulls at the end of a corrida, and Pandarus and Thersites were left alive to carry on as before. All over Europe, Thersites' great cry held true. On the Unter den Linden, along the Naples waterfront, and wherever accounts were settled in France, he had the essence of it: 'Lechery, lechery; still wars and lechery: nothing else holds fashion.'

3

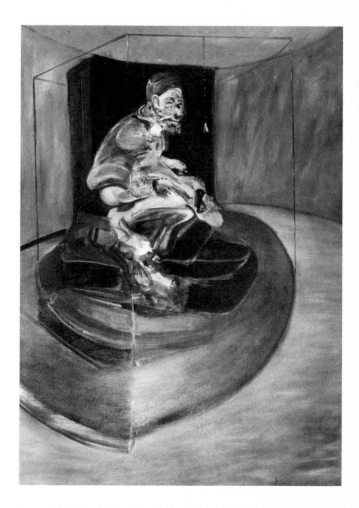

16 *Study of Red Pope*
(Study from Innocent X) 1962

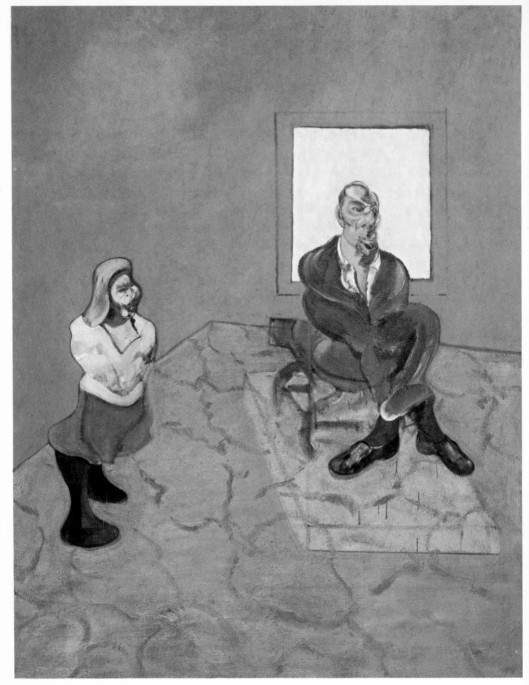

17 *Man and Child* 1963

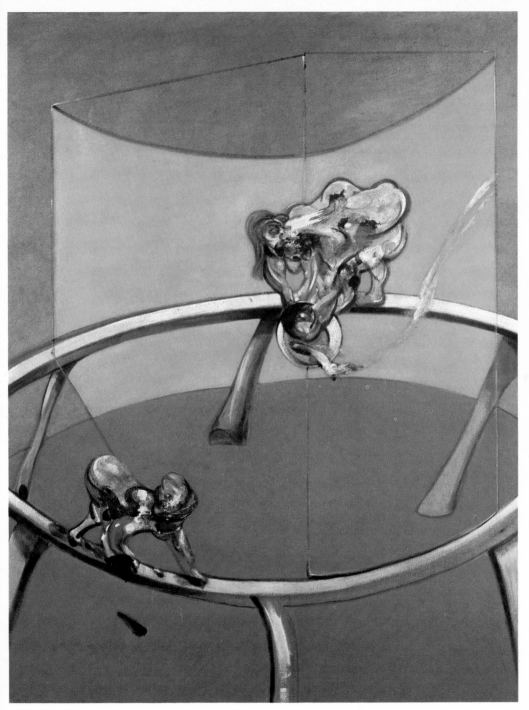

18 *After Muybridge – Woman emptying bowl of water and paralytic child on all fours* 1965

In *Painting 1946* Bacon adapted all this to the conventions of the European state-portrait. There was the abnormal costume. There were the accoutrements, awesome or ludicrous, according to whether or not one accepted their significance. There were furnishings, again of an abnormal sort, which said 'Watch out! This is someone special.' And, again as in Velazquez, there were indications that the outer world was being kept at a distance: Velazquez's sumptuous hangings were paralleled by Bacon's blinds pulled down by a cord. The Pope establishes himself as Pope, in state-portraits, by attributes which happen to be accepted by a large part of the human beings who are alive at the time. Take away that connivance, and he becomes a fine-looking old boy who has dipped deep into the fancy-dress basket. Bacon's figure presides, with equal aplomb, over a nether-world or anti-world in which ribs of beef stand in for state-papers and an umbrella doubles for a baldachino by Bernini.

It so happens that from Velazquez's portrait of Innocent X, and indirectly from its ancestor, the Raphael *Pope Julius II* in the National Gallery in London, Bacon took a motif which served him many times over. In so far as he was 'influenced' by Velazquez, however, the influence was more subtle than the mere borrowing of a motif. Looking, for instance, at Velazquez's portrait of Philip IV of Spain, he was struck by the fact that hidden within that great and complex image was a perfectly straightforward portrait: Velazquez's genius lay in the deformations which in his hands looked inevitable. Bacon was also moved by the element of continuity in Velazquez: the determination, that is to say, to vie with the state-portraits of Titian and remake them in the image of Velazquez's own time. The great paintings, in this sense, are the paintings which contain all other, previous paintings within them. They produce a side-image as well as a direct image, and they cast a shadow into the past: a shadow which streaks backward into the collective memory of our race.

This is a very different thing from producing what Bacon calls 'a mixed-up, willed, "modern" image'. English art in the 1920s and 30s was full of such images: images which ape the past and are born dead in the present. The difficult thing is to keep open the line to the ancestral European imagination while at the same time producing something that comes across as entirely new. In all this, Bacon is handicapped by his determination to stake everything on each canvas, and to go at it with none of the preliminary sketches and intermediary drafts which, in earlier painters, illustrate the creative process at a particularly moving and vulnerable stage.

Seurat, for example, is a painter whom Bacon reveres especially for the quality of his oil-sketches. The finished *Grande Jatte* is a monumental composition in which everything is defined quite clearly; but in the sketches

the image hovers like a butterfly, not quite in the net and yet near enough for us to guess what it might look like if it were ever to be pinned down. Bacon treasures these moments at which the image might go one way, and then again might go another. The same touch of Seurat's brush, at such a time, could stand for either a leaf on a tree or the ear of a monkey. Yet when the painting is carried out on its full scale this hesitant and tentative quality must be sacrificed. How to carry over the magic into the larger statement? That was the problem; and it had become more and more difficult as more and more 'boring modern-art images' had got into the dictionary. Francis Bacon compounded this particular difficulty by leaving out all those inter-mediary states in which painting communes with itself for its ultimate advantage.

It is, of course, one of the paradoxes of Seurat that, in spite of using a fragmented idiom in which the unit of expression, the dot, was tiny and discontinuous, he ended up with images which are as monumental as anything that has been done since the Egyptians. When those images were first seen, people concentrated on the novelty of the dot. Only later, when that novelty had dropped away, did the grandeur of the images assert itself. It became clear, that is to say, that Seurat had used an idiom without precedent to produce images that continued the European tradition in the noblest and most timeless of its manifestations. The left-hand figure in *Les Poseuses* could be sub-titled, like more than one mature Bacon, 'A Study from the Human Back'. Such images are at home anywhere and at any time; yet they are quintessentially modern.

In this context it is remarkable that when Bacon had a retrospective exhibition at the Tate Gallery in the summer of 1962, the first strangeness of the work was seen to have dropped away. What we saw had a grand, ordered, coherent look. Anyone who came in search of Gothick fancies went away disappointed: in their place was a renewal of the European tradition, with very little about it that could be called bizarre or gratuitous. Bacon's attitude to that tradition has, however, always been highly selective. He carries within him, in this as in all other departments of life, a panoramic discontent and a strongly developed capacity for rejection. In any conversation with him about the art of the past, anathemata whizz by like meteorites, and great reputations are consigned to the junkyard without the right of appeal. Careers are torn apart like haystacks in which an indispensable needle may somewhere be secreted; in Matisse, for example, he is likely to salvage only the *Bathers by a River* of 1916–17, for its schematic handling of the naked human body, and one or two of the single-figure cut-papers of 1952 in which, once again, the facts of the human body are set out in an audacious and unprecedented way.

47

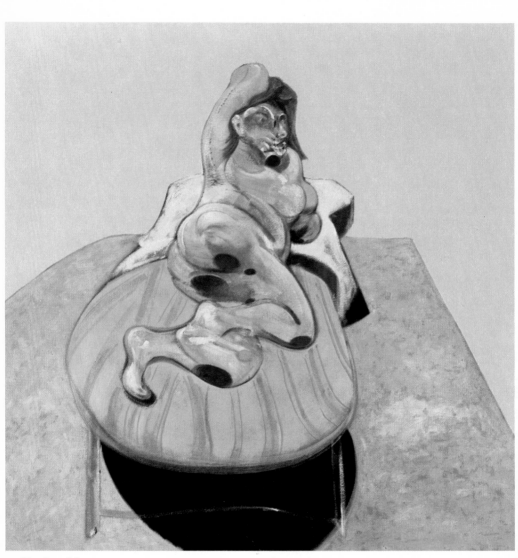

19 *Henrietta Moraes* 1966

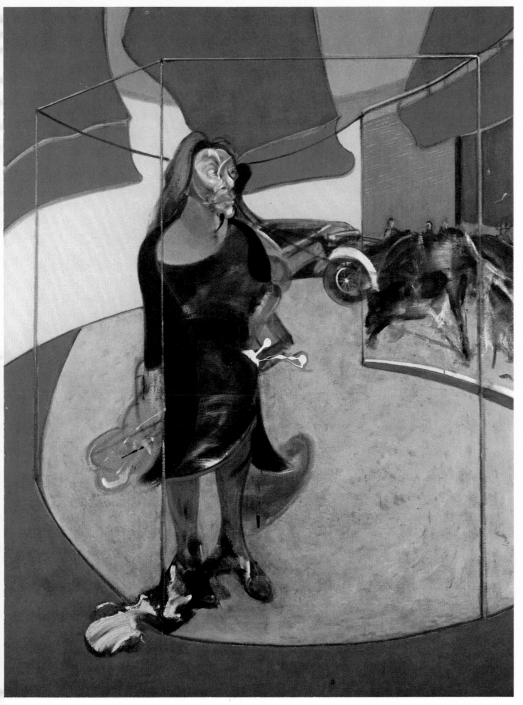

20 *Portrait of Isabel Rawsthorne Standing in a Street in Soho* 1967

Bacon reacts to the past entirely or not at all. A raider, rather than a detached estimator, he will swop Byzantium and the Middle Ages for a single Ibero-African drawing in which the ways in which one human being can kill another are set forth with a succinct finality. Himself preoccupied with getting the nude out of the classroom and back into life as it is actually lived, he is inclined to single out Courbet as the first master, on occasion, of the 'stark naked nude'. Rubens is a very great painter; but *volupté* veils nakedness when Rubens paints the nude, and to Bacon's eye the movement of the flesh is not as truthful as it is in Courbet. Where the instinctive twist and turn of the naked body is concerned, he inclines once again to single out individual exemplary works within *œuvres* for which he has no panoramic taste. 'Boccioni's paintings are hideous and vulgar,' he will say, 'but that sculpture of his, *Unique Forms of Continuity in Space*, has something inventive about it.'

But, beyond these inner allegiances, Bacon owes a more general loyalty to all painters of the past whose area of implication seems to him to foreshadow the one for which he himself strives. He admires Ingres, very much, for instance; but he nevertheless detects in Ingres a certain meanness of spirit or defensive tightness which puts him just below the very first rank. Looking at pictures is not, for him, a superior distraction, but an activity in which the whole psyche is engaged; and if what comes back is cautious or incomplete, harsh words can be counted upon. The raider, meanwhile, strikes all over the place, and not always where he is expected: the image of the wide-open mouth, so common in early Bacon, can be traced to a drawing by Poussin for the Chantilly *Massacre of the Innocents* as much as to anywhere else, while the right-hand panel in the Crucifixion triptych of 1962 has its origins, however improbably, in Cimabue. But somewhere within Bacon there does exist, also, a general assessor: and that assessor's criterion is 'What has this added to our understanding of human nature? Does it explore territory hitherto forbidden or disdained?'

Where this question relates to European art somewhere between Cimabue and Matisse, the investigation hinges, in the last analysis, on the behaviour of paint in a time of crisis. Is paint doing what it has never been asked to do before? And is the asking being done in the name of mere novelty, or with some larger, grander intent? Where definitive plain statement is concerned, Bacon has an earlier point of reference to which he often returns: that of the 17th Dynasty likenesses of Amenophis III and IV in Berlin, for instance. Thereafter, paint took over the responsibility. That responsibility has lately been much eroded, though Bacon remains convinced that 'paint has been liberated, if only anyone knew what to do with it'. In the last fifty years paint has, however, been driven into a position in which it is quite logical for an

14

intelligent artist to 'go right outside paint', as Bacon puts it. But only one man seems to him to have done it: Marcel Duchamp.

Bacon's admiration for Duchamp is extended not so much to individual works – though he prizes their unfailing elegance and concision – as to the attitude of mind behind them: the unfailing historical sense, the conclusions logically arrived at and decisively acted upon, and the disdain for self-promotion and the making of 'a career'. Many years in America took away nothing whatever from the Frenchness of Duchamp's intelligence. The radical nature of its thrust, the economy of its expression, the irony, the secretiveness, the delight in the word used precisely and once and for all – these relate Duchamp to the French tradition, and they equipped him to set up from 1916 onwards as a one-man antidote to whatever was tired, mercenary or pretentious in the School of Paris.

Bacon has a certain lifelong relish for catastrophe, and the closely argued negativity of Duchamp's attitude towards easel-painting undoubtedly had a bracing effect upon him when he saw Duchamp's retrospective exhibition at the Tate Gallery in 1967. In fact I do not think Bacon would be displeased if he ended up as the last man in the world who still believed in painting: into this there enters the gambler's delight in the last cut of the cards and the hand that will see one player or the other put out of the game for ever. Duchamp, in this sense, acted as the big man who clears the room of pygmies.

Certainly it is a good thing to get pygmies out of the way when a desperate situation arises. But it is also a great reassurance at such times to have on one's side, if not by one's side, someone manifestly of the first order who faced comparable problems and got the better of them. No chapter on Bacon's allegiances to the past would be complete without a reference to van Gogh. This is a complicated subject, in that van Gogh is, even more than Velazquez, a painter upon whom Bacon at one time drew directly. His one-man show of 1957 at the Hanover Gallery was made up, in fact, very largely of variations on van Gogh's *The Painter on the Road to Tarascon*. Bacon had first shown signs of this allegiance in 1951, when the head of a Pope turned at a late stage in its execution into what was more evidently a head of van Gogh. In 1956 there had been a *Study for Portrait of van Gogh I*, which showed van Gogh, head and shoulders, promenading down front on his way out for a day in the fields. But the paintings in the Hanover Gallery show were done at high speed in March 1957, when the opening date of the show was almost upon him and he had nothing else to put into it. 'I'd always loved that picture – the one that was burnt in Germany during the war – and as nothing else had gone right I thought I'd try to do something with it. Actually I've always liked early van Gogh best, but that haunted figure on the road seemed just right at the time – like a phantom of the road, you could say.'

13

The paintings caused a great stir at the time, and for several reasons. The subject-matter was attractive to thousands of people who were baffled or repelled by paintings like Bacon's *Figures in a Landscape* (1956–57). The colour was hectic: the red, the blue, the yellow, had a clamorous quality which was quite new in Bacon's work. In the paint itself, Haste was made visible: a headlong streaking and smearing took over from the relatively

22 cautious handling of the *Study for the Nurse in the Film 'Battleship Potemkin'* of the same year. One of the van Gogh paintings has in it an outdoor version of the cage-like structure which Bacon had been using to isolate the human figure; but in general the figure of van Gogh was as if liquefied by the overwhelming heat of the southern sun, and seemed in fact to be running into its own shadow in the way that a gutting candle runs into its own grease.

In the general excitement it escaped notice that the figure was as much like a famous photograph of Cézanne on his way to the *motif* as it was like van Gogh. Nothing, however, could have been less akin to Cézanne than the splashy, approximate procedures which make this, in the context of Bacon's entire *œuvre*, perhaps the weakest of his groups of paintings. Over the next thirteen years Bacon was to develop an idiom which makes the van Gogh paintings look melodramatic and illustrative; but in 1957 they did seem to be a necessary rebellion against the quiet greens and subfusc blues which had dominated his palette for some years. The van Gogh paintings made palpable the element of gambling in the work; and in the climate of the day they made an effect of freedom and exhilaration. Bacon's had been for years an indoor art: an art of house-bound figures in deep shadow. Suddenly it took a new turn; and although Bacon very soon went back indoors, and stayed there, the show at least proved that he was still someone whose art could be entirely remade, on impulse and without thought for the catalogues and card-indexes which haunt other successful painters in their late forties.

There is, to my mind, an altogether greater bite and cohesion to a later

21 variant of van Gogh: the *Head of a Man – Study of Drawing by van Gogh* (1959). This derives from a self-portrait drawing of *c*.1885, and it prefigures some of Bacon's most extraordinary inventions of the late 1960s: the peremptory gleam of the eye, the continuous swirl of paint which seems to draw the entire cranium with one sweep of the brush, the distortions and double or triple statements which yet end up by looking perfectly natural. It is after all, on the issue of meaningful distortion that Bacon and van Gogh are allied. In character, and in the nature of their relations with the outer world, no two men could be less alike. With the failed evangelist, with the man who felt himself shunned by society as if he were a leper with his bell, with the man who could find nobody to buy his paintings, Bacon has nothing in common. His loyalty is to a man who could say in 1885 that 'the real painters

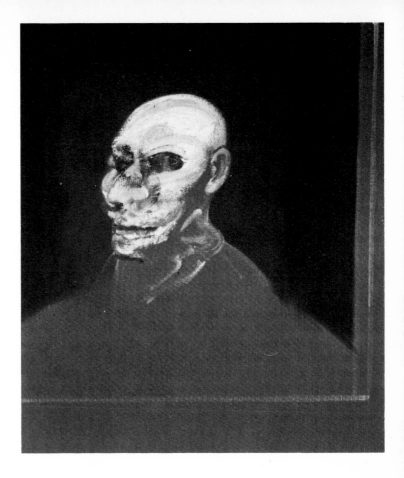

21 *Head of a Man –*
Study of Drawing by
van Gogh 1959

do not paint things as they are, after a dry and learned analysis. They paint them as *they themselves* feel them to be.' 'My great wish', van Gogh went on, 'is to learn to change and remake reality. I want my paintings to be inaccurate and anomalous in such a way that they become lies, if you like, but lies that are more truthful than literal truth.'

Bacon in life is a great accommodator of opposites, and it is by a natural extension of this that he has for his preferred figures from the recent past one man who thought that retinal painting should be discarded altogether and another who thought that its possibilities were only just beginning. It is precisely this capacity to keep simultaneously in mind two antithetical points of view which gives tautness and unpredictability to a career which could otherwise have been all negative irony on the one hand, or all naive manual involvement on the other.

53

The prehensile image

Art once fed on art, and on art only. An art-student was a person who wanted to learn about High Art, and an artist was someone who made it. Art was a superior science, like medicine, and there was an acknowledged hierarchy of accomplishment that ran all the way from apprenticeship to masterhood. I never go to *Die Meistersinger* without thinking that art once had rules quite as convoluted as those which David, in Act I, sets out before the disconcerted aspirant to Mastership. Art had its short notes, its long notes, and its longer-still notes. It had its distinctive melodic forms, quite as varied as those which David details: the rainbow tune, the cinnamon-stick tune, the 'English tin' tune, the true pelican tune, and the departing glutton tune. They were all codified, and the student who did not know them got bad marks. Art was an in-breeding, self-perpetuating affair, in which it was professional suicide to look to left or to right.

But in time people dared to say that landscapes did not come all in brown, like a Cremona violin, and that human beings did not always adopt the poses authenticated by antique statuary, and that there were other ways of making an image than by going to look at what had been done already and trying to do it half as well. As long as High Art kept its near-monopoly as a source of images, this process was slow and much-contested. But from the moment that photography came along, and newspapers carried illustrations as a matter of course, and large-scale advertising turned the streets of big cities into an art-gallery of a thoroughly democratic sort, then High Art was on the skids. It was not that it lost its prerogatives, but simply that what it had to offer was an experience among others.

There was never a time in this century when metropolitan people could live without being exposed to what I shall describe here as Parallel Art: the art of the illustrated papers, of the mail-order catalogue, of the billboard, of the ephemeridae of advertising. No matter how august the household or how lofty the conscious preferences of those who formed part of it, Parallel Art got in. Alternative images proliferated: and people were marked, whether they knew it or not, by the kind of imagery which was predominant in their own youth and early manhood. Bacon was sixteen in 1925, twenty-one in 1930: a natural drifter, reacting to the world around him in a voracious but quite unstructured manner, he had no defined

ambition to set against the chaos of impressions which comes flooding in at that time of life. The newest manifestation of Parallel Art in the late 1920s was, beyond a doubt, the cinema: more especially, the Soviet cinema. Bacon values that early experience very highly, both for the stills which were constantly turning up in the magazines of the period and for the revelation of the films themselves – the fact that our notions of the image, and of what it could achieve, were being remade literally 'before our eyes' by men whose powers of invention were equal to those of all but the greatest of the Old Masters. (Bacon was facinated to learn from Anton Zwemmer, many years later, that Eisenstein was a regular customer of Zwemmer's art-book-shop in the Charing Cross Road.) In the Soviet films of the 1920s, and especially in Eisenstein's, there was adumbrated the great subject which Bacon always has at the back of his mind: 'The History of Europe in My Lifetime'. Too complex to be treated by painting in an orthodox way, and beyond the powers of an amateur *cinéaste*, no matter how discerning, the subject none the less presides over everything that Bacon has done: portraits, figure subjects, landscapes even. And the initial push – the idea that a single image could summarize the self-destructive courses of a whole continent – came as much from the silent cinema as from anywhere else.

The cinema of the 1920s could borrow from High Art as readily as Godard, forty years later, borrowed from Pop Art. A film like the 1926 version of *The Student of Prague* could include a direct transposition from Caspar David Friedrich; but Henrik Galeen's borrowings in that film amounted primarily to the grafting of an adventitious spookiness on to the trance-like qualities of Friedrich's *Two Men Looking at the Moon* (1819). When Bacon fixed on the famous episode of the Odessa Steps in *The Battleship Potemkin* he had quite other intentions. The image he chose was that of the nurse who was caught in a revolutionary situation while wheeling perambulator and baby down a broad flight of steps. These steps, then as now, led from the upper town, with its luxurious (and since renamed) Hotel de Londres, to the proletarian dockland. On one reading, her misadventures were simply those of an individual swept away by forces to which her concerns were irrelevant. On another and deeper level, however, she stands for the society which at that moment in time could still employ nursemaids as a matter of course; and when she and the perambulator part company and she herself goes down in a welter of blood and broken spectacles, we feel that society as a whole, rather than one unlucky old lady, has been given notice to quit. Her death at the hands of the forces of 'law and order' stands, in fact, for that society's unconscious determination to destroy itself; and what we see is not a lurid incident among many, but an epitaph as concise as any in the lapidaria of the Greek and Latin poets.

Bacon waited until 1957 before referring directly to this episode in any one painting; this was his *Study for the Nurse in 'Battleship Potemkin'*, but it was really a study *from* the nurse, since Bacon in point of fact had withdrawn her from the context of the film and placed her in one of the dark geometrical surrounds which he was using at the time. The nurse's head had, undoubtedly, a double fascination for him. It was an image which, as I have tried to indicate, was a part of 'The History of Europe in My Lifetime', rather than a sensational episode of no general significance. And it was also a particularly vivid example of the kind of deformation under stress that Bacon was aiming to parallel in paint: the great soundless O of the mouth, above all. Bacon has rarely quoted so directly from anything or anywhere; in this one instance, Eisenstein provided him with the kind of anatomical fact which normally he transposes at one or more removes. (He at one time haunted medical bookshops in search of an ever greater precision in the portrayal of extreme states. From a book on diseases of the mouth which he bought in 1935 or 1936, he has still kept one or two hand-coloured plates – for the incongruous beauty, above all, of the colouring, and the magnificence and purity of the teeth.)

With this one exception, Bacon has never 'worked from photographs', or from ready-made material of any other kind, in the conventional sense. Adaptation of that kind has many motives: some of them commendable, some of them not. It can be prompted by the wish to follow an *ignis fatuus* of total accuracy, as when Millais, in painting *Murthly Moss* in 1887, substituted a look of under-exposed photography for the brilliance and vivacity of his earlier treatment of landscape. It can have a polemical intent, as when Courbet incorporated into his *Women Bathing* of 1853 precisely the formal vocabulary which pioneer photographs of the female nude were initiating in that year. It can be used with great dexterity by artists who either disbelieve in the authority of paint or are unable to re-authenticate that authority. (Efforts of this sort get no sympathy from Bacon, who has often been heard to say that 'Art and cleverness are not the same thing'.) Photography can be used, finally, in a compositonal way: and was so used by more than one painter to whom the dismissive adjective 'clever' cannot be applied: Degas was one, and Vuillard another.

What painters got from photography in a compositional way was the kind of freedom which the hand-held camera gave to the film-director after half a century and more of working with a relatively fixed and inflexible apparatus. More was let in than had seemed possible before: the activity designated by Ehrenzweig as 'unconscious scanning' was brought nearer to the surface by the example of what could be done by a machine which took Accident for its bride. There were, once again, two ways of adapting from

22 *Study for the Nurse in the Film
'Battleship Potemkin'* 1957 ▶

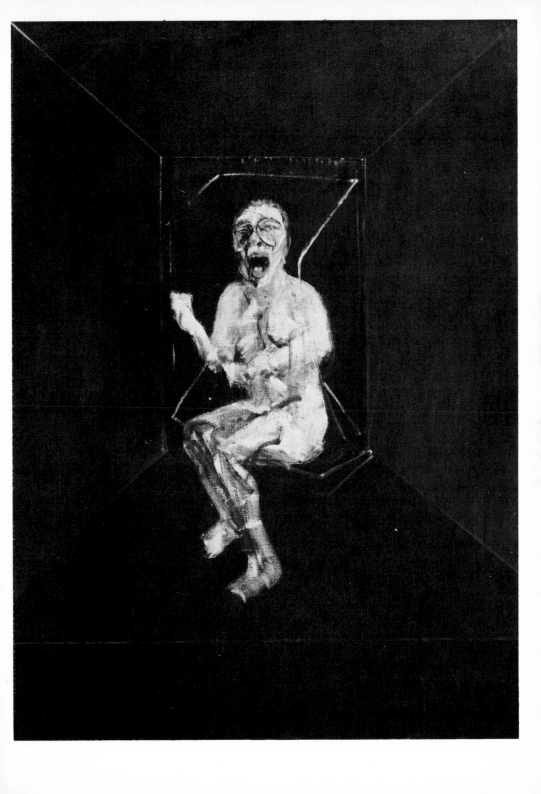

photography. There was the method followed by Fantin-Latour in his *Autour du Piano* of 1884: the *Journal Amusant* of a year later was absolutely in the right when it said of this painting that Chabrier and the others 'appear fixed in the pose set up by the photographer's "Hold it!"' And there was also the method followed by Degas and Vuillard – and, for that matter, by Monet in the views of Paris which he painted at the high-point of Impressionism in the early 1870s. In this, the *données* of photography are completely subsumed in the paint, which retains its authority intact while gaining a greatly enlarged vocabulary. It is this second approach which Bacon has followed in the many paintings which have the elasticity of the photographic image without any of its particular and by-now-predictable eloquence.

Photography stands, therefore, for certain great single images which come pounding across our century like the great single images in Aeschylus. It also stands for a whole new catchment area in which form is caught off its guard. Much has been written, for instance, about the famous photograph of July 1917 which shows the people of Petrograd in every variety of bizarre posture as they run for shelter, throw themselves flat across the Nevsky Prospect, and in general abdicate the sedate procedures of everyday life in the street. It is true that this photograph had in its day a real pioneer significance, and that Bacon prizes it for the strange kinship between this panic-stricken populace and the distortions of cave-painting. But it would be quite untrue to suggest that there is a one-to-one relationship between this photograph, or any other photograph, and what Bacon does in his painting. The photograph in question is simply an early landmark in an evolutionary process as a result of which a very large part of human experience is now acted out at second hand in the form of a processed image. It is difficult for anyone under the age of forty to realize with what an impact of candour photographs of this sort broke over the sensibilities of an earlier generation. Today they belong to the incunabula of news-photography; but at the time the strangeness of the image matched exactly the strangeness of the event.

Stravinsky once picked out from Huizinga's classic *Waning of the Middle Ages* the fact that life at that time was characterized by a quality of silence quite unimaginable in the second half of our own century. In contradistinction to this silence, music in late medieval times had an almost supernatural power: we who have music all round us, invited or supererogatory, would find it hard to recapture the state of mind of Denis the Carthusian when he walked into the church of St John at Hertogenbosch and happened to hear the organ playing. Stravinsky in his taut, spare, brief late works says 'No' to the undifferentiated aural mass which floods in upon us. The point of this divagation is that Bacon is also affected, as any thinking

person must be, by the superabundance of images which is a characteristic of life in the 1970s; and that he aims to set up one day against this undifferentiated flux of visual garbage the great single image which will halt the wandering eye and cause us to say, 'This makes new sense of life.'

To make such images was always the painter's prerogative. When the cinema tried to usurp that prerogative, it did so in an environment which ran exactly parallel to the one in which painting had known many of its supreme triumphs: the high altar, set above the mob. Time has somewhat modified this, and our intake of images is now much dependent on the portable altar of the television set. But initially, in the gigantic cathedral-like movie-houses of the 1920s and 30s, with their apses and their ambulatories and their fonts and their stoups, the high altar was the focus of all things: the place set apart and above, the place where revelation was forthcoming. In this sense, D. W. Griffith and Abel Gance and Fritz Lang did for their generation what Rubens and van Dyck did for their contemporaries in Antwerp and Malines: and something in painting withered, as a result. Bacon's purpose has been to bring that something back to life.

He began to do it at a time when the photograph as an adjunct to art was in process of rediscovery. Its career in this respect has gone through several phases. There was a first phase, when documents like the street-photographs of Aguado and Jouvin were taken up by the Impressionists as instruments of liberation. This phase continued as Muybridge and Marey infiltrated one after another of the strongholds of painting: and painting of all kinds, be it noted, from the avant-garde to Meissonier and Detaille. There came later a second phase, when painting had momentarily exhausted the *données* of photography and went off on tracks where photography had no relevance. Bacon came in at the outset of the third phase, when the primitive jubilation of the 1870s and 80s was replaced by a more complex appreciation of what the photograph could mean in a context of high art.

In the case of one or two classic photographers of the nineteenth century, this whole cycle was reproduced in miniature. Responses to their work had an early period, when the sheer novelty of the achievement was uppermost. They had a middle period, when that achievement was taken for granted. And they had a late further flowering, when their achievement was given a new meaning by the needs of the day. This applied especially to photographers who were not at all 'artistic' in their intentions, but aimed simply to present fact as truthfully as possible. Among these the old master was Muybridge, and it is to Muybridge that Bacon has turned over and over again.

Muybridge was born Edward James Muggeridge on 9 April 1830. In his early twenties he emigrated from England to the United States, and by

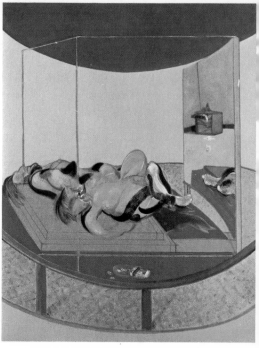

23 *Triptych (inspired by T.S. Eliot's poem 'Sweeney Agonistes')* 1967

the 1860s he was quite well known in California as a documentary photographer. It would seem to have been in 1872 that he began to make sequential photographs of horses in motion. He did this by putting twenty-four cameras in a row at right-angles to the direction in which the horse was going. As the horse passed by, it broke the series of threads which, in its turn, activated the cameras. There resulted from this twenty-four exposures, each of two-thousandths of a second, at regular and very short intervals. What initially prompted him to do this is not quite certain. For a long time it was ascribed to an argument as to the exact way in which a trotting horse set its feet on the ground; but it would seem more likely that Muybridge was commissioned by Leland Stanford of the Central Pacific Railroad to make a documentary survey which would help him to train his racehorses in a more scientific way.

In 1878 Muybridge published a selection from his photographs of *The Horse in Motion*. Almost immediately these aroused a great deal of attention, and Muybridge was fired to transfer his attentions to other living creatures. In the year in which he began to do this, 1879, his work was the subject of articles in *La Nature* (Paris), the *Berliner Fremdenblatt* (Berlin), the *Wiener Landwirtschaftliche Zeitung* (Vienna) and *The Field* (London). Intelligent painters the world over soon realized that Muybridge's activity could offer

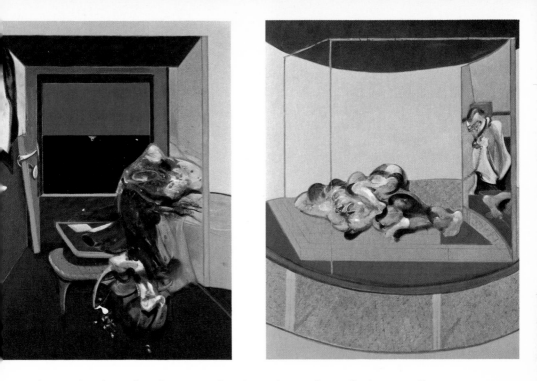

them a heightened and more authentic understanding of what actually happens when a human body is in motion. Eakins in the United States, Seurat and Degas in Paris, were only three of the artists who benefited directly or indirectly by Muybridge's work in the 1880s; and we know of an evening-party in Paris in 1881 at which Meissonier showed Muybridge's photographs to an audience which included Gérôme, Detaille, Léon Bonnat and Alexandre Dumas.

Muybridge's first series of photographs had owed something to the brilliant light of California, and something also to the ambitions of a pioneering individualist. But when he resumed work on an altogether larger scale, he needed corporate backing; and he found it in the University of Pennsylvania. Thomas Eakins was not only the greatest American painter of the nineteenth century; he was also a man of powerful and searching intellect who seems in retrospect to have dominated the imaginative life of Philadelphia in the 1870s and 80s. He became one of Muybridge's keenest supporters, and in 1884 they were jointly responsible for the invention of a camera which had two discs in front of the lens, one of which revolved eight times faster than the other. Eakins was himself photographed – running naked – in sequential progression; but for the bulk (and bulk is the right word) of his researches Muybridge drew upon a large body of performers.

When he issued a catalogue of available photographs in 1887, he mentioned among other subjects 'a member of the State Militia', 'a well-known instructor in art', an ex-athlete in his sixties, and a pair of 'public acrobats'; a number of hospital patients were brought into service as examples of what Muybridge called 'abnormal locomotion', and he had also called upon 'women of all classes', including one who at the age of twenty weighed three hundred and forty pounds.

The general purpose of all this was to show 'actions incidental to every-day life' with a clarity and authenticity to which no other form of documentation could aspire. Animals, as well as human beings, had been persuaded to take part, and after eight years of preparation Muybridge was able to offer to the subscriber a choice of 781 plates, comprising over twenty thousand individual images. For a hundred dollars, the subscriber got a hundred plates: these were held to constitute a copy of the book. Muybridge also listed the subject-matter from which a choice could be made. From this it was clear that the notion of 'actions incidental to everyday life' had been interpreted quite liberally. The sight of a 'Man heaving a 75 lb rock' cannot have been an everyday sight in Philadelphia, even at that date; 'A man performing a head-spring, pigeon interfering' must also have been a rarity on campus. Buyers could choose 'Dancing (fancy)' and 'Dancing (nautch)' if they pleased: likewise 'Gnu bucking' and 'Chicken scared by torpedo'. Some plates were altogether more grim; A child getting out of a chair after double amputation of its thighs, for instance, and 'Man walking, after traumatism of the head'. but in all this, as in the great paintings which Eakins was at work on in the 1870s and 80s, there was a noble objectivity: an attempt to bring a total integrity into areas previously corrupted and sophisticated.

What got through to a substantial public at the time was, however, something quite different: the white magic of seeing the nearest that anyone had got to a moving picture. This is what caused the Prince of Wales to preside, in London in 1882, over a demonstration of the new procedures which was described at length by George Augustus Sala in the *Illustrated London News*. What pleased people was the imitative element. And Muybridge himself rather went along with this when he tried to get Thomas Edison to join forces with him in synchronizing sound and pictures. Synthetic projections were to give the illusion of movement, synthetic sound the illusion that what was going on on the screen could be heard as well as seen. Muybridge had in mind the preservation of a complete performance from what was – in vocal terms, if in no other – one of the golden ages of opera. Stereoscopic projection and special binocular spectacles were to be brought into service 'for the instruction or entertainment of an audience long after the original participants shall have

passed away'. But Edison did not think that the gramophone was sufficiently far advanced, and the project fell apart.

So what remains of Muybridge is the legend, which is supported mainly by one or two often-reproduced extracts from his books, and the fact of the books themselves, which are not easy to consult in their complete form. In that form they are, however, still unequalled as a repository of the ways in which people can be seen to behave. They also act as a counterweight to the alternative sources on which painters had been drawing for many generations: the continuum of past art, that is to say, and the discipline of drawing from the model in art-school. One of the great subjects of cultural history is the extent to which individual works of art can add to the repertory of identifiable feelings which humanity has at its disposal. This has, as everyone knows, its counterpart in literature: inventions like Antigone, Iago, Tartuffe, Racine's Titus, Julien Sorel, Dorothea Casaubon, Vautrin, Natasha Rostov, Charlus, and Molly Bloom correspond to enduring human realities for which we did not have a name until the authors in question got down to work. Anyone who knows these characters and has thought a little about them will find it easier to come to terms with questions like 'Why on earth do people behave in the way that they do?' or, less generally, 'What does it mean to be an Englishman / a Frenchman / a Russian / an Irishman / an American?' And later writers will be haunted, whether they like it or not, by what their predecessors have defined.

Art had, in all this, a long start over literature. People responded, for instance, to *le sourire de Reims* for a great many years before enough of them were capable of reading enough books to find anything like a comparable equivalent in print. Dürer's *Melancholy* stirs within the observer a huge complex of ideas for which only the learned have, even now, a counterpart in literature. The notion of human beauty, the notion of leadership, the notion of love and the notion of the seasons are among the aspects of life for which art once gave the vividest and most readily available account: so much so that when later artists came to discuss these things, they pored over the old masters in the way that Baudelaire pored over Racine. In both cases, the past armoured the present.

The importance of Muybridge in all this is that he showed human movement as it actually was, at a time when many people wanted to do this but did not know how to authenticate their statements. (In point of fact, every generation has its own way of moving, but that is another question.) What he had to offer was not offered specifically to artists, but artists made it their own. In a quiet and wholly non-polemical way he broke the hold of the old masters. He also introduced an ideal democracy into the study of the subject. The people he photographed could be good-looking or not,

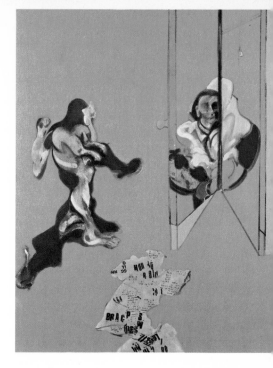

24 Triptych – Studies from the Human Body 1970

practised or not, whole or not: it was all one to him. The handling was all. Looking through the books, we remember how in *Macbeth* the First Murderer has lines as good as anyone else's. Individual still-photographs of the time brought this same message, but the point of Muybridge lay in the multiplication of insights, and the impartiality with which every one moment in life was given the same weight, and the same degree of commitment, as every other one. All this was at the opposite extreme from classic fine-art procedures, in which artists were at enormous pains to choose the one pose, the one light, the one composition, that suited their purpose.

Muybridge's photographs were uncontaminated, therefore, by art. To a degree not paralleled by any later photographs they were exempt from conscious shaping and composing. The time was to come very soon, and it has not yet been completed, when all photographs aspired in greater or lesser degree to the condition of art. The traffic of influence flows back, in our century, from art to photography; and although many artists have made direct use of photographs, Bacon is alone in having taken from photography nothing but the initial stance: the readiness to accept a deformed or implausible image as true. He has given back to photography its involuntary, uncalculated status. Where a still photographer like Cartier-Bresson or a film director like Jean Renior attempts with varying success to

64

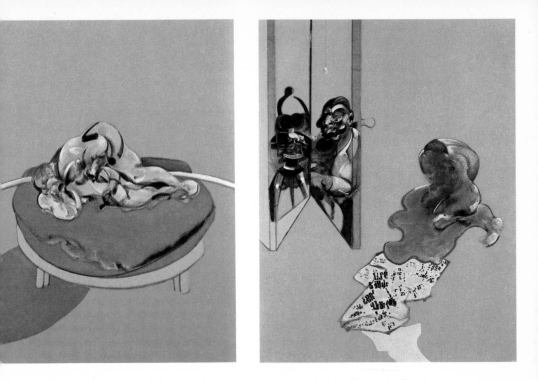

update the language of French nineteenth-century painting, Bacon is firmly non-arty, or anti-arty, in his attitude to nineteenth-century photographs.

In one or two cases one can actually look up, in Muybridge, the plate 32, 42 which served Bacon as a point of departure. What one cannot look up is the photographic material from a later era which Bacon has composted beyond the point of no recovery. The photographs in question were not scientific documents; still less were they works of auxiliary art such as one can find in the photographic equivalent of the Salons. They were objects of consumption: disposable souvenirs of 'the way it was', assuagements for greed and voyeurism. They were arrived at by a process nearer to animal mastication than to the sanctified activities of art; and when Bacon painted his *Triptych – Studies from the Human Body* in 1970, he fulfilled an ambition of 24 several years' standing by putting a camera into the painting and characterizing it as vividly as any of its human co-participants.

The camera in question was prehistoric in design: a matter of splay-footed tripod, massive goggle-like lenses, antlered external levers. It stood for the primeval curiosity, the hunger for fact truly and wholly observed, which photography was invented to assuage. Looking at this particular camera and at its operator, we could imagine to ourselves a relationship in which the camera is the dominant partner and the man a mere quavering accomplice:

or, equally, one in which the camera was an extension and magnification of certain traits in its owner. Bacon has a horror of moralizing in any form, and above all of moralizing in art; the camera, here, stands for the faculty of impartial observation. It sees all, and comments on nothing.

Bacon in life has no feelings about cameras, one way or the other, and is quite as pleased with a strip of Photomat portraits taken in a booth in Aix-en-Provence as he is with the fastidious stalking of any *vedette* of the lens. In general he likes journeyman-photographs in which human movement has been remade irrespective of the photographer's conscious intentions. Sport is one great source of these; crime, another. Bacon has at one time or another hoarded thousands of such photographs; and just as James Joyce was said to be able to put his hand on just the book or newspaper or magazine in which he could find the everyday phrase that he wanted to metamorphose, so Bacon knows every one of his strange family of images by name. Over the last twenty years he has been fascinated, also, by colour-photography: or, more precisely, by reproductions of colour-photography. Oscillating as he does in his paintings between very calm and neutral colour and colour of the utmost violence, he finds in the heightened and falsified colour of photography a stimulus more potent than that which other peoples' paintings can normally offer. By taking a magnifying glass to some colour-plate book, he can bring into focus the 'wonderfully arbitrary' procedures by which form is conveyed in such conditions; somehow or other, in these bizarre tumbles, falsehood and truth change places.

25 *Study for Three Heads* 1962

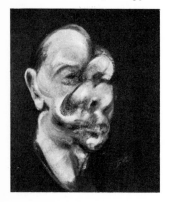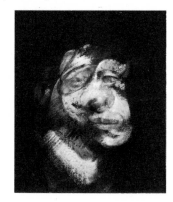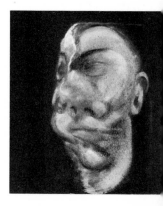

Bacon began to collect photographic material at a time when films were something that you had to go out of the house to see, and when photography had not yet altogether replaced drawing as a means of heightening the news in newspapers and magazines. The *Illustrated London News* might no longer have Constantin Guys as its special correspondent in times of emergency, but the 'artist's impression' had still considerable prestige. Most of the photography which appeared in newspapers and magazines was stiff and unimaginative, and an 'artistic' photograph was one which tried to escape from the dominion of fact, and enter – by the back door – the domain of Victorian academic art. There was no such thing, in short, as a democracy of images, and it took a strong nature to ignore the jealousies and pomposities which were involved.

Sickert had just such a nature, however, and when he happened to have worked from a news photograph in 1927, he did not at all mind calling his picture *King George V Talking to Major Featherstonehaugh at the Grand National, By courtesy of Topical Press.* At the time this was thought to be very perverse, but today it looks more like a piece of characteristically intelligent anticipation. Sickert in his seventies used photographs to break up and re-form the image in ways still overdue for close examination; and he did it as someone who had known Degas and could remember a time when very great painters had welcomed the photograph as an ally.

What those painters saw in the photograph was, as we have just seen, an instrument of truth. Photographs showed what was wrong with fine-art convention. The photograph in Muybridge's day was still a rare and authoritative document; but by the time Bacon began to collect photographic material it had a cliché-language of its own, a set of hackneyed formal conventions which had lost all power to surprise or instruct. Herkomer in his portraits was a wild man, a veritable saboteur of appearances, by comparison with the big-time photographers of the 1920s. The stalking had to be done all over again before a new repertory of images could be evolved.

Bacon began to do this in an unplanned, improvisatory way, and he was very much helped by the disrespectful tone which began to come over the news-magazines – or some of them – towards the end of the 1920s. The cameraman as polemicist was a new and largely wholesome element in European society; and when it came to committed reporting, the photographer soon ranked as *primus inter pares* with the descriptive writer. This new power of the camera was the more effective for being allied to a new notion of journalism: Stefan Lorant, in the *Münchner Illustrierte* and later in *Picture Post*, turned the image into the light cavalry of communication, where it had formerly been part of the ponderous machinery of supply. But

the initial break-through was due largely to Dr Erich Salomon, whose exploits in the late 1920s were the more startling for their contrast with his portly and impeccable person.

'Famous Contemporaries, Caught at an Unguarded Moment' would be an English title for Dr Salomon's *Berühmte Zeitgenossen in unbewachten Augenblicken*, which was published in Stuttgart in 1931. Not all the photographs look very daring, in the context of today: what was extraordinary was that this well-fleshed paterfamilias in his anonymous formal clothes had broken the cypher of public life by penetrating into forbidden places at forbidden times. Where other photographers waited patiently for permission to take an authorized formal portrait, Dr Salomon went to work with a telephoto lens at forty yards' distance, insinuated himself into an empty seat in the front row at private meetings, passed himself off as a lawful late-comer at the Royal Academy dinner, and risked a prison sentence by taking his camera into the German courts of law. He was particularly good at eavesdropping on private conversations – moments after an official luncheon where one great Sir was button-holing another, and moments late at night when the delegates to an international conference collapsed on the sofa like stranded landfish, jaws agape, waistcoats awry, liqueur-glasses refilled just once too often. Dr Salomon even got his camera into the court where the Lord Chief Justice of England sat in judgment, so that Reality was caught off its guard and a new, more truthful twist was given to Appearance.

It was only till 1955 or thereabouts that Bacon's activity ran directly parallel to this. Human nature is caught off balance in the paintings of that period in ways which relate quite closely to Dr Salomon's intrusions. The effect of those intrusions was premonitory: looking at the results of them, we say, 'That society is on the skids, and those particular men will never save it.' Bacon despises illustration and does not like his paintings to be given any one interpretation; but it is worth saying that just as certain early paintings prefigure the look of Eichmann in his glass box, so do certain others prefigure the trapped and self-destructive condition of what had not yet been named Organization Man. Where the photograph had helped, and helped decisively, was not in proffering individual images but in enlarging our dictionary of appearances and making it plain that there was more to behaviour than fine-art had hitherto taken on.

In the 1930s and early 40s the urgency of photographic reportage was thought to be quite different from the urgency of art. The activity of our War Artists in 1939–45 overlapped hardly at all with that of the news-photographer. (It was, if anything, the news-photographer who overlapped into fine-art: the photographs which people found most heartening during

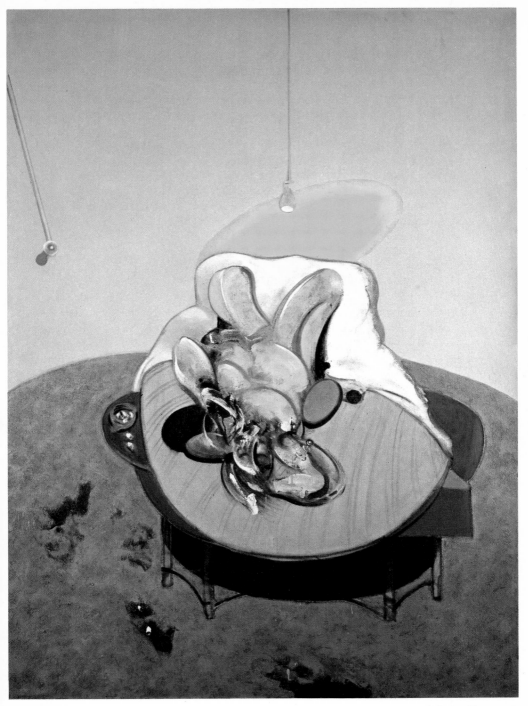

26 *Lying Figure* 1969

these years were adaptations, conscious or involuntary, of genre-painting.) It seemed, in fact, almost a point of honour with War Artists to keep to sober Beaux-Arts procedures. Art was uplifting, news was a squalid and temporary necessity – that was the general idea. But then, over the next twenty-five years, there came about a steady and cumulative change, until by 1970 it was almost taken for granted that there was something archaic or retarded about a painter who did not somehow make use of photographic images. ('You still use brushes, don't you?' was a remark often addressed by students, at that time, to teachers in their thirties.) What had been a solitary passion in the 1930s and 40s had become standard form: there was hardly a studio in the English-speaking world that did not have a scratch-board covered with ready-made images. And artists made use of them in much the same way, and with much the same feelings of dependence, as the Venetian masters had used the marbles in the Museo Archeologico. Certain favourite images – Kennedy dead in his car, Che Guevara in battered fatigues, Marilyn Monroe at her most peachy – were almost mandatory; and the position was further consolidated by the popularity of screen-printing. The images were there for the taking; the public was longing to buy the prints; and only a very little effort was required to produce something that would look arresting and up to date. The use of photographic material at the end of the 1960s was about as daring as the use, in the shops around Westminster Cathedral, of a Raphaelesque formula for the Madonna and Child.

This is one of many respects in which the whole climate – or, one should rather say, the industrial structure – of art has changed completely since Bacon first came to notice in 1945. Most people think in an unfocused way that 'Oh yes – Bacon uses photographs'; and some of them remember that a small part of his archive was documented by Sam Hunter in a photograph taken in the summer of 1950. We can go a little bit further and suggest that the image of Goebbels in full flood in the Hunter photograph relates to Bacon's open-mouth images of 1945: also that, as Ronald Alley pointed out, the *Head IV* (1949) is a free version of another image in the Hunter document – that of a man holding a small monkey. A thorough search among the less familiar plates in Muybridge would point to later borrowings; and Bacon's lifelong interest in spectacular crimes comes out, beyond a doubt, in at least one triptych of the 1960s. Marius Maxwell's *Stalking Big Game with a Camera in Equatorial Africa* (1924) is another *pièce justificative*: Bacon's African landscapes of 1952 can be traced in part to its speckled long-shots. But it is also relevant that Bacon had actually been to Africa in 1952; that many of the actions which he lifted from Muybridge were as familiar to him as the act of picking up the telephone is for the Managing Director; and that when it comes to the demonology of recent years, Bacon is not the kind of artist who

70

sits cowering in a remote rectory and relies on photographs to whip up his imagination.

In other words, it was only at a very early and comparatively primitive stage in Bacon's evolution that photographic images stood in what could be called a horse-and-cart relationship to his paintings. Traction of this primitive kind has long vanished from the work. It could, however, be said to have reappeared in life, with the roles reversed, in that there are days on which it is quite difficult to open the newspaper and not find that life is imitating Bacon. Whether it be President Johnson in full flood before the microphone or a television image rescreened in newsprint, the father-image is, over and over again, a Bacon of the first half of the 1950s. The interplay between parallel art and art *tout court* is continuous, and Bacon's use of photographs has not so much come to an end as gone underground, while life itself has taken over the role which he inaugurated a quarter of a century ago.

The falsity of one-to-one assumptions in this context is borne out by the story, many times told but none the less true, that once when Bacon was working on a portrait his sitter sat as still as a statue, only to find that Bacon's concentration was being given unabatedly to a photograph of a hippopotamus which lay on the floor at his feet. Bacon values the photograph as a source of significant falsehood, and he values it as a source of exact information about incidents to which he has not had direct access. (In this latter context he likes to remember that Sigmund Freud had in his possession a set of particularly horrendous photographs from the Viennese police archives; and he has himself been an attentive visitor to the Black Museum in Scotland Yard.) But above all he values it as a way of breaking back into reality: or, equally, of taking reality by surprise.

Talking over the use of photographs, Bacon said not long ago: 'I think of myself as a kind of pulverizing machine into which everything I look at and feel is fed. I believe that I am different from the mixed-media jackdaws who use photographs etc. more or less literally or cut them up and rearrange them. The literalness of photographs so used – even if they are only fragments – will prevent the emergence of real images, because the literalness of the appearance has not been sufficiently digested and transformed. In my case the photographs become a sort of compost out of which images emerge from time to time. Those images may be partly conditioned by the mood of the material which has gone into the pulverizer.'

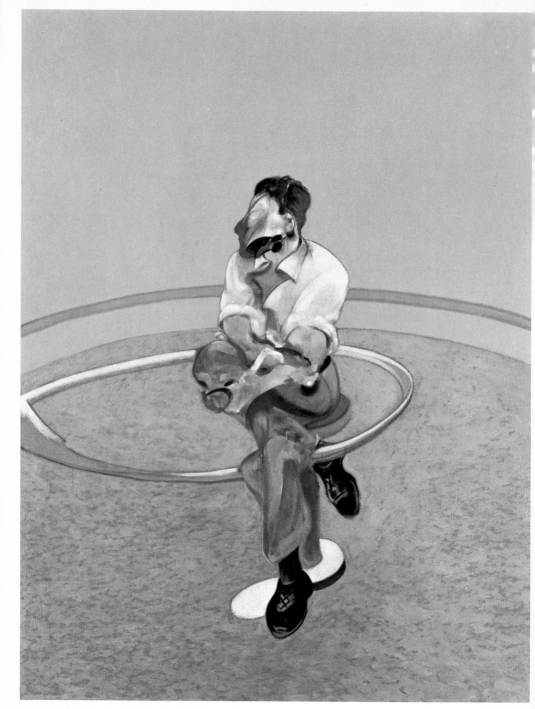

27 *Study for Portrait of Lucian Freud (sideways)* 1971

An irreducible self

When all has been said and written, when Velazquez has been matched with the *Münchner Illustrierte* and Muybridge with the exhibits in the Black Museum, there remains something not yet defined: the irreducible Baconian element, the something put into painting by Bacon and nobody else.

There is, to begin with, his concentration on the Room. Bacon himself is for much of his life a self-committed prisoner in a room, doubling as both jailer and prisoner, condemned man and prosecutor, hermit and fugitive. He is Pascal, well aware that all man's misfortunes come from his not being able to stay home by himself; but he is also one of nature's anti-Pascalians, an archetypal night-wanderer for whom London is a labyrinth beyond the dreams of Daedalus. And since he has an acute historical sense, he knows that the small impersonal room is to the twentieth century what bear-pit and cockpit and lion's den were to earlier ages: the place where the last bill is presented and we have to pay up or die (or both).

Of course one could know this by intuition and without having experienced it directly. In a century during which millions of people have been locked in rooms against their will, while others have thought of the room primarily as a place in which they can be surprised by the enemy at four in the morning, it is an insensitive nature that sees the room simply as something pencilled in by Palladio. Kafka did not have to be tried, still less to go to prison, to write *The Trial* and *The Castle*. But in Bacon's case the basic perception did in fact spring from direct experience – acquired at the age of eight. His grandmother was at one time married to the Chief of Police for Kildare; the Room, for Bacon at that time, was a place sandbagged from floor to ceiling which could at any moment be attacked with bullet and bomb. The Room was the place where the buck stopped: driving home in the dark, the family would find that trenches had been dug across the road to trap the motorist. Stuck one night in the Bog of Allen, he and his step-grandfather found that the countryside was alive with flashing lights and loud with hallooing as their plight was signalled from one hostile group to another; and when finally they abandoned their broken-down motor and picked their way to the nearest big house, the householder and his family stood behind the door, guns in hand, before being persuaded to take them in. Bacon in Ireland had his share of the orthodox 'haunted house' (he

73

remembers being driven half mad with fear by one such at the age of ten), but from 1917 to 1922 the haunting was done by live human beings; and the sense of the Room as the last point in an endgame has never left him. (Nature has played her part, too: Bacon well remembers how when he was living in the south of France in the late 1940s Cannes was surrounded by flames one night, and all the mountainsides behind the town were suddenly ablaze with forest-fires and the Room became, once again, a beleaguered place.)

The Room is borrowed space, in Bacon's work, the way time is 'borrowed time' in middlebrow romances. It is space on loan, space rented for a day or two – or for an hour, as in the drinking-clubs and gambling-rooms in which a great deal of Bacon's life has been spent. It has a curious, irregular conformation: at times not unlike the narrow, many-cornered space of the Colony Room Club in Dean Street, Soho, but more often like the standard hotel-bedrooms or rented rooms in which so much of the inner life of our century has been played out. The furniture is wire-sprung and covered with worn velvet; the carpeting comes from stock; the ash-trays are chunky and throwable. In the late 1960s Bacon referred directly to a variant of the Room which was at its apogee during his first youth: the wagon-lit, apotheosized in Maurice Dekobra's *La Madone des Sleepings*, complete with marquetried panelling, convertible furniture, corded blinds, hidden resources for washing, secret looking-glasses, ladders and carpeted handrails and standard-issue, monogrammed linen sheets and pillow-cases. This was the Room in perhaps its most gorgeous manifestation: bedroom and drawing-room in one, a cell policed and serviced, custom-built for copulation and tailor-made for murder.

The Room considered as an object on its own, in Bacon's work, has elements of shower-room, zoo, hotel, Broadcasting House and operating-theatre. Bacon is sensitive to every kind of enclosed indoor space; and although he responds immediately to manifestations of the European grand manner in building – the long room at Mereworth, for instance – he also has idiosyncratic ideas about what could be, in certain circumstances, an ideal place in which to live. 'I'd rather have a carpeted aircraft hangar, any day, than an ugly house. The huge space with a bathroom and lavatory in one corner could look very grand. Even the pipes could look so beautiful. I'd like it to be in flat, treeless country – Essex or Norfolk – because very intimate country, "rolling country", is not for me. I was brought up for much of my childhood on the edge of very flat marshlands full of snipe and plover. That's the kind of country I find exciting.'

With the exception of one or two paintings inspired by African landscape, what we see of outdoors in Bacon's work is, in effect, a flat plain traversed occasionally by motor-cars. As for the metropolitan outdoors, such glimpses

as we get of the street have, it seems to me, a certain remembered strangeness. It may be relevant that when Bacon's father worked in the War Office during the war of 1914–18 and the family lived in Westbourne Terrace, near Paddington Station, the paths in Hyde Park were sprayed with luminous paint to deceive the Zeppelins. The metropolitan outdoors stands for something odd, in paintings like the 1967 *Triptych*; and the metropolitan indoors is above all things a place where a particular human being is contained and brought up close, for scrutiny.

Bacon sees the interiors in his paintings not as portraits of a given room but as a way of enhancing the human form: 'I want to make the interior so much *there* that the form will speak more eloquently.' The forms in question are of many kinds, and the degree of their dislocation also varies very much. Some of his most memorable images are not of complete people at all, but of human features calamitized and rearranged. The *Heads* of 1948–49 are instances of this. Bacon in his beginnings was a great mystifier, even if on occasion echoes of certain omnipresent brutes of that period (Foster Dulles, Frank Buchman, and others) may force themselves on a reminiscent observer. But by the end of the 1940s there were signs that he was returning from what had seemed a far point of oddity. In 1949 there was a large upright painting, now in the National Gallery of Victoria in Melbourne, which showed a naked man in the act of passing through a divided curtain to which a large safety-pin was attached. There was a painting in that same year of a man in what now looks like Eichmann's glass box in Jerusalem but was then much more like the glass panelling of a broadcasting studio with a prototypical newscaster mouthing away behind it. There was another painting in 1950, now in the Leeds City Art Gallery, of a naked man seen walking in profile with a disquieting and quite unrelated shadow on the wall beside him. The softly luminous figure in the Melbourne painting is a monumental achievement which no other painter in England could have paralleled at that time; Bacon when he wishes is one of the great painters of human flesh and can give it a kind of creamy resonance, a fulfilled soft firmness, for which both Ingres and Courbet had also been searching.

But what he was looking for was a way of painting which would be as remarkable, and as personal to himself, as the thing painted. More exactly, the paint was not to lag behind the idea; nor was it to seem supplementary to it, a voluptuous auxiliary to distract us from the sombre business in hand. The paint and the idea were to be one, indissoluble and indistinguishable. By the time of his first one-man show at the Hanover Gallery in 1949, Bacon already had a name in the news-magazines; but that name was owed primarily to his subject-matter, and in particular to conjunctions in his earlier work which now look like a late but signally energetic variant of

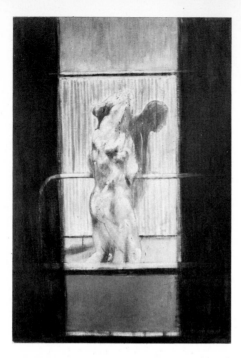

28 *Painting* 1950

surrealism: above all, for American observers, the conjunctions in the
Painting 1946, which since 1948 had been on view at the Museum of Modern
Art in New York. To this day, in fact, a great many people think of Bacon in
terms of lurid subject-matter: for years he himself could not meet a new
person without fancying that he saw the words 'Ha! Slaughter-houses!'
outlined in red in the thoughts of his interlocutor.

So it is worth saying that from 1950 onwards very few of Bacon's
paintings are directly concerned with sensational subject-matter: 'When I
was younger, I needed extreme subject-matter. Now I don't.' Very great
violence is still done, often enough, to the image as we expect to see it; but
the violence is in the painting, not in the thing portrayed. (When Bacon tried
to paint a bull-fight, in 1969, he found that it didn't really work to his
satisfaction because the image itself was already too dramatic: heightened,
that is to say, beyond the point at which paint has something significant to
work upon.) Of course there are often details which can be misread as
gratuitous: a swastika armband, a bloodied pillow, a hypodermic syringe.
And Bacon has come to dislike certain paintings which others would rank
among his best achievements – the *Fragment of a Crucifixion* (1950), for one –
because they seem to him too explicit, too near to the conventions of
narrative-painting.

76

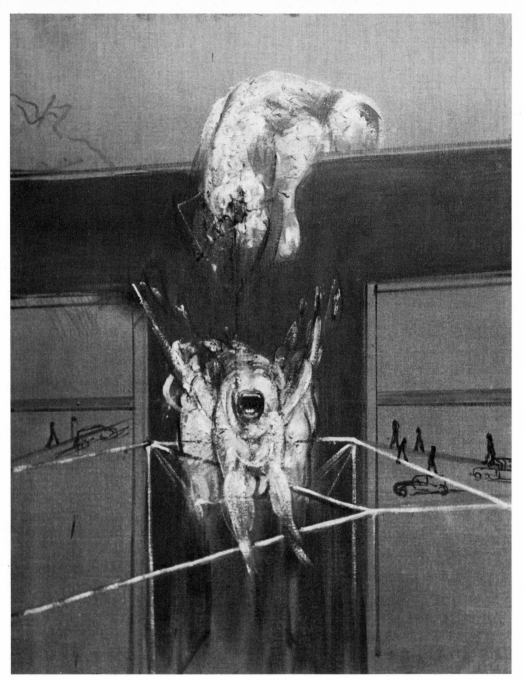

29 *Fragment of a Crucifixion* 1950

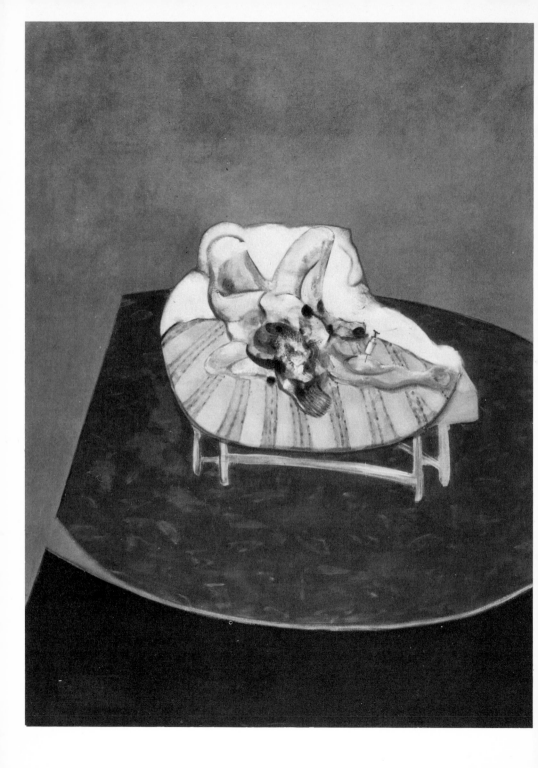

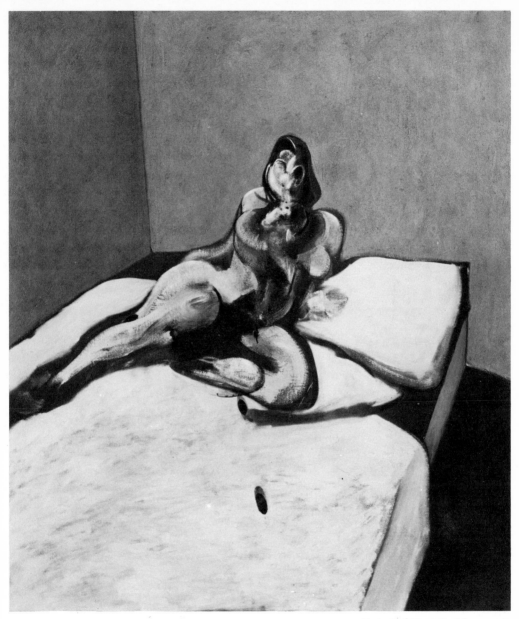

31 *Portrait of Henrietta Moraes* 1963

◀30 *Lying Figure with Hypodermic Syringe* 1963

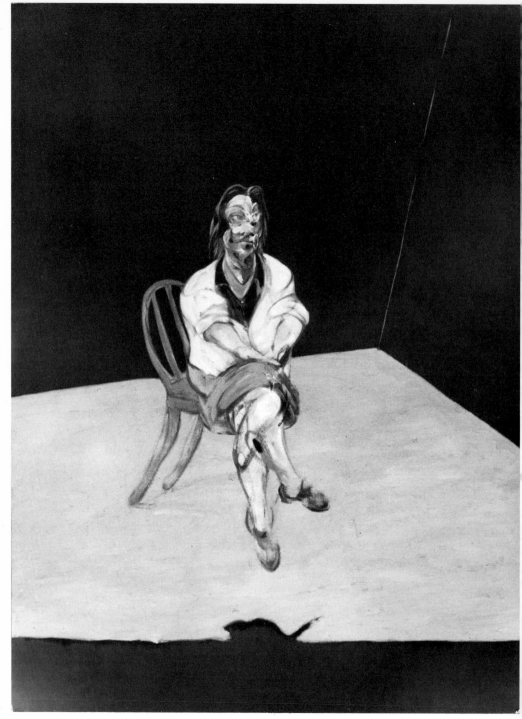

32 *Study for Portrait (Isabel Rawsthorne)* 1964

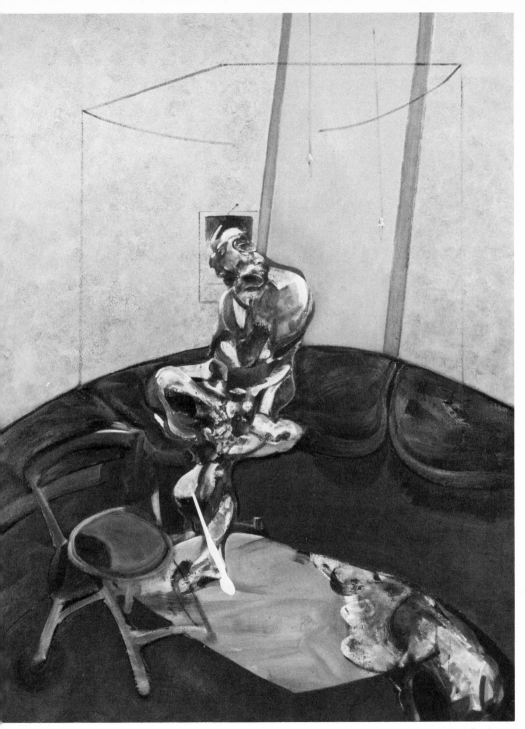

33 *Portrait of George Dyer Staring at Blind Cord* 1966

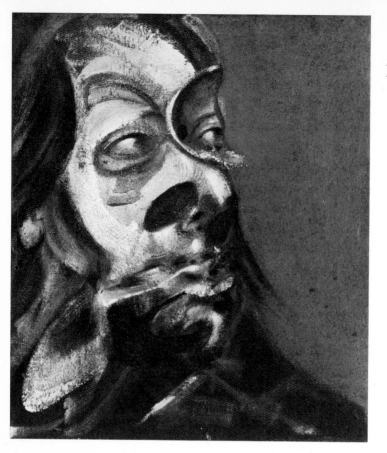

34 *Study of Isabel
Rawsthorne* 1966

37 By the standard of *George Dyer on a Bicycle* or *Isabel Rawsthorne Standing in
20 *a Street in Soho*, the earlier picture is undeniably savage and unequivocal in its
subject-matter. The crucified figure, the dog bending down to savour the
fresh meat, the indifferent bystanders going about their business – all this
amounts to traditional story-telling, and to the telling in this case of a
particularly repulsive story. (That story has its twin, as it happens, in the
history of Dublin; for when Robert Emmet was hanged outside the church
of St Catherine in Thomas Street, and the hangman sliced off the dead man's
head with a butcher's knife, the dogs of Dublin rushed in, so V. S. Pritchett
tells us, 'to lick up the blood on the streets'.)

After a twenty years' interval it is the element of story-telling in this
picture that leaves Bacon himself dissatisfied; we, on the other hand, may
remember above all the paradoxical beauty of the image itself, and the

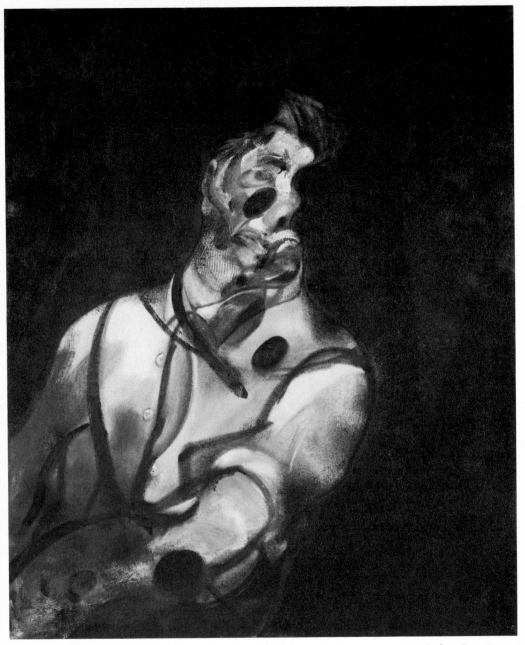

35 *Study for a Portrait* 1966

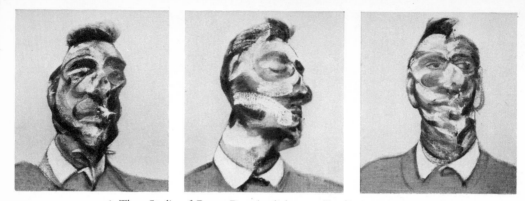

36 *Three Studies of George Dyer (on light ground)* 1964

energy with which the two figures are painted, and the power and economy with which the scene is set on a largely bare canvas.

Talking to David Sylvester in 1966, Bacon said that the difficulty of painting portraits in present-day conditions was such that, for him, portraiture had replaced the mythological or religious subject as the most taxing of all forms of painting. The difficulty in question is manifold, but it springs above all from the fact that we no longer accept the unitary and unambiguous and closely structured view of human personality which portrait-painting traditionally involves. We disbelieve in the monolithic view of human nature; we are not awed – quite the contrary – by the trappings of power; we see human beings as flawed, variable, self-contradictory, subject to the fugitive and the contingent. Portraiture belongs to the drawing-room, and our century has concentrated on the consulting-room, the *maison de passe* and the displaced persons' camp.

The unitary ideal in portraiture is one which reached its apogee in the Roman bust: a statement so plain, so direct, so unequivocal that it should have had on its plinth the words 'This man is all of a piece'. Selfhood is absolute in sculptures of this sort: nothing is feigned, nothing is borrowed, nothing is held over for further discussion. Such confidence is rare, in later periods. But at least it was accepted in portraiture, until quite lately, that the official personality was also the real one. A man was what he wore, what he owned, what he had married and what he had bred. Portraiture was by its nature congratulatory; scallywags did not get their portraits painted – or not, at any rate, after they had been found out. It was the unblemished Ancient, in Roman times, who had his bust displayed outside his house.

As it happens, few men have as great a faculty of admiration as Francis Bacon, and very few indeed are readier or more generous with praise when a friend happens to do something well. His private Pantheon is not

84

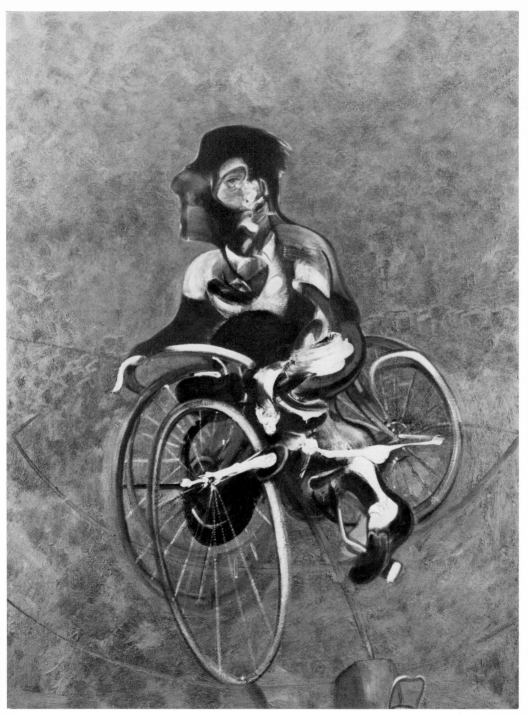

37 *Portrait of George Dyer on a Bicycle* 1966

overcrowded, but there is nothing inert or flaccid or taken-for-granted about his feelings for such figures from the past as have managed to get in there. But this is not to say that either the living or the dead can count on the kind of slovenly, undifferentiated approval which elsewhere passes for friendship. Bacon in life practises the kind of aristocratic plain-speaking which was common among the friends of Charles James Fox but has now gone down, almost everywhere, before a convention of wadded hypocrisy. 'Who can I tear to pieces, if not my friends?' is a favourite maxim of Bacon's, and he lives up to it. When he paints portraits, as he does more and more, it is his friends, once again, who come under scrutiny: 'If they were not my friends, I could not do such violence to them.' This violence, however, is perpetrated *in absentia* – since he paints his portraits most usually from memory, and from photographs, and in general from anything except the actual living and sitting model. To have the models in the room inhibits him because, as he said to David Sylvester, 'If I like them, I don't want to practise the injury that I do to them in my work before them. I would rather practise the injury in private by which I think I can record the facts of them more clearly.'

'People believe', he went on to say on that occasion, 'that the distortions of them are an injury to them no matter how much they feel for or like you.' Bacon sees this as being especially true of 'simple people', but it is common ground with both simple people and very complex people that a portrait is a form of assault, and one which may endanger the psyche. How many state-portraits did de Gaulle allow to be painted of himself? None. When did Winston Churchill fall beneath his own ideal of magnanimity? When he saw Graham Sutherland's portrait of himself. Portrait-painting is one of the few human activities to which an undisputed magic attaches. Superstition, not fact, underlies it: superstition, and the longing to see, just once in one's life, an unflawed image of oneself. The portrait is traditionally a sub-department of paradise: a place in which all sins are forgiven, all minuses are turned to plus, and the fundamental rightness of the nature in question is laid uppermost. Bacon's portraits are not at all like that. His sitters are not in their Sunday best; nor are they shown in rooms tidied for the occasion.

The qualities which Bacon prizes most are, I think, those of forthrightness, endurance, quick-wittedness, and readiness to take a risk. He is not interested in people who are in retreat from life; still less, in those who look on at it from fortified positions. He likes his friends to 'abound in their own sense', as the French say: to test their natures to the farthest possible point. Borrowed space, borrowed time, borrowed rooms and borrowed bodies make up, in many cases, the emotional climate of his portraits. Life in them is lived from minute to minute, and not at all in the abstract and timeless world of

traditional portraiture. Bacon likes powerful instinctive natures and dislikes, very much indeed, those whose speciality is a kind of embroidered hesitation.

The earliest named portrait in Bacon's *œuvre* is the *Portrait of Lucian Freud* of 1951. Bacon at that time had lately returned from a visit to his mother in South Africa. He has been to Africa from time to time ever since, and from two points of view it interests him quite particularly. First, it is still, in this post-colonial age, a human game-reserve: a sanctuary for the kind of English man and English woman who now finds England itself too heavily democratized. Card-playing, drink, love-making and cheap coloured help are almost as abundant in white southern Africa as they were in Kenya when Karen Blixen gave an unforgettable nobility and a proud instinctive loftiness of bearing to Denys Finch-Hatton and other exemplars of colonialism in its greater days. Subtract that nobility, and you will be left with a society set fast in obsolete ways, living the privileged life against the day when the last remaining parts of white Africa will be reconquered by Africans.

Second, Africa is a museum of animal life: a place where high grass is parted almost invisibly by the passage of a four-footed creature, furred or armoured, that may at any moment break cover. If Bacon in the Kruger Park was fascinated by the instinctual behaviour of wild animals, it was not so much for that behaviour's own sake as for the analogies which it suggested with human behaviour. He did make one relatively straightforward game-reserve painting, the *Elephant Fording a River* of 1952; but fundamentally what caught his interest was the relationship between the living creature and its environment, and the extent to which that environment was by turns protective and treacherous, dissembling and revelatory. The bison was 'lost' in the long grass in the way that the Chairman of the Board is lost in the standard single hotel-bedroom; a hunter's footfall for the one, a telephone call for the other, are the social complements without which both lapse into an unstructured instinctual chaos.

In choosing to paint Lucian Freud in 1951, and on many occasions since, Bacon made what now seems almost a predestined choice. Freud at that time was twenty-nine years old. Then as now he was *homo Londiniensis* in an exceptional degree: a man who used all London as the bison uses the long grass and lived with an absolute minimum of circumstantial baggage. As far as is possible in the late twentieth century, Freud owns nothing and lives nowhere, though it could be said with equal truth that he has everything he wants and is at home everywhere and in all societies. He is contradiction personified. His ivorine features and slight frame belie a constitution that on closer acquaintance turns out to be indestructible. Gifted with a generalizing intelligence of a very high order, he yet specializes in the particular: in the

fact precisely observed, the individual case that applies to itself only, the subjective experience that appears to owe nothing to induction from earlier happenings of a comparable sort. Freud is not so much 'lawless' in his behaviour as a volatilizer of law: someone who dismisses the general rule as inapplicable and reacts to any given situation as if it were something previously unknown.

The 1951 portrait of Lucian Freud was based in point of fact on a photograph of Kafka as a young man which was used as the frontispiece to Max Brod's *Franz Kafka: A Biography* in its original edition (Prague, 1937). Bacon – to revert to de Bono's distinction – has always favoured the lateral as against the vertical approach. In his portraits, he prefers to bait the trap in such a way that conventional 'likeness' at first sight seems excluded, only to be caught unawares at a later stage. The 1951 portrait is still remarkably true to the more fugacious aspect of Freud's character: the sense that he is in a given place only momentarily. Proceeding always according to an idiosyncratic time-table and seemingly absolved from the normal human necessities of sleeping, eating, dressing in more than the most summary sense and keeping up some sort of ordered relationship with the world of everyday observances, Freud is a man on his own; no one cuts more of the fat off life. This makes him an ideal Bacon-subject.

Before going further with the roster of Bacon's portraits, I should like to say something about the general complex of attitudes within which Bacon's activity is carried on. Bacon himself would not, I think, care to put this into words, if only because a specifiable notion of human beauty has immediately something of illustration about it. Helleu, van Dongen and Marie Laurencin are painters who had such a notion; what Bacon is after is, on the contrary, the most direct and poignant of possible statements about the fugitive nature of human beings. What he stalks in his sitters is a certain resonant energy in the realization of their flawed natures.

It was in the mid-1960s that Bacon was given a little book by Michel Leiris (later to become a close friend of his) in which there appears a passage which he at once ringed with a thick, flat nib. Leiris traces back to its origins in Baudelaire the notion of an ideal beauty that is quintessentially modern in that it refuses to fall back on 'the emptiness of a beauty that is absolute and cannot be defined'. That notion has within it an element that is timeless and immutable; but it has also, and indispensably, a circumstantial element that is in a continual state of change. 'For Baudelaire,' Leiris wrote, 'beauty cannot come into being without the intervention of something accidental (a misfortune, or the contingence of modernity) which drags the beautiful clear from its glacial stagnation; it is at the price of degradation that the mummified One turns into the living Many.'

'The current idea of beauty as something that arises from a static mixture of opposites is, therefore, implicitly obsolete', Leiris went on. 'Beauty must have within it an element that plays the motor-role of the first sin. What constitutes beauty is not the confrontation of opposites but the mutual antagonism of those opposites, and the active and vigorous manner in which they invade one another and emerge from the conflict marked as if by a wound or a depredation.' To Bacon, with his lifelong interest in the look and nature of wounds, this passage and the one which immediately follows had a particular fascination: 'We can call "beautiful" only that which suggests the existence of an ideal order – supraterrestrial, harmonious and logical – and yet bears within itself, like the brand of an original sin, the drop of poison, the rogue element of incoherence, the grain of sand that will foul up the entire system.'

Leiris saw both the stable and the unstable as essential to beauty, which can present itself either as an area of calm invaded by a tempest or as a state of frenzy which struggles to disguise itself behind a mask of impassivity. Ideally there should be a balance, a perfect polarization, between the two mutually indispensable elements of beauty: 'On the right-hand side, a beauty that is immortal, sovereign, sculptural; facing it, the element of the left, sinister in the strict sense, since the left stands for misfortune, and for accident, and for sin.' Beauty resulted, not from a conflagration of opposites, but from an equivocal struggle between them, an ambiguous coupling or, better still, a tangential coming-together of the straight line and the curved line, a marriage between the rule and its exception. 'And yet', Leiris said finally, 'we shall see that even this image of the tangential meeting is an ideal almost never attained. Our aesthetic emotion – or approximation to beauty – depends in the last resort on that lacuna which represents the left-handedness of beauty in its highest form: an obligatory incompleteness, an abyss that we can never traverse, a breach that opens on to our perdition.'

The notion of dexter and sinister in the concept of beauty is one that applies at many levels to Bacon. His paintings are what Leiris called 'mythic translations of our inward structure which move us to the extent to which they throw light on ourselves while at the same time resolving our contradictions in a harmony not to be found elsewhere'. The equivocal couplings of which Leiris speaks are figured directly in paintings like the *Two Figures* of 1953; and although the popular idea of Bacon is, one might say, all sinister and no dexter, the poignancy of his distortions comes precisely from the fact that the straight line is present, unseen, as the complement of the curved line, just as the rule is present, unseen, as consort to the exception. Somewhere behind even the most radical of Bacon's injuries to the norms of beauty there is a counter-image; as Leiris says

41

elsewhere in the passage I have quoted, beauty is a function as much of the self-regenerative as of the self-destructive, and our final impression of any major painting by Bacon is that of the rehabilitation of beauty. If this were not so, the work would be mere sensationalism, flat and cartoonish.

For the joint presence of the straight line and the curved one, the right-hand image of beauty and its counterpart on the left, Bacon has metaphors of his own – or ones which we can infer from his conversation. 'One thing I'd like to have', he once said, 'is an enormous room lined with distorting mirrors from floor to ceiling. Every so often there'd be a normal mirror inset among the distorting ones. People would look so beautiful when they passed in front of it.' In Bacon's portraits of the 1960s the distorted image and the normal image are simultaneously present, laid each on top of the other. Fact and its repercussions are put before us at one and the same time and in a single image. 'Fact leaves its ghost' is another favourite saying of Bacon's and in these portraits the ghost and the fact are both present, and in such a way that no one can tell them apart.

The word 'ghost' is not a favourite with Bacon, for it has creepy, spooky connotations: overtones of Poe and M.R. James which are exactly what he least wishes to evoke. He does not see his work as in any way nightmarish, and there are not many painters of any consequence whom he dislikes more than Fuseli. If there are moments of violence in his work, he sees them as purely matter-of-fact. Violence is as much a part of modern life as it was, in the eighteenth century, a part of the easy sociability of Dublin. When the weavers of Dublin clashed with the butchers of Ormonde Quay, there was no nonsense about the Queensberry rules. 'The butchers' (I quote from V.S. Pritchett again) 'cut the leg-tendons of the weavers; the weavers hung the butchers by the jaws on their own meat-hooks.' The ghosts in Bacon are after-echoes of facts such as these.

They took some time to get through. I myself would date their first appearance somewhere at the very end of the 1950s. Bacon was, of course, a master of image-making long before that; but a great many of even the most commanding of his images from the 1950s could almost be reworked movie stills, insomuch as the paint remains the servant of the image. This is a complex question, and made the more so by the fact that in those years Bacon tended to work for exhibitions – i.e. to wait until his next one-man show (at the Hanover Gallery, in almost every case) was so near that he absolutely had to get the pictures done. Pictures not painted at those times were often destroyed or discarded; others turned out to be 'one shot' affairs – experiments never repeated, or paintings done to please someone or other and later given the rough edge of his tongue. Bacon in the 1960s was a paragon of concentration when concentration was called for; but in the

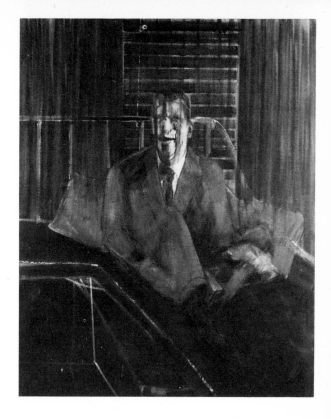

1950s he had more wayward habits. Ideas came and went, forced themselves on him all over again, and were various enough and arresting enough to conceal a certain discontinuity in the achievement which resulted. Where, later, the fact and its ghost would cohabit in a single canvas, in the 1950s the fact would appear on one canvas and its ghost on another. The paint was not ready to bear too complex a statement.

An instance of this is the series of eight *Studies for a Portrait* which Bacon 38
painted in the summer of 1953 for a show (his first in the USA) at Durlacher's
in New York. With this should be associated the *Study after Velazquez's* 8
Portrait of Pope Innocent X of the same year. Bacon had painted three earlier
Popes in 1951, and there were to be others – notably a series of six in 1961.
But the Popes of 1953 illustrate with a particular clarity the way in which
Bacon at that time used his ideas one at a time and was not yet ready, or able,
to use them all together as he did in the 1960s. There are no ghosts in the 1953
series, and the heads are painted almost as unambiguously as they had been in
the two very grand pictures called *Pope I* and *Pope II* of 1951. The figure is 15
pushed towards us like the rings and bracelets and necklaces in a jeweller's

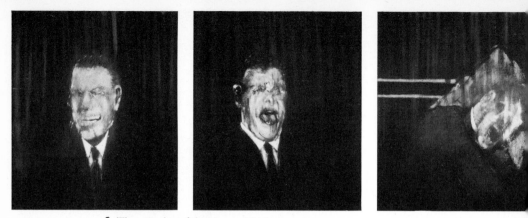

39 *Three Studies of the Human Head* 1953

window, and it is held in place by a tubular construction, half single-bed, half
8 unpadded throne. (Only in the *Study after Velazquez's 'Pope Innocent X'* is the
Pope seen at full length, in the white skirts that so deftly de-sex him.) 'The
tubes do come from my own metal furniture,' Bacon once said, 'but
fundamentally they are an attempt to lift the image outside its natural
environment.' The Pope has, therefore, some of His Holiness's normal
appurtenances; but he is also cut off, exposed, held up for scrutiny.
Sometimes we might think that he had lost his legs altogether, sometimes
that he is an invalid in process of rehabilitation. He is by turns resigned and
petulant; now slumped in a posture of complete regression, now gazing
around him with something of formal benignity, now gathered up as if to
throw the thermometer at the next person who comes round the door.

 The series is like an anthology of paternal attitudes; and we remember that
in Italian *il Papa* is both a diminutive and a name that can strike awe. Bacon's
Pope is both tyrant and pampered baby; but he is not, at this stage in Bacon's
career, both at the same time. This was a time for separation, and for careful
7 spelling out. 'In the *Study for Crouching Nude* of 1952 I tried', Bacon once
said, 'to make the shadows as much *there* as the image. In a funny way, and
though I hate the word, our shadows are our ghosts.' But the ghost at that
time was something that followed one pace behind, as it does in Victorian
40 thrillers; a prime example in Bacon's work is the *Sphinx I* (1953), where the
sphinx casts a shadow that reshapes itself in the form of a man with a gun.

 Two other works from this notably premonitory year should be
39 mentioned. One is the *Three Studies of the Human Head* which inaugurated a
form much favoured by Bacon in later years: that of the three heads, set
together in one frame, that between them comprise a complete pictorial
situation. As in many other paintings of the 1950s, the light falls on the heads

40 *Sphinx I* 1953 ▶

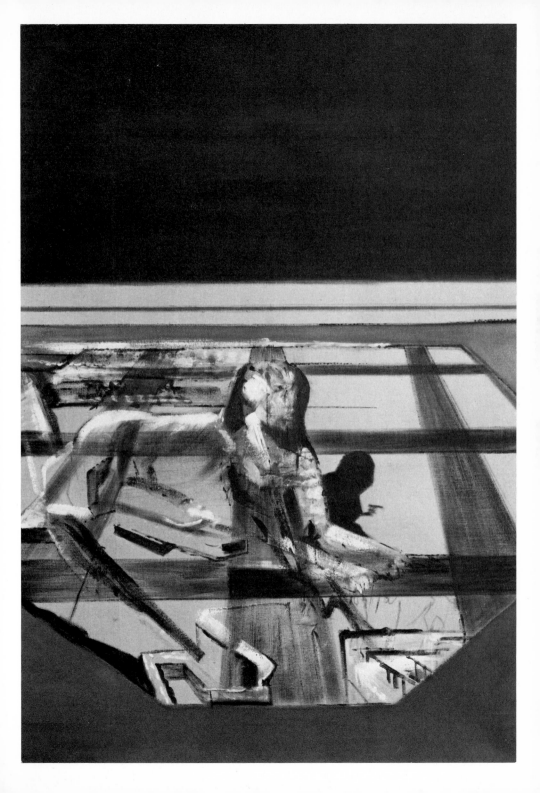

in vertical folds, as if refracted through tall blinds, and the flesh has the
creamy quality apotheosized in the *Two Figures* of the same year. The group
can be read sequentially. The left-hand head then stands for a quiet and easy
sociability; the central one for the Public Man in full flood (it is pointed out in
Ronald Alley's catalogue that the portrait is strikingly akin to a photograph
of the then Canadian Prime Minister which had lately appeared in *Time*
magazine); and the right-hand one for the dissolution of the public mask
which comes when the great man falls asleep or, just conceivably, is
smothered to death in his hotel. Once again, the anthology-principle is at
work, in ways which Bacon would have scorned in the 1960s.

The *Two Figures* of 1953 could in some respects be put in an earlier
chapter, in that it was based partly on an echo from Muybridge. It could also
be related to the Greek third-century bronze of which a replica is in the
Uffizi: *The Wrestlers*. (Bacon has never seen this.) There is also Courbet's
Wrestlers. Bacon's figures have the humped, hoop-shaped look of the Greek
wrestlers. The painting has also something of Courbet's *Le Sommeil*: not
least, the extraordinary, wraith-like beauty of the bedclothes, which parallels
the relation of Courbet's bedclothes to the figures heaped upon them. And
the *Two Figures* exemplify, above all, something that Bacon acknowledges
in Michelangelo and has never found since in anything like the same degree:
the element of male voluptuousness. On this point he is quite specific: male
flesh has a puissance all its own. That puissance is not replaceable: it cannot be
counterfeited by women who have a male strength of character, any more
than female voluptuousness can be counterfeited by men who happen to
have certain female characteristics. In many ways the Renaissance sold the
pass, in this respect: an androgynous Italianate boy-girl beauty passed into
legend, leaving the realities of masculine beauty with no one to record them
truthfully. Seekers of the ideal were deflected, and the 'love that dared not
speak its name' made do with hypocrisy. The *Two Figures* of 1953 are quite
free from the element of experimentation which marks other paintings of
that year: we do not feel that Bacon could have done a dozen versions of the
subject. There is about that mound of flesh, pink flecked with violet, the
wholeness and the oneness that come when a subject is seen completely and
set down entire.

The two figures are not, of course, portaits in the sense that the two figures
in Courbet's *Le Sommeil* are portraits. Bacon has not negotiated, as Courbet
did and Modigliani (for one) could not, the tricky moment at which
complete definition of the body is suceeded by complete definition of an
individual face. In fact, what to do about the human head is a problem which
Bacon seems to me not to have solved too well between 1953 and 1960. If we
try to find a parallel elsewhere in the work for the opulent assurance with

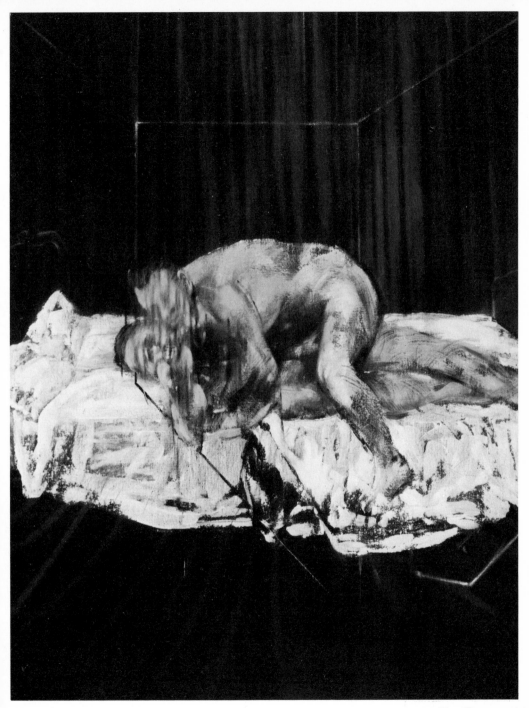

41 *Two Figures* 1953

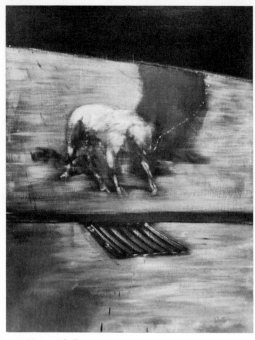

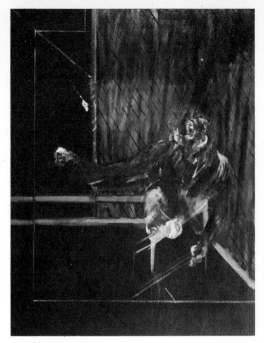

42 *Man with Dog* 1953 43 *Chimpanzee* 1955

which the two figures were painted in 1953, I do not think that it will be
forthcoming: or not, at any rate, in paintings where the human head is the
subject. Dogs and monkeys are another thing; sphinxes, likewise. But a
sequence like the seven *Men in Blue* of 1954 is an essay above all in placement
and in lighting; the head itself is a phosphorescent splodge. The dog skirling
42 along the gutter in the *Man with Dog* (1953) is also a splodge, on one reading;
but it is a marvellously haunting splodge, complete with a suggestion of
bone-structure and a hint of gait. Bacon's figure-paintings in the second half
of the 1950s tend to be either variants of existing images, like the life-mask of
Blake or the van Gogh of himself going to work, or second workings of
ideas that Bacon had already brought off superbly. The Blake, a commission,
looks to me more like Vladimir Nabokov than like William Blake; but the
44 vertically banded version, No. III, is an imperious piece of painting and, like
the portraits of Robert and Lisa Sainsbury, it stands for an important phase in
Bacon's negotiations between image and appearance.

 But more crucial than any of these was the first, dated 1956, in the long
series of his self-portraits. 'I couldn't think what on earth to do next,' is his

96

characteristic comment on that painting, 'so I thought "Why not try and do myself?"' Like its successors, it was painted out of his head. It remains remarkably faithful to his way of holding himself, to the well-cut but ill-used grey suit which he brings out on formal occasions, and to his general air of only just controlling the impulse to rush out of the room. 'Portraiture is impossible now,' he will often say, 'because you're asking chance to fall your way *all the time*. The accidents have to work on every level at once.' But both in this first self-portrait and in the second one which he made two years later, the accident-ratio is comparatively small; in relation to the self-portraits of the 1960s these are sedate and secure.

In Bacon's early seated figures the figure is *seated* in the classical sense: as if bolted to the chair, that is to say. The attitude is that of a man giving (or a man awaiting) judgment. Where movement is suggested, in the first half of the 1950s, it is suggested by a chimpanzee whirling round on his hunkers or a 43 dog veering across the pavement towards a drain. Later the human figure 42 also began to twist and turn. Sometimes on a revolving chair, sometimes with no apparent means of support, sometimes in Thurberesque contortions like those ascribed to the female *Lying Figure* (1959), sometimes in something 45 like formal *contrapposto*, the figures are caught in the act of turning through 360 degrees. This went on until in 1963 the act of turning became the named subject of the picture (*Turning Figure*), and the figure was wound round and round itself like barley sugar. 'More life, less art' was the motive behind all

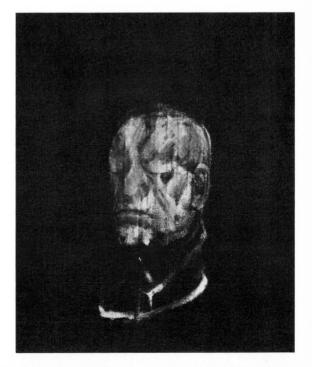

44 *Study for Portrait III (after the life-mask of William Blake)* 1955

this: Bacon had had enough of the controlled grandeur of the figure that sits still and does nothing. 'I've always been more interested in what is called "behaviour" and "life" than in art. If my pictures come off, it is because of a chance conjunction between actual living and art. Painting makes me more aware of behaviour, and it is easier for me to say what I want to say about behaviour with the methods of art than it is for me to say them in conversation.' By 1959 Bacon had the figure lolling on its back with one leg in the air, or posturing for its own amusement with its clothes pulled up above the waist; by 1960 the figure was strutting along a corridor by itself, or

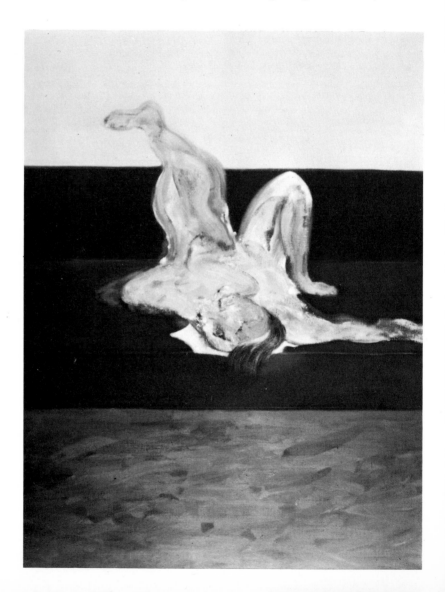

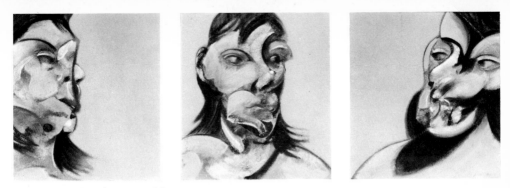

46 *Three Studies of Henrietta Moraes* 1969

peeking round a half-opened door. What decided the 'pose', or lack of it, 53 was not 'chance' in the dictionary sense, though chance entered into it. It was chance *plus* concentration *plus* the instinctual drive to make the image true to actuality.

'I terribly don't want to make freaks,' Bacon once said, 'though everyone seems to think that that's how the pictures turn out. If I make people look unattractive, it's not because I want to. I'd like them to look as attractive as they really are.' Equally, he is not at all interested to show people, as is often supposed, in a state of intolerable nervous tension. 'I'm not a preacher. I've nothing to say about "the human situation". What gives the pictures their desperate look, if they have one, is the technical difficulty of making appearances at the present stage of the evolution of painting. If my people look as if they're in a dreadful fix, it's because I can't get them out of the technical dilemma. As I see it, there's nothing, today, between a documentary painting and a very great work in which the documentary element is transcended. I may not manage to produce that "very great work", but I intend to go on trying to do something different, even if I never succeed and nobody else wants it.'

Portraiture in the 1960s was very important in this respect. The single head, fourteen inches by twelve, was from 1961 onwards the scene of some of Bacon's most ferocious investigations. Just as a gunshot sometimes leaves an after-echo or parallel report, so these small concentrated heads carry their ghosts within them. 'The great portraits of the past', Bacon once said, 'always left me with a side-image, as well as a direct image. Every image casts its shadow into the past, and I could never dissociate myself from the great European images of the past — and by "European" I mean to include Egyptian, even if the geographers wouldn't agree with me.' I myself associate, however unwarrantedly, paintings like the *Three Studies for*

99

◀ 45 *Lying Figure* 1959

59 *Portrait of Henrietta Moraes* of 1963 with the cut-down self-portrait by Giorgione in Brunswick. 'This is the most', both seem to say, 'that can be said in paint at this time about human beauty.' Taken close-up, the head fills the canvas: there is no need for the bare surfaces which, in larger canvases, served to trap the image in a severe and non-logical surround. The choice of named individuals served, also, to tauten the intention. Above all, it helped to focus on the central problem: that of conveying fact in a non-illustrational way. 'Once you know how to do it,' Bacon said, 'it becomes illustration': the essential thing was, therefore, to remain within the area of the not-known, in technical terms, while concentrating on people known as minutely as one human being can know another.

The initial *donnée* in these portrait-heads is not so much distorted as contorted. We do not feel, as we do with some of Picasso's more bloody-minded rearrangements of the female head, that the features could never reassume their conventional appearance. We feel, rather, that we have penetrated to the inmost nature of human behaviour, and that these people are betraying in the everyday traffic of life something of that instinctual violence which marked the great warrior Cuchulain in the height of battle. (I owe this analogy to Michel Leiris.) Cuchulain in the heat of the fray was said to twist round in his own skin to such an extent that at moments he was literally 'back to front'; and something of that sort happens to Bacon's subjects when he commits them to canvas. The portrait-heads grew consistently more and more violent as the 1960s progressed: to the point, in fact, at which the face as we know it would disappear altogether in the jewelled slime of the paint, leaving behind it an eye-socket, or the deep cave of a nostril, or an irreducible patch of hair, as tokens that somewhere among the strong-willed chromatic smearing a named individual was com-memorated. No question, here, of setting the scene: we are at a dentist's distance from eyes, nose, mouth and teeth, and the rest of the world is blocked out.

But what if the rest of the world were not blocked out? What if the rest of the body were to be treated as the head is treated in these paintings, and the complete human being were to be surprised in its environment? There would be implied in this a degree of contortion far surpassing that to be found in a Bacon of the 1940s or 50s; and the gamble, hitherto confined to a small canvas and an anatomy cut short at the neck, would be compounded over a very much larger surface and with a vastly larger potential for disaster. Bacon would never settle, in such a matter, for the stakes appropriate to a Clouet or a Corneille de Lyon: the larger risk was no sooner formulated than run – in a series of full-figure compositions which extended throughout the 1960s and into the 1970s.

To be and not to be

Few living painters of consequence are as loyal as Bacon to the traditional properties of oil paint. 'People don't realize', he will say, 'how mysterious and fluid a medium oil-painting is.' As indifferent to plastic paints, on the one hand, as to the silk-screened image on the other, he remains a lifelong, convinced, committed and unreconstructed oil-painter. The paint, once applied, may be manipulated in ways which would have made Sir Joshua Reynolds bite the carpet – it may, for instance, be pulled or rubbed with an old pullover or a squeegee roller – but it remains the same old volatile substance. And what goes on between him and it is still very much an open subject.

There was, however, a time in the late 1960s when Bacon had it in mind to be unfaithful to painting. For several years, in fact, he made sculptures in his head. What he envisaged were sculptures of the human figure, a little below lifesize. They were to be set in a simple, tubular steel framework, not unlike the ones which he has often used to isolate the human figure in his paintings, and each would be a unique cast. The intended material varied from month to month, but most often it was to be some kind of synthetic but not weightless substance which could take colour quite easily. The idea was to simulate human flesh as vividly as possible, either by painting the figure or by pouring a bucket of flesh-coloured whitewash all over it. Remembering the rough beauty of a newly whitewashed house, Bacon thought that a comparable beauty could perhaps be wrested from a newly whitewashed figure. The figure itself was to stand or sprawl on a highly polished steel surface. It was to be an organic body-form, but not literal or directly illustrative. 'It would *make* the arm, or the leg, without *saying* it. . . . Arp tried to do it, but I think I could give it another twist.' Conceivably it would be adjustable.

There were times when Bacon got to the point of talking to people who could give him technical advice in the matter. Once or twice he almost got out a putative time-table for his debut as a sculptor and began to wonder in what kind of room the sculptures would look best. But then suddenly, around 1968, nothing more was heard of the idea, and it became clear to anyone who had been following its evolution that its ups and downs corresponded to the downs and ups of his painting. When painting was up,

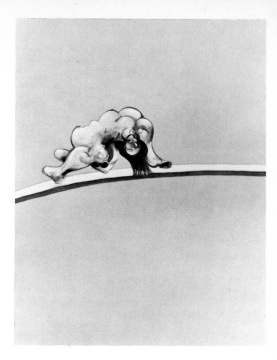

47 *Triptych – Studies of the Human Body* 1970

the sculptural idea subsided; and when painting went up very high indeed, as it did when Bacon began to work for his exhibition in the Grand Palais in Paris, there simply wasn't any room for the sculptural idea, or any need to pursue it further, since the new paintings annexed and transposed and fulfilled it. In December 1970, for instance, Bacon painted a triptych of three single female figures which had something of the sculptural idea which he had been caressing for years. In particular the chunky central figure put many observers in mind of an antique torso cut off at the top of the thighs. Above the massive breasts and shoulders was an umbrella, bottle-green against the palest of mauve backgrounds; and where the face could have been Bacon put in an ambiguous form which was derived, in point of fact, from a photograph of a bird diving out of the sky in Rhodesia. It could have looked arbitrary or contrived, but it didn't; and the bodies themselves were quite free from the cancellations which had lately haunted his figure-paintings. Each form was followed through closely and coherently; these were some of Bacon's strongest and calmest images. It was as if, when hypothesizing his sculptures-to-be, he had entertained the idea with just enough seriousness to make painting say 'But *I* could do all that for you, just as well or better.' 'Jealousy', Bacon likes to say, 'is the greatest aphrodisiac there is.'

There had, for that matter, been a consistent and a cumulative change in his work ever since the beginning of the 1960s. One could put this very

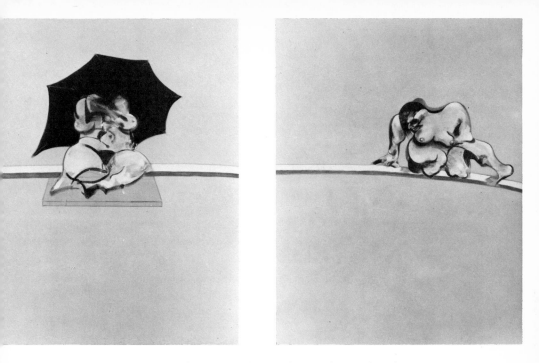

51, 52

briefly by saying that with the group of single heads of 1961 there began a
period during which the paint and the image interlocked more and more
closely. In the work of the 1950s there had been times when the image came
out front and the paint did its best to keep up; and there had been times (as in
several of the van Gogh series) when the paint looked very strenuous but had
got somewhat adrift from the image. In the close-up heads of 1961 the image
was often twisted like barley-sugar, and the paint turned round upon itself
like a dog tormented by fleas, and yet the image and the paint coalesced in a
way that was both 'right' for the painting in question, and 'like' for the
person portrayed.

Bacon has, in fact, been aiming since 1960 to tauten his human images by
making them more factually 'like' and less generally reminiscential. This
heightened particularity has its compositional equivalent, in that Bacon in
the 1960s got progressively further and further away from the schematic,
deep-shadowed space of the figure-paintings of the mid-1950s. That space
persisted into the 1960s in a certain number of paintings; and where the
image was strong enough – as in *Pope No. 2* (1960) – it still worked quite 48
well. The white-skirted Pope, in that painting, leans on a glass table on
which is a large and spectral cut of beef; behind him the space is splayed out
in such a way as to push the Pope down front and out towards us; a pair of
blind cords dangle down as if to tell us that the blinds are drawn, so that there

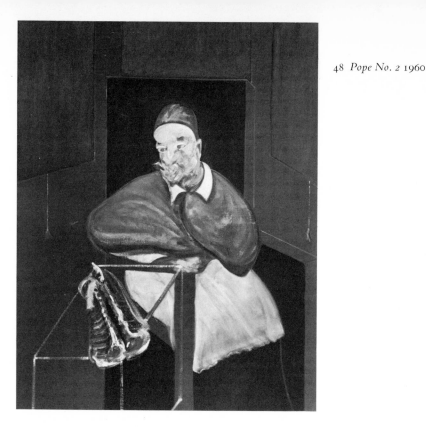

is no point in our scanning the darkness outside: beef and the Pope are all that we have to look at. Where the image was not so strong, as in the six *Studies for a Pope* (1961), we realize that this particular compositional device is no longer adequate for Bacon's ambitions.

We could also say, I think – and the work of the next ten years will bear us out – that images from earlier art do not have the immediacy, or the involvement with Bacon's most private experience, that he needed to blast off into a new kind of painting. The act of painting 'after Velazquez' or 'after van Gogh' is an abrogation of responsibility, in this context, no matter how much the initial *donnée* is transformed. The later Popes have an element of safety and repetition which is quite foreign to Bacon's nature. They are doubly safe, in that there is a twofold diminution of risk: not only was Velazquez himself home and dry, but by 1960 the idea of 'one of Bacon's Popes' was also home and dry – fixed, that is to say, in art-history. The kind of painting that Bacon has in mind to attempt in the 1960s called, on the contrary, for the maximization of risk. And that risk could not be grafted on

to the readjustment, at no matter how many removes, of a famous image from the past.

There remained two main departments of effort in which risk could be maximized. One was the portrait, large or small, and the other was the full-scale composition with one or more figures. Bacon was drawn to portraiture, more and more, by reason of its evident impossibility. 'You simply can't bring off a portrait today', he would say. 'You're asking chance to fall your way *all the time*. The paint has to slide into appearance at every level, the accidents have to be all in your favour.' In this desperate adventure he recruited not the actual presence, but the memory in one guise or another, of people he had known very well. Most of these people shared with him a relish for risks run consciously, and for the notion of destiny as something to be outwitted for as long as possible. They were free-spoken, instinctive, unprevaricatory. They were slack-wire walkers who forgot the safety-net; and, as Bacon is so often associated only with a degraded idea of human activity, it is worth saying that a great many of the paintings of the 1960s are in their implications the very reverse of squalid and claustrophobic. The portraits of Isabel Rawsthorne are, for instance, an acknowledgment of all that is staunchest and most generous in human nature. Energy, intensity of perception, depth of feeling, bodily magnificence and an undiminished vitality in the face of great private difficulty – all these come out in the work in one way or another. It is not that Bacon has any illusions about human nature – 'Rotten to the core!', spoken *tutta forza*, is his estimation of many people of his acquaintance – but rather that he never allows the shortcomings of others to dictate his feelings towards them.

50

49 *Three Studies for Portrait of Isabel Rawsthorne 1965*

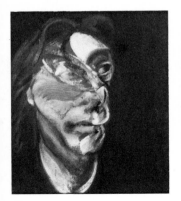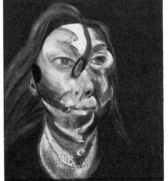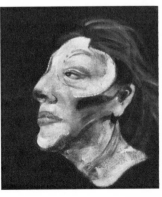

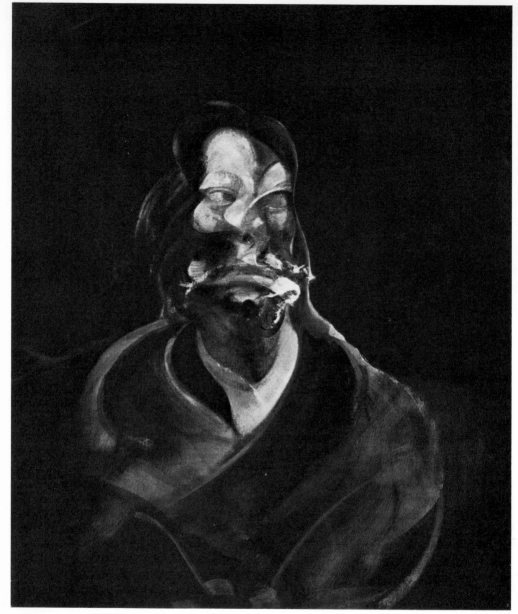

50 *Portrait of Isabel Rawsthorne* 1966

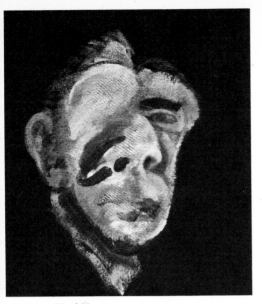

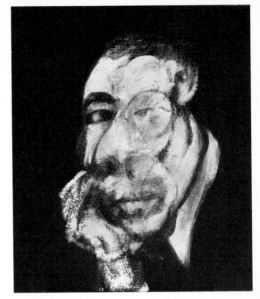

51 *Head II* 1961 52 *Head III* 1961

The problem, in painting the close-up heads of the 1960s, was how to ally 49
the strongest possible dose of verifiable reality to the strongest possible dose
of inspired risk. The painter had to have one foot on ground that was
common to all of us, and the other on ground that no one had essayed before.
Without the one, the picture could not be read; without the other, it would
be at best a meritorious remake. Not to know what answers are already on
file would be to court provincialism; to use them again would be academic.
'The moment you know what to do', Bacon said in the 1960s, 'you're just
making another sort of illustration.'

Portraiture had a bad name in the 1960s. In the sitter, it was known to
appeal to states of mind – pride, envy, arrogance, and fear – which were
universally regarded as demeaning. In the painter, it was thought to breed
servility and equivocation: people remembered how Orpen had begun as
one of the most brilliant students in the history of British art and ended up
repainting Woodrow Wilson's ears to make them smaller and less
protuberant. Portraiture had all its old hazards without any of its old
prestige. People still felt, in a primitive, unjustifiable but quite irresistible
way, that a portrait could deny and destroy them. They remembered how
Winston Churchill had reacted when he saw Graham Sutherland's portrait
of him; and they remembered how de Gaulle, when in power, never sat to a
painter. Portraiture had become a gamble in which you laid your identity on
the gaming-table and ended up as the loser.

As against this, enlightened people knew that within every human being there are contradictory strains, and that the attempt to suppress or ignore those strains which happen to be inconvenient will end in disaster. They remembered what Carlyle had said to Watts: 'You have turned me into a delirious-looking mountebank, full of violence, awkwardness, atrocity, and stupidity, without recognizable likeness.' And they knew that, so far from being the quirk of a disappointed old man, this was in pre-Freudian terms about the highest involuntary compliment that could be paid by a sitter. 'Without recognizable likeness' is a key-phrase; 'full of violence, awkwardness, atrocity and stupidity' is another. Rereading them, I thought of the Latin tag which Holbein introduced into his *Portrait of a Member of the Wedigh Family* in 1532: 'Truth breeds hatred.' This was the message which Holbein inscribed on Mr Wedigh's book-marker. We know a good deal more about hatred than either Holbein or Mr Wedigh; and we also know that the relationship between painter and sitter is as charged with contradictory feelings and instincts as any other human relationship. It can be brief and perfunctory, a master-man relationship hardly more telling than that of client and *commis* in an old-fashioned restaurant. But portraiture can also be an act of love, and the penetrations involved can be as profound as anything in sexual relations: each partner gives himself, in such a case, without reserve. It is because we are aware of these things, and can adjust our expectations to fit them, that portraiture in the 1960s was in an open situation. On one level, it was discredited: but that very discredit opened up a gap in human experience which someone, sometime, would certainly fill.

Something of the same thing had happened to the compound figure-subject, a domain in which Bacon was shortly to excel. Painting as drama had long ago been done down by the cinema. The cinema might occasionally borrow back from painting – as in Jean Renoir's *Partie de Campagne* – but in general we now look to films, and not to paintings, for the great single images of human predicament. Of course there are exceptions. Bonnard is vastly superior to any film-director when it comes to the evocation of life near Cannes in the 1920s and 30s. There are overtones of stress in his paintings which are very much more subtle than anything we shall ever see at the movies, and the formal beauty of his canvases is something that the cinema can merely hint at. But these things remain exceptional, and by the 1950s painting did not have the leadership in the creation of single images that it had when Munch painted *The Cry* in 1893. Painting was discredited in this respect: yet, once again, that very discredit opened up a gap, and eventually Bacon's *Portrait of George Dyer Crouching* (1966) came along to fill it.

62

In this way, painting was reborn to certain of its responsibilities. Birth is a desperate business, and rebirth even more so, and we can read desperation into the way in which, from 1961 onwards, Bacon wrenched, reversed, abbreviated, jellified and generally reinvented the human image. The paint-structure was by turns brusque and sumptuous, lyrical and offhand, pulpy and marmoreal. Swerving, pouncing, colliding with itself, taking for granted the most bizarre conjunctions of impulse, it produced a multiple imagery which was quite new in painting. It was not the multiple faceting of the cubists, which Bacon regards as merely a decorative annex to Cézanne. It was not the schematized imitation of movement to which the futurists had accustomed us. It was about the risks which we take, and take gladly, every time we approach another human being; and as far as Bacon himself was concerned, it was about man as a choosing animal – and one who can choose, among other things, not to repeat himself.

Bacon always likes to work towards a particular project, and over the last few years there have been three exhibitions which appealed to him especially. On was at the Galerie Maeght in Paris in 1966. Another was at the Marlborough-Gerson Gallery in New York in 1968. The third, at the invitation of the French Ministry of Cultural Affairs, opened at the Grand Palais in October 1971. These were by no means his only shows during these years: he appeared regularly at the Marlborough Fine Art in London, and he had retrospectives at the Tate Gallery in 1962 and at the Guggenheim Museum in New York in 1963. But Paris in 1966 was something different again: new work, new rooms, a new public, and an environment which he prizes quite enormously.

Bacon still holds to the view, now incomprehensible to most people under fifty, that if a work of art looks well in Paris, it has passed the supreme test. In believing this, he is concerned not so much with today's judgments as with the unsmiling tribunal of the past. Paris is the place where the great things were done – or, if not done, nurtured – over the last hundred and fifty years. Relations between the painter and society in Paris had been almost uniquely harmonious, in that to be a painter at all in Paris was to pursue a valued activity. Bacon has a small private treasury of French insights – he enjoys quoting, for instance, Paul Valéry's remark that what people want from art today is 'the sensation, without the boredom of its conveyance' – and I suspect that he prefers good French conversation to almost any kind of formal entertainment. He loves the radical, unsparing character of French talk; and he loves the prodigality of imagination which has been shown by the best French painters, the vaulting ambition, the total seriousness, the readiness to dare anything, the instinctive knowledge of how to pace a career. One can like or dislike individual works by Degas, by Matisse, by

Braque, or by Bonnard, but it is quite impossible to imagine any of them settling for a lucrative second-best, as happens in America, or running out of steam, as happens in England, or going down in rant and pretension, as happens in Germany. The sense of fulfilled purpose was always there, and it is the sense of fulfilled purpose that Bacon went all out for in the 1960s. In the 1940s and 50s he sometimes allowed pictures to get out of the studio that were either dull, silly, forced or inept; if in the 1960s he was very much more the governor of his gifts, in that respect, Paris can take a part of the credit.

A shortcoming of many earlier Bacons is that the figure is not set in any kind of convincing space, but emerges from a cage-like structure traversed by laser-beams which stand sometimes for plain walls and sometimes for a more elaborate but still ghostly architecture. For a long time critics liked to explain this device in terms of 'the human situation', in one way or another, with allusions to Kafka, the Sartre of *Huis Clos*, the *néant* of existentialism, and other topical fancies. Bacon had seen it rather as a simple way of isolating the figure and ensuring for it our full attention; but towards the end of the 1950s he began to work on new ways of achieving this end – or, rather, he began to work on ideas which demanded a different presentation.

Examples are the *Lying Figure* (1958), which called for a strong, even light and a firmly handled, sarcophagus-like structure in the foreground; and that 45 painting's namesake of the following year (the most successful, by the way, of his first group of female nudes), in which the figure sprawls on a sofa, head downwards and planturous pink leg in the air, across a background laid out 53 in broad horizontal bands of colour. In the *Man with Arm Raised* (1960) the space was hinged, and in the *Walking Figure* of the same year it was divided by a screen which marked off the right side of the canvas. In both cases the figure itself moved into an articulated space, and those articulations served to site it more ambiguously than was possible in the earlier cage- or box-like structures. An element of doubt and instability entered into the painting, as it enters into a movie-still if we have not seen the movie and are not sure what has happened before or what will happen after the moment portrayed.

Perhaps it is worth adding that the severe verticals in both these last paintings have a likeness, coincidental or not, to the majestic ordering of space which Barnett Newman had achieved in his paintings of the 1950s. To 53 put it another way, Bacon's *Man with Arm Raised* looks as if he had managed to swing open the right-hand section of a Newman as the rest of us swing open a door. Newman was in the 'New American Painting' exhibition which came to the Tate Gallery in 1958; and although Bacon is no great admirer of the artists in this exhibition, there is no doubt that he gave them his usual penetrating attention. ('Remember that I go to see *everything*' he replied when someone remarked on an unexpected affinity of this sort.)

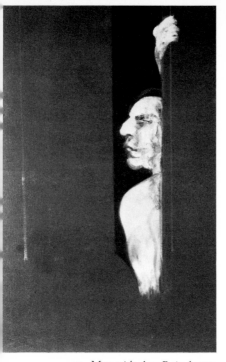

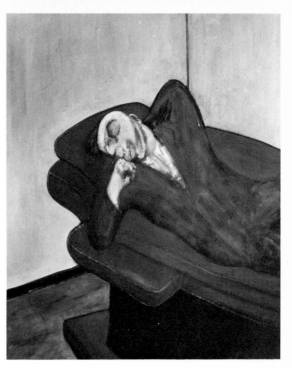

53 *Man with Arm Raised* 1960 54 *Lying Figure* 1958

But to my mind the key-painting of this transitional period is *Miss Muriel Belcher* (1959). Miss Belcher is the redoubtable proprietor of the Colony Room Club, an establishment much frequented by Bacon and valued by many as much for its owner's lively and uninhibited turn of speech as for its conspirational lay-out and adroitly varied membership. The portrait is remarkable, first, for the saturated green-against-green of the background; and, second, for the monumental thrust of the neck and throat as Miss Belcher swings round to confront an unseen interlocutor. In two male heads from the same year Bacon attempted a comparable freedom of manipulation, but there is no doubt that in the portrait of Miss Belcher the play of instinct is very much freer and more eloquent. The final image has, in fact, precisely that succulent ferocity which we find in the heads of the 1960s. The reds are temperamental, rather than descriptive; and the turbulence of the paint in the face and neck is the more striking by contrast with the flat calm of the background. The painting is not 'like' Miss Belcher in the Passport Office's sense, but it leaves an unforgettable impression of a certain

55

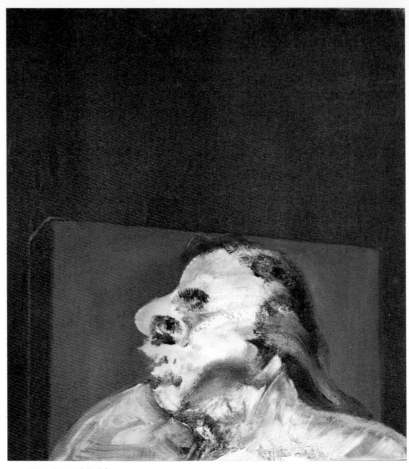

55 *Miss Muriel Belcher* 1959

neck, a certain nose, a certain hair-line, a certain set of eyebrows. Looking at it, we understand what Bacon meant when he once said in conversation that whereas in Shakespeare's time 'To be or not to be' was a phrase that really struck terror into the audience, the painter today has to take 'To be *and* not to be' as his central problem. In other words, the marks on the canvas have to make the image, but they also have to not-make it: to marry the already-said to the never-yet-said in such a way that each fortifies the other. Of this problem, *Miss Muriel Belcher* seems to me the first complete expression. The head is human, and yet there is something about it of the brisk upward turn of the homing shark. It is Experience made visible: nothing is burked, and nothing is done for sensation's sake; the feeling is deep and true.

Bacon likes, as I have suggested, to raise the stakes before a major exhibition. Pictures, at such a time, arrive too late to be catalogued and with the paint still wet. Or they turn out to be what he calls 'freaks' – paintings in which the precipitation of instinct is unusually intense and results in work which displeases him less than usual. (The word 'freak', here, applies to the degree of success and not to the subject-matter). 'I don't know, and I never know, quite how the image will come about. If I did know, I should become just an eccentric illustrator and I could never surprise myself.'

One of the paintings which Bacon regards as freaks – paintings, that is, in which everything seemed to go right – is the *Three Studies for a Crucifixion* 14 (1962), which was done just in time for the Tate Gallery retrospective of 1962 and is now in the Guggenheim Museum in New York. 'A crucifixion', here and elsewhere in Bacon, is not a descriptive title, and still less is it a reference to an actual event. It is, rather, a generic name for an environment in which bodily harm is done to one or more persons and one or more other persons gather to watch. 'It may be unsatisfactory.' Bacon said to David Sylvester in 1963, 'but I haven't found another subject so far that has been as satisfactory for covering certain areas of human feeling and behaviour.' He also said on that occasion: 'One of the things about the Crucifixion is the very fact that the central figure of Christ is raised into a very pronounced and isolated position, which gives it, from a formal point of view, greater possibilities than having all the different figures placed on the same level. The alteration of level is from my point of view very important.'

This particular painting is one of the few for which Bacon has given a direct historical reference. The right-hand panel is based, that is to say, on Cimabue's *Crucifixion* and is an attempt to find an equivalent in other terms for the undulatory downward movement of the figure on the cross – the 'worm crawling down the cross', as Bacon sees it. And, of course, it also has to do with Bacon's belief that 'we are all carcasses', sooner or later; Harrods' meat department can in fact claim equal rank, almost, with Cimabue in the derivation of this image. (Bacon also mentioned, in 1963, a book called *Positioning in Radiography* which he has kept by him for a long time, both for the X-ray photographs and for the repertory of positions in which X-rays should be taken.)

Carcasses as such recur in the left-hand panel of this triptych, while the centre panel is occupied by one of the bloodied human figures which Bacon liked at this time to set down on the broad oval of his own unmade bed. Other preoccupations of his which find a place in the triptych are the notion of the shadow, the notion of the onlooker, and the notion of the window which can be read as closed but can also be read as looking out on to a world in darkness. The snouted shadow in the right-hand panel, the ambiguous

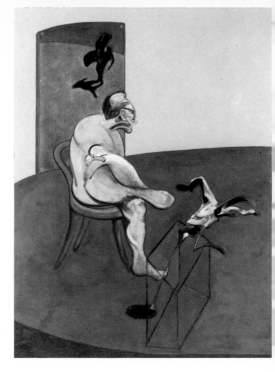

attitudes of the two figures in the left-hand panel, and the strange form (like a protruding tongue) of the bed-throne on which the central figure lies – all were to recur in the triptychs of the later 1960s. What he went on to achieve was, however, a much greater clarity of internal organization as betweeen one panel and another. The Guggenheim triptych has a very considerable power when we come upon it on the ramps of that egregious building, and the two figures on the left are susceptible of so many interpretations, all of them quite plausible, that we must rank them with Bacon's most fertile essays in ambiguity. But if we set it beside the triptych after *Sweeney Agonistes* of 1967 or the *Two Figures with Attendants* of 1968, the Guggenheim triptych does look rather like three canvases which have been assembled in a largely fortuitous way. As the decade went on, Bacon began to attach more and more importance to the idea of the triptych – partly, perhaps, because the gamble was on so much larger a scale, partly because it was possible in a triptych to give a compartmented view of life. Bacon lives his own life on many levels and takes care to keep them apart from one another; and in the triptychs, as in life, there are those who do (or are done to), there are those who look on, and there are those who pass by in the street below, or on the far side of the open window.

114

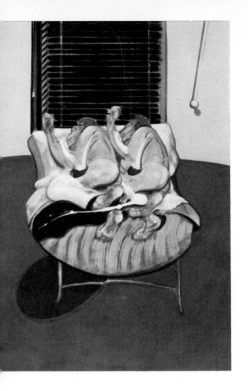
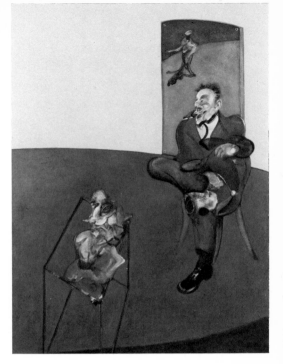

It was towards the middle of the 1960s that Bacon broke away from that tradition of European painting by which, in most single-figure subjects, an unspoken 'Look this way, please!' has passed between the one who paints and the one who is painted. This is not to say that in all such paintings the sitter faces the observer, eye to eye; but rather that a kind of magnetic pull draws one to the other. It is as rare for the observer genuinely to eavesdrop on the person portrayed as it is for a visitor to come into the room and find himself ignored by his host. There are exceptions: Tischbein's drawing of Goethe looking out of the window in his lodgings in Rome, for instance. Goethe here is not the elder statesman of German letters, but the eager young northerner, still only half dressed, who cannot wait to get downstairs to see what is going on in the street below. But, in general, painting is a form of social contract: people do their best for the painter, even if their best is not what he is after. Even the most hallucinatory of Bacon's earlier paintings retain this residuary formality; a gleaming eye, full front, acknowledges the painter's presence.

Three Figures in a Room (1964) was bought by the French Government in 1969 after the subject-matter of its left-hand panel had caused many another potential buyer to greet it with a reluctant 'Yes, but then again No.' In that

57

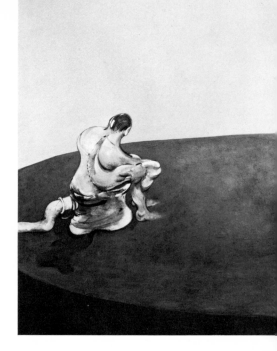

panel, a naked man is sitting on the lavatory, and sitting in such a way that he and the lavatory are one. His flanks merge with those of the long white basin; it seems to have, as much as he, a firmly modelled white leg; we could almost believe that one day they will change constitutions, so that the lavatory becomes a vertebrate creature and the man a curved, ridged, sloping-shouldered piece of custom-built porcelain. But the immediate point, here, is that the man does not acknowledge the painter's presence: Bacon has reinvented the relationship between the painter and the thing painted in a way that has to be done every two or three generations.

It had last been done, I think, by Degas. The painters in between had, indeed, gone backwards from the point reached by Degas. Cubist portraits by Picasso and Braque are, for instance, a throwback to Corot in their formal arrangement. Expressionism kept to the formal conventions of German nineteenth-century portraiture. Adventurous as they might be in all other ways, painters kept to the forms of portraiture, and of figures-in-an-interior, as they had existed for hundreds of years. Gauguin had tried to 'vindicate the right to dare anything', but in this respect he had dared nothing at all. Degas was the only painter who introduced a new set of relationships into the act of painting and being painted.

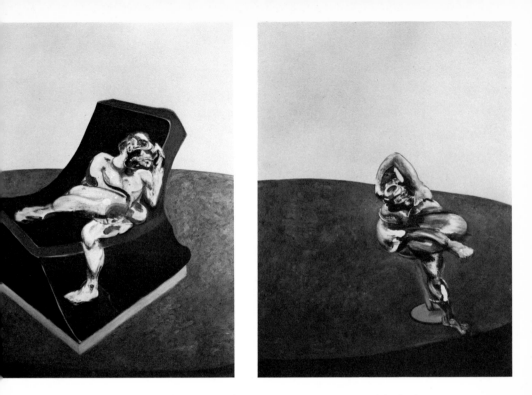

He did this, above all, in the pastels of women getting in or out of the bath, or drying themselves, or in other ways getting ready to face the day's traffic. He did this in such a way that all the usual apparatus of art-appreciation was suspended. The poses helped, certainly, for he took care to avoid anything that had overtones of high art. But, more than that, he was determined to stray into areas of involvement which had never been the subject of art before. He must have known that he had succeeded in doing this when J.-K. Huysmans wrote of his pastels, 'Never have works been so lacking in slyness or questionable overtones.' In many ways Huysmans missed the point. He thought, for instance, that Degas had deliberately chosen ugly women and forced them to pose in ways disadvantageous to them; and he thought that Degas glorified 'a carnal disdain, as no artist since the Middle Ages has dared to do'. But where he was quite right was in seeing that Degas had moved into a zone of total involvement, and that in that zone there was no room for beauty or ugliness, attraction or repulsion, decency or indecency. This is what Bacon also did, seventy-five years later.

As had happened with Degas, change of feeling brought about a change in the paint. Jean Sutherland Boggs describes how this affected Degas: 'About 1895 Degas did some of his most beautiful paintings of nudes. . . . The

exoticism of the colour was often quite independent of any literal description of a human figure in an interior. In the same way, other elements in Degas's work became increasingly arbitrary and abstract. Degas used the charcoal and the pastel as though they were abrasive tools, their rough hatching creating an atmosphere of friction around the body which is twisted into an unlikely, if not ungraceful position, caught between agony and ecstasy.'

Bacon has always been a great admirer of Degas's late pastels – both for the unique overtones of complicity which reverberate from even the most down-to-earth image and for the fact that when Degas had new things to say he accepted the challenge of finding new ways of saying them. 'You must know', he said in an interview with David Sylvester, 'the very beautiful Degas pastel in the National Gallery of a woman sponging her back. You will find at the very top of the spine that the spine almost comes out of the skin altogether, and this gives it such a grip and a twist that you're more conscious of the vulnerability of the rest of the body than if he had drawn the spine naturally up to the top of the neck. He breaks it so that this thing seems to protrude from the flesh. Now, whether Degas did this purposely or not, it makes it a much greater picture, because you're suddenly conscious of the spine as well as the flesh which he usually just painted covering the bones.'

57 Harking back to Dr Boggs's description of Degas's nudes, and reading it with the left-hand panel from *Three Figures in a Room* also in mind, one can recognize in both the Bacon and the National Gallery pastel the patches of exotic, non-literal colour, the 'atmosphere of friction around the body', and the 'unlikely' position, 'between agony and ecstasy', into which the body has been twisted. Bacon in this panel created a centaur for our own time, a creature half man and half not; and in doing so, he, like Degas, trespassed in zones of feeling which painting had not previously marked out for itself.

It was absolutely essential to Bacon's continuance as a painter that he should go on finding new zones of this sort. At the time when this triptych was painted he had been in the public eye for the best part of a quarter of a century. Most museums of consequence had at least one painting by him, and most people who were interested in painting had a generalized notion of what 'a Bacon' was. Now, it is important to the security of painters in their fifties that they should have established a certain relationship with the public: they need it themselves, in dry periods, and the public needs it for purposes of identification. Bacon's particular problem is that although many people did by 1965 have a clear notion of what 'a Bacon' was, it was his constant purpose to prove that that notion was wrong. In so far as they could pin him down, he had failed. If they could describe the effect of his pictures, or of any picture by him, in terms of sensational subject-matter, he had failed. And he had also failed if they could predict what his next picture would be like, or

what its effect would be. In the case of most big painters there is a tidal element in their relations with the public: the modes of feeling which they established in earlier years go on pulling even if the immediate flow of the work is in another direction. Their work is also likely to reverberate in the work of others, so that it comes to have a multiple existence. It exists so strongly, in fact, as to challenge the identity of the work around it. If we take away from French paintings of the 1920s and 30s the presence of Picasso, the presence of Matisse, the presence of Braque, how many will be found to stand up undiminished?

But Bacon's influence, in so far as he had one, was not of that order; nor was others' influence upon him, in so far as it existed, of that order. Bacon grew up in a period when the great living masters permeated the art around them in the way that the Atlantic Ocean permeates Nantucket Island or the North Sea permeates Cuxhaven. It could also be said of our century that almost without exception the big changes in art have been wrought by groups of artists working together in one form or another of free association. This was true of fauvism, and of cubism, and of the Brücke and the Blaue Reiter, and of surrealism, and of neo-plasticism, and of constructivism, and of abstract expressionism, and of post-painterly abstraction, and of later movements also. The association may have been as close as that of Picasso and Braque, or as informal as that of what the Americans loosely called Pop artists. It may have depended in the last resort on a place, like the Bauhaus, or on an individual who was not himself primarily an artist, like André Breton or Clement Greenberg; but in every case it was too much to expect that any one man should bust art, and bust society, single-handed.

With Bacon in his forties and fifties there was none of this. In his twenties the friendship of Roy de Maistre had been important for him, and in his thirties he had for a time been close to Graham Sutherland. Picasso was present to him, as a *grand aîné*, throughout the time when he was looking for his own identity as a painter. Lucian Freud knows him as well as anyone, and Freud's gift for what can best be called metropolitan pastoral – for figure-subjects set, that is to say, in an interior tufted with *Zimmerlinden* or spiky with pandanus – in some ways runs parallel to Bacon's preoccupations. But whereas painting for Freud is an ordeal of patience, an affair of session after unsparing session in which the image is built up as a hare might build the Pyramids, Bacon likes to set up a subject in his mind and go at it *prestissimo*. Bacon has for many years been a friend of Frank Auerbach, and more recently of Richard Hamilton, but in both cases the alliance is based rather on the pleasures of intelligent conversation than on a shared aim at the easel. The fact is that since Bacon marked out his own style – since 1945, let us say – he has been a man on his own. He has friends, but no disciples. What he does is

not transferable. Once or twice in large, mixed international exhibitions an emulator has disclosed himself with an effect uniformly laughable; but in general Bacon works in a state of moral isolation from what has been accepted elsewhere, over the last twenty years, as 'the new art'.

I don't think, as I said earlier, that Bacon wholly dislikes being in the situation of Thomas Hood's 'Last Man in the World'. If anything, he often likes to exaggerate it. 'Who ever heard', he will say, 'of anyone buying a picture of mine because he liked it?' Nor is it at all his style to band together with the other artists of stature who have kept the tradition of the figure alive since 1945: Dubuffet, or Balthus, or de Kooning, or Kokoschka. He is as hard on their works as he is on his own. (Among younger English artists Michael Andrews comes nearest to getting a good word from him.) Bacon in most respects is more stoic than romantic; but just as he rather enjoys slipping from one world into another at midnight, and appearing in each of them as a man momentarily adrift from the other, so does he take a certain pleasure, if I am not mistaken, in appearing in any gathering of artists as a man apart. (What could be said, in this context, is that he would have liked greater elasticity and resilience in argument than can usually be found in London.)

There is no such thing, meanwhile, as a major work of art that was produced in isolation. Bacon steeps himself in what is going on around him, even if the steeping is usually followed by a thorough decontamination. It has certainly not escaped him that the triptych, as such, was used to considerable effect by Max Beckmann, in *Departure* (1932–33), *The Actors* (1942), *Blindman's Buff* (1945), and *The Argonauts* (1950). (Kokoschka's *Thermopylae* triptych of 1954 should also be adduced.) Michael Andrews's *All Night Long* (1963–64) was an attempt on a comparable scale to make a complex statement about society. It may be a mere coincidence that four triptychs were included in the Beckmann exhibition which came to the Tate Gallery in 1965. Certainly Bacon did not in the least degree 'take from' Beckmann; but we can at least point to the parallel regard for human dignity with which Beckmann worked away in occupied Amsterdam on one triptych after another. 'With furious tension', he wrote in his diary, 'one waits for the explanation of the secret. I *believe* in the unknown.'

'Furious tension' is just the phrase for the state of mind in which Bacon works on his own triptychs, even if the image which results has nothing of the heavy-breathing sententiousness of Beckmann, and nothing, either, of Beckmann's feeling for symbolic fancy-dress. 'Belief in the unknown' – or, rather, faith in what the unconscious will dredge up at the critical moment – likewise plays a part in Bacon's procedures. The triptych as such allowed him in the 1960s to pay out more and more rope in the hope that the sea-monster on the hook would be the white whale that no single canvas could encompass.

Between four walls

At the beginning of the 1960s there was, as I said earlier, a new freedom and a new largeness of expression in Bacon's work. The Tate Gallery's *Seated Figure* of 1961 is, for instance, quite a different thing from the seated male figures of 1953. Sickert himself could hardly have accommodated more factual information than is here on offer. We know the man's taste in shirts and shoes; we could price the Turkey rug; the turned legs on the empty chair can be read quite easily. The prime element in the painting may be the multiple image of the head, but the chromatic impact is many miles away from the North Sea greens and the *Tailor & Cutter* blues which Bacon had kept to in 1953.

58

A no less telling example of this new tendency is the *Man and Child* of 1963. Bacon has dropped, once again, the darkling geometrical foreground of his earlier paintings. In its place is a swept-wing-shaped area that pushes up towards the left-hand top corner of the painting. That area is not entirely flat, because the man and his chair are set on a platform which looks to be about nine inches high; but the carpet carries on over the platform, just as it does in the furniture shops on the Tottenham Court Road, in London, and on many another metropolitan street that is not quite either Bond Street or Park Avenue. The carpet itself is of a particularly hideous kind. Having once or twice espied Bacon walking by himself in just such a street as the Tottenham Court Road, I know with what a concentrated and baleful stare he examines shop-windows of this sort. (There are no carpets in his own apartment.)

17

After the carpet, we notice the white area against which the man's head stands out. It could be a window, or a screen in a private cinema, or the white sheet on which images are thrown in an interrogation-cell. All here is ambiguity, as it is also in the relationship between the man and the girl. No one interpretation fits that relationship. Is the girl standing in disgrace before her unforgiving father? Is she the man's jailor, outfacing him with folded arms as he writhes in his chair and looks the other way? Is she an abnormality, a physical freak returned to haunt him, or is he a man set on high, a judge who will shortly pass sentence? We shall never know, and we shouldn't even ask to know. The picture is complete in itself, and the last thing Bacon wants is for us to read it as story-telling – or, as he once described it, as something that would 'tell you the story through a long diatribe in the brain.'

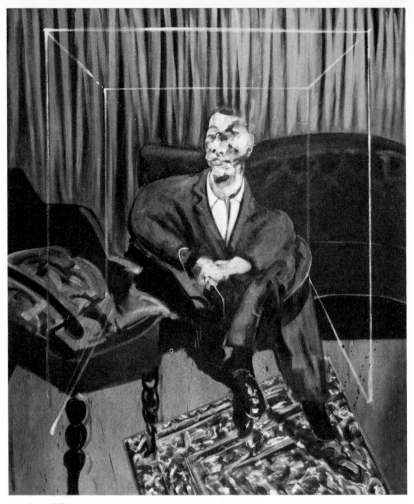

58 *Seated Figure* 1961

This (1963) was the year in which Bacon said to David Sylvester that he loved 'the story and the sensation to be cut down to its most elemental state. That's how one longs for one's friends to be, isn't it? One can do so much without the padding. If they would only just give themselves straight and tell the story as precisely and as deeply as one longs for, so that you have the very precise story, which is deeply complicated, and so difficult to find.' It was around this same time that Bacon did indeed begin to portray some of his friends in their 'most elemental state': above all, in the single heads which have formed an important part of his *œuvre* ever since.

These heads got really under way in two groups dated 1963: the *Portrait of Man with Glasses, I–IV*, and the *Three Studies for Portrait of Henrietta Moraes*. They relate, of course, to the reworkings of the human head which Picasso has been producing since 1907. They also relate, though at a further remove, to the portrayal of successive movement which began with Muybridge and played a spectacular part in Marcel Duchamp's *Nude Descending a Staircase*. But there are also important points of difference from both these forebears. Picasso pulled the human head about with a freedom and an implied savagery which could hardly be surpassed; but when he put it together there resulted most often a monumentality, a look of inevitability and resolution, which are not a part of Bacon's intent. Picasso's heads could often be reproduced in sheet-iron without any real loss. (The Chicago Civic Center sculpture of 1965 can, in fact, be read as a reproduction of this kind.) Bacon's heads by contrast are pure painting and could not be transposed into any other medium: the thing said and the way of saying it interlock completely. 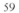 59

Duchamp's *Nude* is, once again, quite another thing. Duchamp was not out to investigate character, except in so far as everyone reveals something of his character by his way of walking downstairs. He was interested in process as a subject for painting, and in the way in which a human body makes a coherent structure when it walks downstairs, even if that structure is never revealed completely at any one moment in time. Bacon's object is not to show successive appearance, but to superimpose appearances, one on top of the other, in ways different from those vouchsafed to us in life. Henrietta Moraes in the *Three Studies* of 1963 is not moving from left to right or from right to left. Bacon is restating the facts of her appearance in ways which correspond to no one sequence in life but do none the less, or all the more, reveal her in the 'most elemental state' which he spoke of in 1963. 59

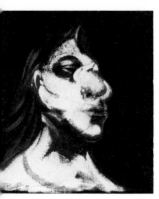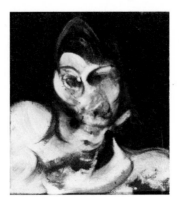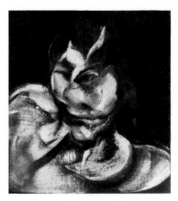

59 *Three Studies for Portrait of Henrietta Moraes* 1963

It is worth saying again that Bacon does not regard any of his heads as nightmare images, or as portraits of degradation, or as any of the other things which legend attributes to them. There is nothing gratuitous or wilful about the distortions which he imposes upon the sitters' features (not least, his own). Anyone who knows even one of the sitters will end by agreeing with him that, although the features as we know them in everyday life may disappear from time to time in a chromatic swirl of paint or be blotted from view by an imperious wipe with a towel, individual aspects of the sitter are shown to us, by way of compensation, with an intensity not often encountered in life. The eye, above all, has a way of fixing us with an urgency which we cannot forget. The mouth is realized, from time to time, with a vitality that makes ordinary portraiture look vapid and deceitful. The way hair sits on a scalp, the double tunnel of the nostrils, the interlock of colour and substance in flesh which is thoroughly aroused – all these come out in the single heads, and come out in ways which make talk of 'distortion' and 'artifice' seem quite ridiculous.

These pictures stand up, therefore, as representations of known persons. They do not offer us a walk around these persons, according to cubist practice. Nor do they show them in serial guise, as would happen if successive frames from a movie were spread out, fan-wise, before us. They offer a superimposition of states, in which certain characteristics of the person concerned appear with exceptional intensity, while others are obliterated. Risk is built into the picture; without it, this way of painting would soften into a decorative convention. It follows from this that some of the heads are very much more successful than others: Bacon's procedures in the 1960s run parallel to the dizzying reversals of fortune which occur in gambling.

In the pursuit of what Lawrence Gowing calls the 'pigment-figment' of people whom he knows very well, Bacon is, of course, sustained by skills acquired over more than a quarter of a century; but the supreme success – the image unlike any other, the unspoken truth made visible – depends on his not allowing habit to take over. Portrait-painting as Reynolds and Lawrence knew it was akin to the long slow haul towards bourgeois prosperity: their skills accumulated like money in the bank. Bacon's attitude has always been nearer to that of the gamblers whom Tolstoy sat up with while serving in the Caucasus. A glass too many, an unthinking throw of a card, an imprudent faith in a horse or its rider, and such people were ruined. Experiences of that sort had been fed into Bacon's imagination over and over again: and, with them, the collapse in the persons concerned of all social façade. Gamblers are natural nomads, not least in matters of the heart. Bizarre passions spring up among them, are quickly slaked, and fade away without a trace. Alliances, like fortunes, turn on the fall of a card. Promises turn out to be written in

water, and what looks like a stable, unified, consistent human being turns out to be fugitive and polyvalent. The more conspicuous, in all this, are the rare, impregnable, clairvoyant natures. They can be called heroic; and Bacon's paintings in the middle and late 1960s are as much about heroism as they are about heroism's alternative, passivity.

Heroism traditionally calls for the Grand Manner. But heroism and scoundreldom can co-exist, as the Greeks knew better than anyone. Heroes can be lewd, lazy, and dishonest: the traditional Grand Manner cannot accommodate such traits. David in the *Oath of the Horatii*, Delacroix in his *Liberty in 1830*, present us with heroism purified: all energy, all selfless leadership, all high intent. When Venus brings arms to Aeneas, in Poussin's painting in the Louvre, it does not occur to Poussin to suggest that Aeneas may have sat up too late the night before. Today such idealization would be matter for mockery: Brecht, for one, killed it off. But heroism with a small 'h' is still a characteristic of some human beings, and a figurative art has to find ways of dealing with it. It is one of the strengths of Bacon's painting over the last few years that it makes vivid for us the persistence of this trait in human nature. The hero may be massive, contained, and slow to anger. He may be an evident scamp, a quicksilver deceiver. Either way, Bacon brings him before us, unidealized, in ways which compel our acceptance.

There are women-heroes, too, in Bacon, just as there are paragons of energy and ferocity among the Amazons in the fourth-century frieze from the Mausoleum of Halicarnassus. Bacon doesn't care too much for Penelope, I suspect, but Ulysses in female shape will always interest him. She will win his attention even after death, as she lies disembowelled on an unmade bed, or *in absentia*, if she can be presumed to have been killed on board the Blue Train and pushed out of the window. One of the finest of all his paintings is the *Isabel Rawsthorne in a Street in Soho* of 1967. If the painting were to be transposed in masculine terms, that proud, watchful, experienced figure could be a great captain on leave: a lifelong single-handed adventurer stepping out from a blue-awninged restaurant after an unusually good luncheon, with a rakish open roadster of antique design drawn up at the kerb and a searching, unembarrassed glance at the people who have stopped to see him/her get in and drive off. 20

This is one of the paintings of the 1960s in which Bacon combined a rigorous attitude to the human head with the wish to situate a complete human figure in a fully realized environment. No longer content with the vague indications of the 1950s, Bacon tended more and more to drag his figures into the light. Coincidentally he seems to have decided that in certain canvases one figure was not enough for what he had to say: the *Three Studies for a Crucifixion* (1962) formed a triptych, the first since 1944 and the first of a 14

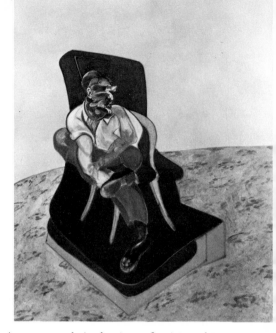

60 *Three Studies for Portrait of Lucian Freud* 1966

series that shows no sign of coming to an end. At the time of writing, thirteen triptychs are in existence, and at least one other was painted and has been either broken up or destroyed. They have this in common: that each one of them is an attempt to reassert the primacy of the fully modelled three-dimensional figure in a world attentive to the ideology of the flat-patterned non-illusionistic abstract painting.

As I said in the preceding chapter, this is the period in which Bacon thought seriously of making sculpture. Looking at the triptychs in sequence, we can see that this preoccupation counted for more and more in the

60 paintings until in the *Three Studies for Portrait of Lucian Freud* (1966) the three-fold figure seems to be pulled towards us by imperious but invisible ropes of elastic. The third dimension, shunned by abstract painters as an obsolete deception, is here the main subject of the painting: the foreshortening of the legs is, indeed, so violent that we feel as if the sitter will send us flying if we get too near to the canvas.

The triptych in itself arose in earlier times from the idea that a portable image should be hinged in such a way that the two outer wings would fold over the central one. Safety and convenience would alike be furthered by this device. The central image became the one on which most attention was concentrated, while the images to right and left were taken up either with

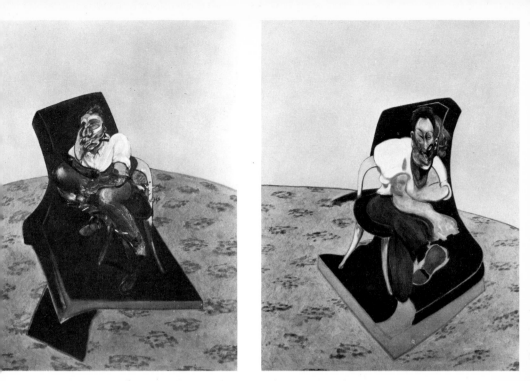

cognate matter of an imaginative sort or with portraits of donors in fancy dress. The donors, in such cases, look to later eyes like privileged voyeurs – as is the case, for instance, on the left-hand panel of the Ingelbrecht altarpiece by the Master of Flémalle in the Metropolitan Museum. Whether those two devoutly kneeling figures can see round the edge of the half-open door is not quite clear to us, but that they are sanctified eavesdroppers is beyond question; and Bacon in his triptychs plays over and over again with the idea of the eavesdropper – the figure who looks across to the central panel and directs our attention to it. His exact role varies from painting to painting, but in general he is close to the action but not of it. More involved than ourselves, he yet shares our immunity. If there is bloody work to be done, he will take no part in it. If what is at hand is a party of pleasure, he won't get to make love, either, but will have to sit on a chair, dressed or undressed, and be content with a watchman's role.

In the first of the series, the Guggenheim Museum *Crucifixion* (1962), 14 Bacon does not centralize the action. The dangling carcass on the right-hand panel, with its exposed rib-cage and wide-open human mouth, is quite as arresting as the slaughtered figure in the middle – more so, in fact: its half-human, half-animal quality and its mysterious appurtenances give it an altogether weightier claim on our attention. The Guggenheim triptych

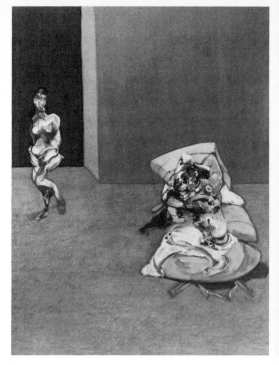

61 *Crucifixion* 1965

seems to me to have a lateral left-to-right movement: the central panel does not have the magnetic pull which it has in the other triptychs. Bacon discourages literal readings of any sort, but we can none the less think of this picture as sequential in time. The two ghouls on the left would, on this reading, be an updated Burke and Hare, a pair of thigh-booted anatomists bent on moving from one indignity to the next. But perhaps this is another way of saying that this first triptych in the series does not work very well as a triptych and too easily breaks down into a series of lurid episodes.

61 In this respect the Munich *Crucifixion* (1965) marks a substantial advance. There is no doubt, here, as to where the key-point of the action falls. That up-ended carcass with its pinioned arms and ripped-open gut is not going to loosen its hold on us. In the right-hand panel are what would, in the Flemish fifteenth century, have been two donors. Propped on a secular altar-rail, they look like two Australian out-of-towners who have dropped by to see a not very good cricket match. Their lack of outward concern is far more telling, in its context, than any sensational posturing; and one could say the same of the almost naked girl who trips past the corpse in the left-hand panel. The Munich *Crucifixion* does on the other hand seem to me to be flawed by the introduction of a Nazi armband in the right-hand panel. Much of Bacon's power comes from his refusal to say outright that 'This man is bad';

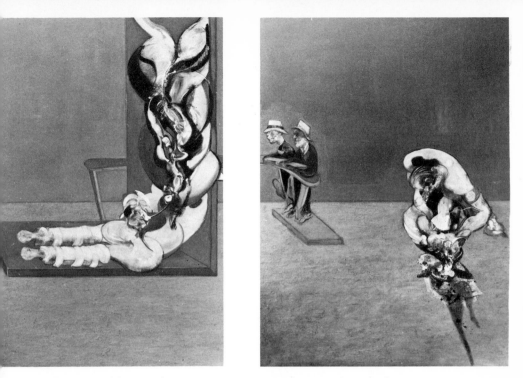

a localization of this sort buys a prompt response but pays heavily for it in
terms of a loss of universality. (Characteristically, Bacon says of this figure
merely that 'I wanted to put an armband to break the continuity of the arm
and to add that particular red round the arm.')

It had been Bacon's ambition for a long time to be able to handle a number
of figures in one and the same painting and yet not introduce the element of
story-telling. If he got near to this in the Guggenheim triptych, that picture
was also, in another way, a backward glance. It had to do with subject-
matter, and with a title, 'Crucifixion', that he had tackled several times
before. He never sets out to shock, but the picture did undoubtedly prompt
people to think back both to the last days of Nazidom and to a particularly
gruesome series of murders which had happened in London in the 1950s. It
had, in short, an element of adventitious horror. That horror was offset in the
Guggenheim triptych by a certain distancing: the girl on the left and the two
men on the right went about their business, or their lack of business, much as
in Callot's *Misères de la Guerre* people go on as usual while other people are
hanged by the neck all around them. Bacon does not dissociate pleasure from
pain and can imagine that as a matter of plain fact people should literally 'die
of love' – be beaten to death, that is to say, in the course of transports that get
out of hand. But the pictures did, even so, bear a sensational interpretation.

129

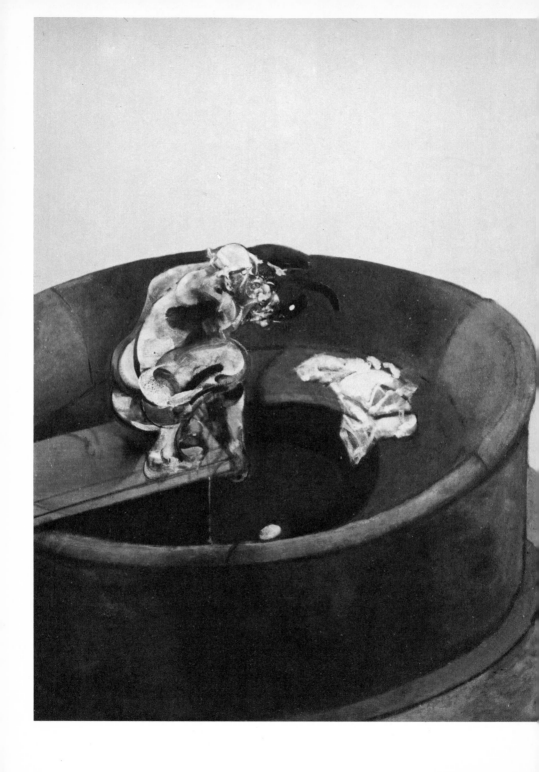

This is not the case with the later triptychs, and it is not the case with the group of single-canvas images which he invented in 1966–67. One of the most remarkable of these is *George Dyer Crouching* (1966). Nobody gets knocked about in this painting; there are no armbands or hypodermic syringes; yet the image is immensely arresting and even its constituent parts have the poetic ambiguity which Bacon desiderates. That strange and apparently circular construction must, for instance, be a sofa of modish design – salvaged, conceivably, from one of Bacon's forays into the furniture-shops. But as treated by him it turns into a blocked-up well: a well-upholstered point of no return. George Dyer is crouching on what must be a coffee-table; but, once again, that table is metamorphosed into an indoor diving board, tailored for the diver who had nowhere to go. As for the figure itself, it reminds us that Bacon has been a lifelong student of the wild-animal image. He has stalked the revealing photograph as persistently as the hunter in the jungle stalks the living prey. The figure is distinctively human, on one level; but on another it exemplifies the patience and the immobility of the jungle-creature for whom time has dimensions irrelevant to those of human life. The figure in the painting has nothing to do and nowhere to go. The evident coiled power within him has no outlet: his activity, such as it is, is dissociated from any imaginable rational end. He is Expectancy betrayed, and Vigilance made mock of, and Vitality gone to rot. Yet he is completely compelling.

Why should this be so? For two reasons. First, Bacon has invented for him a set of circumstances which leaves us for ever uncertain as to what is going on. Is he really going to crouch there for all eternity, as a caged animal wastes away in the zoo? Or is that solid-seeming floor a trap, delicately sprung, through which he will presently disappear? Is he there of his own free will, or is there somewhere behind him an overseer, out of sight? It is as impossible to know as it is impossible not to speculate.

The second reason for this painting's particular fascination is that in the painting of the head Bacon brought off one of the most complex of his achievements. Perhaps this is the first time in more than fifty years that someone invented an entirely new way of portraying the human head. When people say that Picasso's cubist portraits of Uhde and Kahnweiler now look more 'like' than many a formal photograph, this is in part a fact about our powers of assimilation: what they overlook is that those portraits incorporate a great deal of naturalistic detail and are a compromise between cubism and a purely traditional sign-language. Juggling with the elements of representation is one thing; reinventing the human head, quite another.

For what Bacon does here is not simply to rearrange the map of the head. That knotted handkerchief bestrides what is two things in one: a likeness of

◀ 62 *Portrait of George Dyer Crouching* 1966

an individual man and a likeness of a compound, metaphoric creature. To that metaphoric creature, jungle and veldt, butcher's shop and Large Mammal House, have all contributed. And, as happens in Kafka's *Metamorphosis*, the changes which the individual man has undergone make us see more poignantly into his nature, and into our own. That eye, for instance, islanded in a head the size of a leg of lamb: it speaks for a nervous system that goes on functioning, no matter how strange and terrible the pressures upon it. That nose, out front with a huge promontory of flesh behind it: for what sniffings was it fashioned? And that ear, pinned like a diminutive ear-ring just above the mountainous shoulder: what message can it be intended to receive?

This apparition could be no more than a far-fetched freak, a Grand Guignol figure from an out-of-date movie. It could be too explicit: the phrase 'to be and not to be' would then be shorn of its last four words. If it is none of these things, and if on the contrary it carries total conviction, it is because 'to be and not to be' really works, in this context. The image is nowhere fixed, finite, descriptive; and yet it tells us more fully and more truthfully than any conventional portrait what it is like to be a human being. It suggests to us that earlier images have been unwarrantedly bland in their presentation of human nature; and it also suggests that this particular new kind of presentation is something that only painting can do. Painting here reclaims its rights.

Those rights had lately been much eroded. They had been eroded by technology, which puts at our disposal a repertory of images more vivid and more comprehensive than most of what painting had to offer. They were also eroded by art-history, or by those who set up as its spokesmen: a non-referential art was mandatory in many quarters, while in others the image was acceptable only in ready-made form. Bacon regards even the best abstract painting as a superior form of decoration, and for what he calls the 'mixed-media jackdaws' he has very little time. Art, for him, is something to be made with art's own materials.

Towards the end of the 1960s Bacon began to exacerbate a relationship which at the best of times is never easy: that of the image with the thing which it portrays. Where in earlier years he had sometimes portrayed human beings as shadowed by a kind of after-image of themselves, he now began to put them into the same picture twice or even three times. These supplementary images can be read as a commentary on the ironies of representation, as when in the *Two Studies for a Portrait of George Dyer* (1968) the sitter turns away, with a whipping sideways motion, from the painted image of himself which has been tacked on to the green canvas which stands against the wall. When he whips back the other way, as in *George Dyer in a*

63

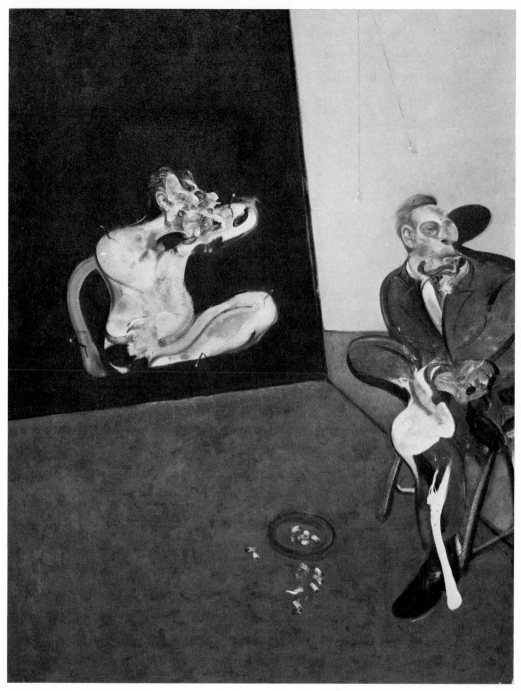

63 *Two Studies for a Portrait of George Dyer* 1968

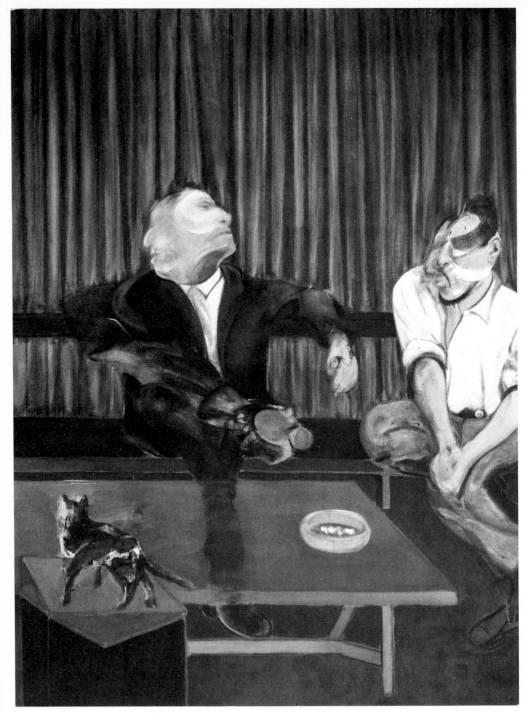

64 *Portrait of George Dyer and Lucian Freud 1967*

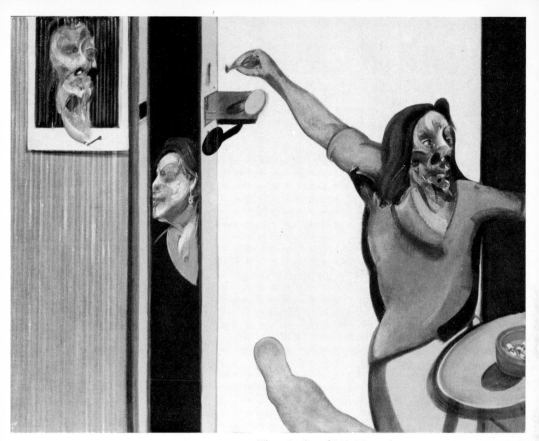

65 *Three Studies of Isabel Rawsthorne* 1967

Mirror (1968), he turns so fast that half his face and half his body goes on 66
ahead. When he looks over his shoulder at himself, in *George Dyer Staring
into a Mirror* (1967), it turns out that the 'mirror' is really a canvas-within-
the-canvas. In *Study for a Portrait* (1967) the subject lolls at her ease with three
little Bacons tacked to the wall behind her. In *Three Studies of Isabel* 65
Rawsthorne (1967) Isabel Rawsthorne has her key in the half-open door:
through it we see herself repeated, and she turns up a third time in a portrait-
on-paper tacked to the wall. Bacon used the device of the mirror, of the
tacked portrait on the wall, when it suited him. But with increasing practice
he began to pluck Likeness from the air, disdaining to furnish any
conventional explanation. Likenesses dissociated from their everyday
function began to turn up unannounced. Like statuettes, they perched on the

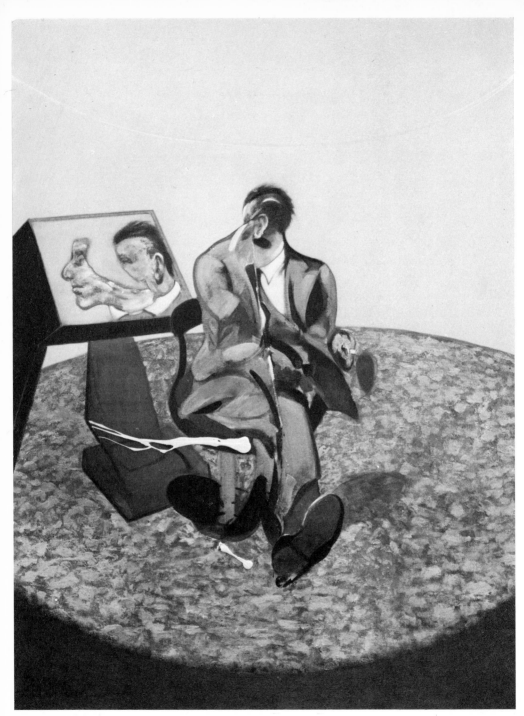

66 *Portrait of George Dyer in a Mirror* 1968

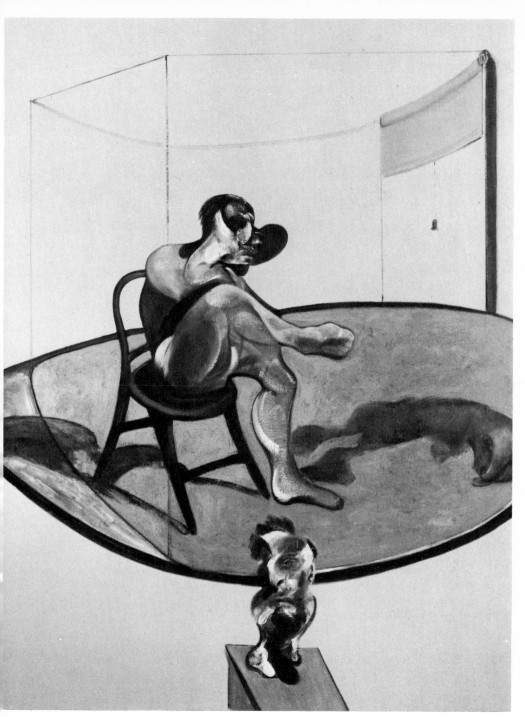

67 *Two Studies of George Dyer with Dog* 1968

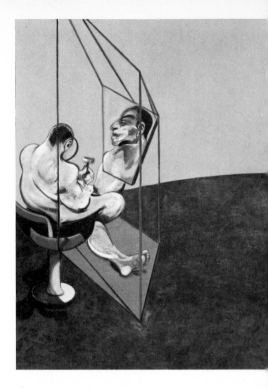

67 furniture in *Two Studies of George Dyer with Dog* (1968) and the triptych *Two*
56 *Figures with Attendants* (1968). It was as if the images went on making
themselves, in an autonomous way, irrespective of Bacon's first intention.

 This doubling of the image assumed monumental form in the triptych
68 *Three Studies of the Male Back* (1970). In the two outer panels, a man shaving
himself with his back to us is reflected in a magnifying mirror just above his
head. In the central panel the mirror is blacked out and the man is holding
one of the newspapers which turned up repeatedly in Bacon's work at that
time. The three backs are the main subject of the painting, and they are most
sumptuously rendered, with the kind of 'male voluptuousness' that Bacon
admires in Michelangelo. The cage-like surround which locates each of them
so precisely is not, of course, to be taken literally. It is simply a space-bending
device; and in conjunction with the mirrors – and with the reflection in the
mirror, where there is one – it pulls our attention back and back to the seated
figures. The two reflected heads likewise set up a magnetic field: we look
from them to the figures in question, and back again, almost as if it were in
our power to fit the heads to their respective bodies. Meanwhile the central
mirror has no reflection to offer, and we suddenly realize how gravely we
offend against an individual if we take away his face – even if, as in this case,

138

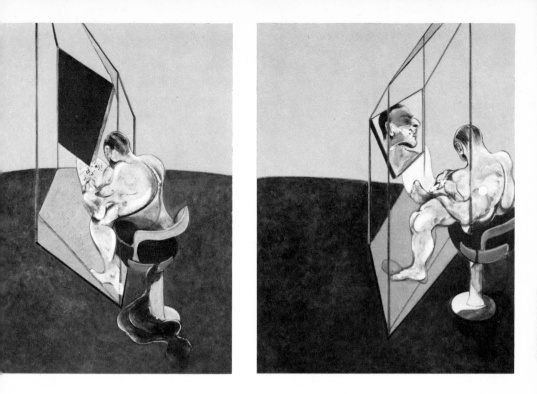

his back is more eloquent than most people's foreheads, noses, eyes and mouths.

Bacon in the late 1960s aimed, in any case, to make the whole body as expressive as is the face in traditional painting. Those well-armoured backs, those meaty and mountainous calves, those rumps up-ended in boisterous play – all contribute to the heroic image. In the clothed figures, equally, a rolled shirt-sleeve (as in the threefold portrait of Lucian Freud of 1969) or the way in which legs are crossed (as in the seated *Self-portrait* of 1970) can speak for natures revealed in their elemental state. As for the face itself, Bacon often at this time followed the maxim of the Captain in Strindberg's *Dance of Death*: 'Cancel, and pass on!' The cancelled and the surviving image co-exist in painting after painting: and nowhere more so than in the triple portrait of Lucian Freud and the group of small self-portrait heads which Bacon completed in 1969. The characteristic brush-movement of that time is the great turning swathe of colour which banks steeply as it turns: something of a sculptor's mark results. The eye and its socket, the cheek, the jaw, the junction of nose and brow – these are the points most likely to be scooped out of space. The mouth may appear twice or not at all. Cancellations in white and black may stand between us and what was once the image. And

60
75

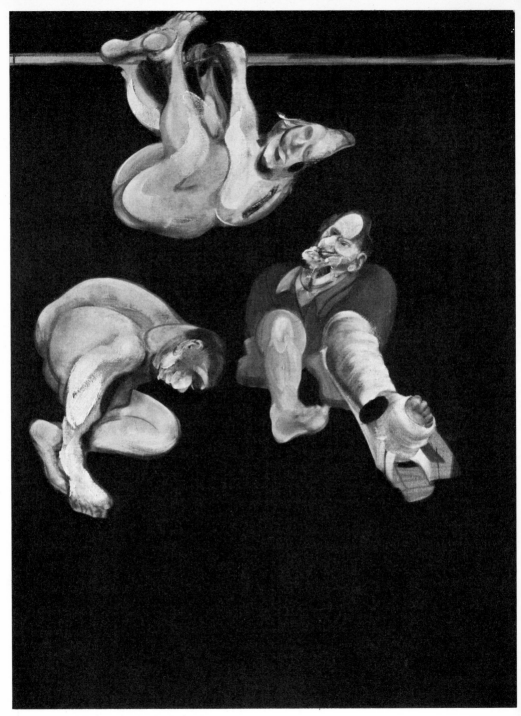

69 *Three Studies from the Human Body* 1967

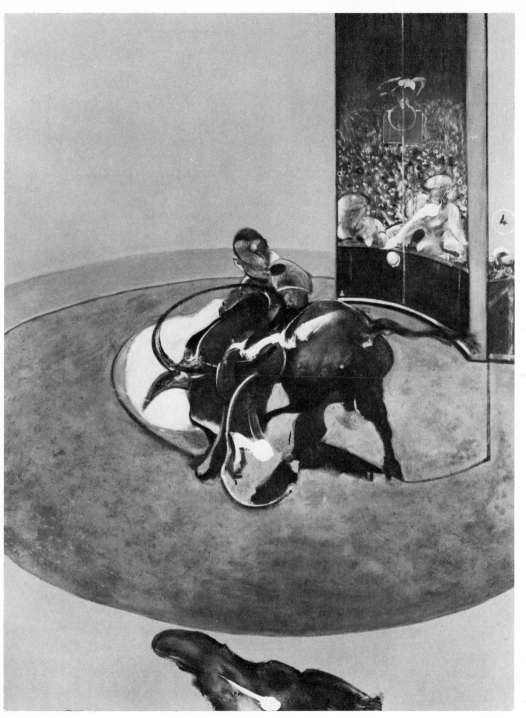

70 *Study for Bullfight No. 1* 1969

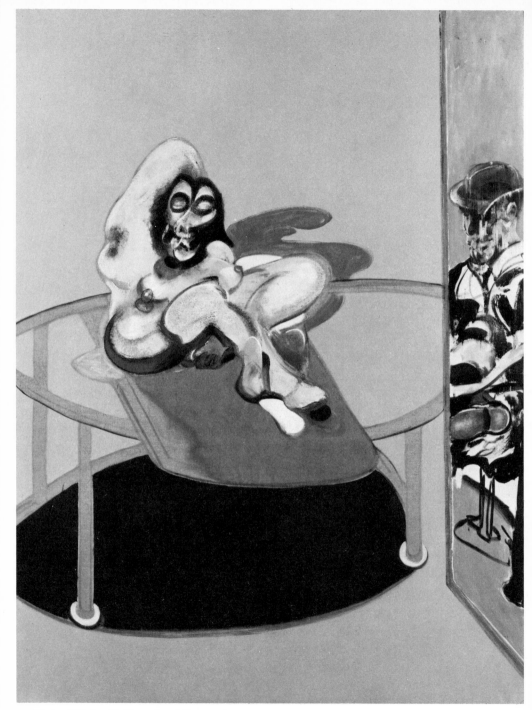

71 *Study of Nude with Figure in a Mirror* 1969

yet, somehow, the sitter is present as he is present to us in life, with part of him exposed and open and another part well below and out of sight.

As always, there were images in the late 1960s which seemed to come from nowhere. One of these is the group of *Three Studies from the Human Body* (1967). This is one of the most poignant and mysterious of Bacon's inventions. The three men could be acrobats in limbo, slowly recouping their powers after an accident which has left one of them seriously wounded. They could also be crazy people, like the ones whom Goya painted after he saw them at exercise in the courtyard of the asylum at Saragossa. Either way, Bacon isn't telling: doubtless the daydream-principle was in operation. But we are free to think that few paintings more vividly express the alienation of the individual.

There were also, as at all times in Bacon's career, projects which he finally discarded. One of these was for a triptych on the theme of bull-fighting. Bacon worked on this when he had the use, for a month or two, of a studio in the Royal College of Art; one panel used to hang in the Senior Common Room of the College. It was a difficult subject, in more ways than one. It was dramatic in a self-evident way. Goya had spent a lot of time on it. Kitsch loomed on the one side, and disadvantageous comparisons on the other. Bull-fighting is not, for any English person, a part of the inner life of the imagination, and there is something willed and adventitious about even the most learned English *aficionado*. Bacon is no expert, in any case, on the subject, and he likes it primarily for the decisions which must be made, and kept to, in situations as hazardous as any that we witness in peacetime. 'Bull-fighting is like boxing', he once said, in a phrase which Mérimée would have applauded, '– a marvellous aperitif to sex.' Like Mérimée when he came to write *Carmen*, he would have liked to convey the emotional climate of the bull-fight without ever describing it. But he felt that the pictures never quite came off: the load of association was too heavy.

The subjects which really did come off, in our estimation if not always in his own, were the concerted Scenes from Modern Life (my collective title, not his). Sometimes these were concentrated in a single canvas, as in the *Study of Nude with Figure in a Mirror* (1969). This shows a naked woman on a strange construction, half-springboard, half-stretcher. Facing her, and reflected in a mirror at the extreme right-hand edge of the painting, is the archetypal enquiry-agent: the bowler-hatted intruder, half *voyeur*, half inquisitor, who looks like a cut-rate Donor at the side of a secular altarpiece. Bacon always deals particularly freely with the female nude, often working from a set of photographs given to him by an obliging woman friend; and in this case the face has been remade in ways which recall the *Demoiselles d'Avignon*. But the real subject is the fact of intrusion: the complicity

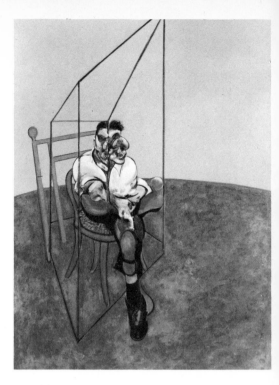

72 *Three Studies of Lucian
Freud* 1968–69

between the two figures, the refusal of 'shame', the role-playing on both
sides. We are left wondering if natural life – life as it is actually lived out,
without packaging – has ever been portrayed more completely in painting.

There is in paintings of this sort, and indeed in all Bacon's later paintings,
a psychological ambiguity so finely balanced and so complete that the
commentator is baulked from the very beginning. Bacon emphasizes this by
employing ambiguities of the picture-language, equally. Those curious
metal-like linear structures, for instance, have no architectural significance
for him and are simply ways of isolating the figure and putting it before us as
the lepidopterist puts a new specimen on a pin. But by 1970 they were more

24 than that: people began to sit on them, and drape themselves around them,
68, 76 and use them as we use a swing in a playground. He also began to tip space
sideways, if it suited his purpose, and to present us with images which could
be reflected up into a room from the street outside, or fragmented
in a mirror, or painted on a canvas-within-the-canvas. He used a hinged
aperture, over and over again, to give a look of conspiracy to the glimpsed
figures within. He invented, continually, new ways of defeating
expectation. Sometimes the figures were bodied forth three-dimensionally;
sometimes they oozed like gutting candles. Sometimes they were

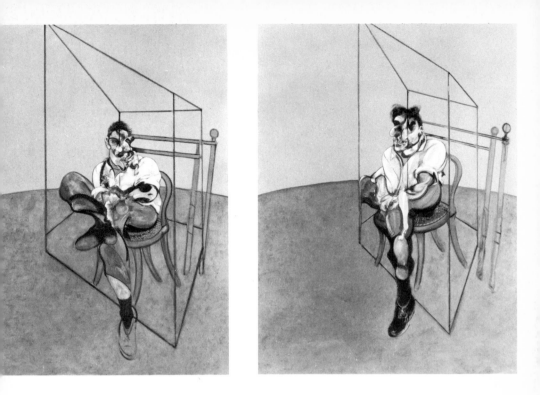

newspapers in the picture, and it was difficult to be sure whether they were 24 .
stuck, vertically, to an invisible window-pane between us and the action, or
whether they were lying on an invisible floor in the foreground and served
to lead us into the action and not to keep us apart from it. Bacon was, more
than ever, a man who saw everything that was going on in art, and took
from it what he wanted. Ambiguity in his work has a whole pocketful of
passports.

There are recurrent themes, even so. Bacon is like the rest of us in that he
feels that certain things were said incomparably well when he was young.
Sweeney Agonistes, for instance, was first published in 1932; but we still have
not come to the end of its implications. That short, dense, elliptic text, with
its eschewal of all scene-painting, all stage-directions, all local specification, is
a great favourite with Bacon. It sets before the reader an amoral, drifting,
entirely erratic milieu in which favours are bought and sold, murder is taken
for granted, and people come and go in the night. It happens nowhere and
everywhere. Its characters, commonplace on one level, are far beyond
normal size on another. Bacon was prompted by it to one of his strongest
concerted statements, the triptych of 1967 which is sub-titled 'Inspired by 23
T. S. Eliot's poem *Sweeney Agonistes*'. The painting has as its central panel a

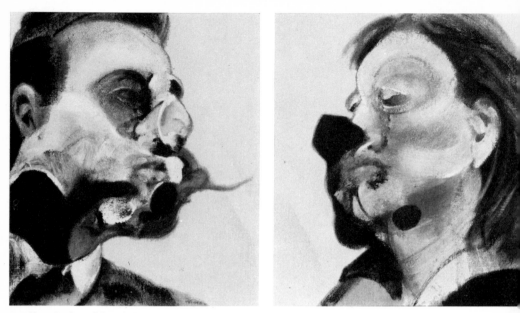

73 *Two Studies of George Dyer and Isabel Rawsthorne* 1970

74 *Three Studies for Portraits (including Self-portrait)* 1969

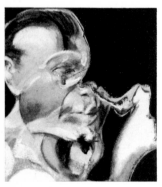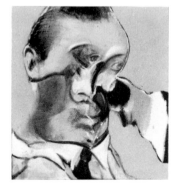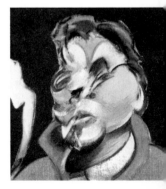

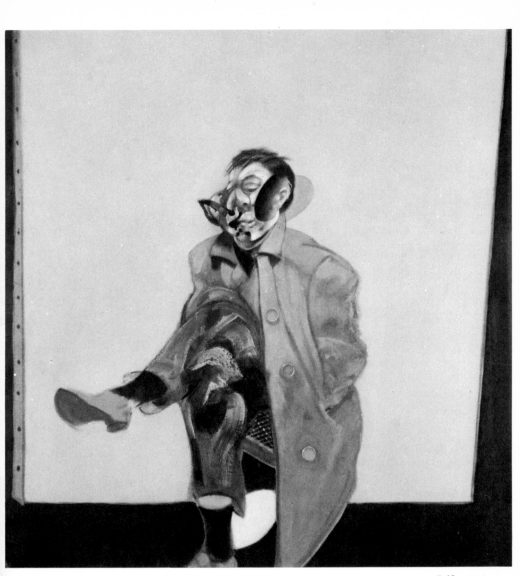

75 *Self-portrait* 1970

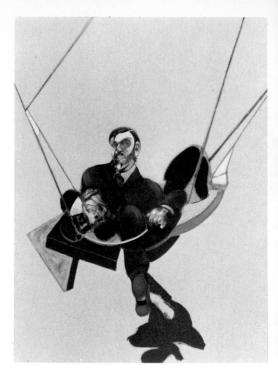

76 *Triptych* 1970

night-piece sponsored, as I said earlier, by the reminiscence of a particularly enigmatic crime of the 1920s: the window of a wagon-lit hangs open to the night-sky, while a bloodied pillow bears witness to murder. To the right is one of the most memorable of Bacon's all-seeing intruders – a man on the telephone (and talking, I suspect, of something quite other than the physical embroilments which are going forward under his nose).

Bacon lives very much between four walls. If he leaves one set of four walls for another, he loses as little time as possible before exchanging the first set for the four walls of a taxi. His is predominantly an indoor vision of the world, and the point of being indoors is to be private. 'Love and murder will out', says Congreve in *The Double Dealer*; and people still feel a tremor of incongruity at the coupling of those two nouns. But what if love *is* murder? What if each is the reverse-face of the other? What if the world is one huge killing-pound in which we pass the time while waiting for our turn in the arena? What if the act of love is a mimed death-scene in which one partner steals the life of another? The Sweeney-chant about 'Birth, copulation and death' does not gainsay this point of view.

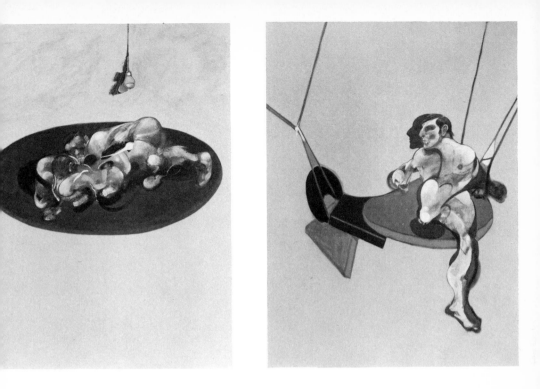

And what if the act of painting, of committing a human figure to canvas, is also an act at once of love and of murder? Love is the instinct which creates that figure and nurtures it to fulfilment; murder, the instinct which pins it down and finishes it off. An interpretation of this kind would accord very well with the nervous reaction which communicates itself even to those who do not really care for Bacon's painting. Very few people can stand before one of his pictures and not feel that it stands for a human activity pushed to its limit. Of course this feeling comes in part from the nature of the image: we should have to be very dull not to feel that in *Triptych* (1970) a certain kind of 76 masculine beauty and its allied qualities are evoked with hallucinatory force. But the feeling derives also and even more from the way in which the image is made. That idiosyncratic substance, oil paint, had been so manipulated that the very manner of its working and reworking creates in us a state of suspense; for the nature of that state, 'To be and not to be' is still the best form of words. What we are looking at both *is*, and *is not*; against all the odds, the first purpose of painting has come to life again.

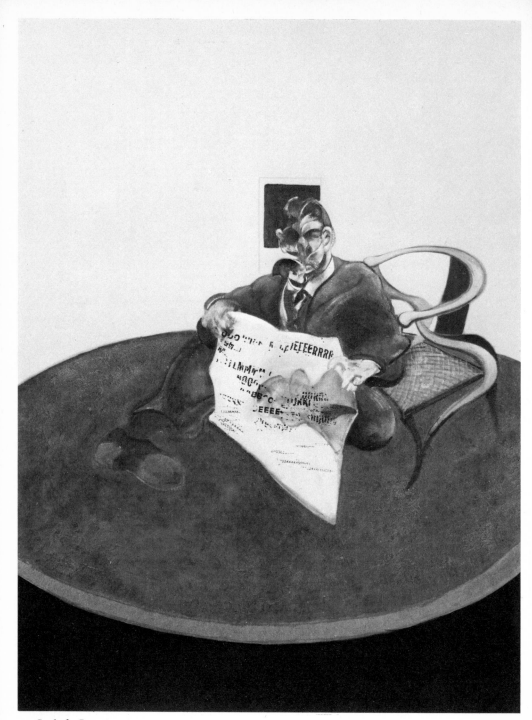

77 *Study for Portrait* 1970

Postscript

Not long after the first edition of this book was published, I left London and went to live in New York. Necessarily, I lost that contact with Francis Bacon to which the book owes whatever immediacy it may have. We were no longer in the same city. Opportunities of seeing his new work were few.

Meanwhile there had come upon him one of the most terrible blows that life has to offer. In the lives of all of us there is a human being whom we least wish to lose. Bacon sustained that particular loss at the time of his retrospective exhibition in Paris in 1971–72. He bore it with a stoicism for which even Homer would have been hard put to find words; but in his real life – his life as a painter, that is to say – it came to the fore over and over again.

For that and for other reasons, he decided that henceforth he would live for much of the year in Paris. He has always felt at home in Paris, and he has steadfast friends there: Michel Leiris, above all. To have that great lord of language only a short walk away is a continual pleasure to him.

He has never stopped working, and it is inconceivable that he ever will. I have no doubt that he would agree with his friend Frank Auerbach, who said not long ago that, 'It seems to me to be madness to wake up in the morning and do something other than paint, considering the fact that one may not wake up the following morning.' There has been no break in his working habits, and there has been no break in his ambition. He still hopes to make images the like of which no one has made before.

And why shouldn't he? For thirty years and more he has been taking great language, on the one hand, and the great images of the past, on the other, and cross-breeding them with an experience of human entanglements that is as strange as any in the long history of painting.

From time to time, moreover, history has turned his way. Paintings that were made for himself alone have turned out to be a part of our universal and peremptory education. The mirror that he has looked into reflects our own experience, no less than his. This has happened throughout his career, but there are times at which history intervenes with a particular decisiveness.

In more than one of his recent paintings there can be found, for instance, an echo of Joseph Conrad's long story, *The Heart of Darkness*. Bacon has always been possessed by the notion of Africa as a place where people do

irremediable things to one another and death stalks in the long dry spikes of the rustling grass. He had this intimation when he first went there, in the days when imperialism still had a look of stability. He has held fast to it with a peculiar intimacy, in that someone very close to him has spent almost her whole life in Rhodesia and has monitored the ever-approaching downfall of that country with a lucidity that is equal to his own. Africa in one or another of its guises turns up over and over again in his recent work: not least in the portraits of Peter Beard, the young American traveller and photographer, who has risked his skin over and over again in Africa.

In this matter, history and the private imagination run parallel. But perhaps the most persistent of all Bacon's preoccupations is the problem of what a man is to do when he is alone in a room by himself. Sometimes he is truly alone; sometimes a familiar returns to haunt him. Either way the drive to set down that primal situation never lets up. ('We are born and we die', Bacon said to David Sylvester in 1975, 'but in between we give this purposeless existence a meaning by our drives').

On the cover of this new edition there is a recent painting that is the epitome of that preoccupation. Exceptionally, Bacon has vouchsafed a clue to its content. In the title, though in parentheses, he put the word 'Eliot' (later omitted). If we turn to the last page of 'The Waste Land' we find these lines:

> *Dayadhvam:* I have heard the key
> Turn in the door once and turn once only
> We think of the key, each in his prison
> Thinking of the key, each confirms a prison
> Only at nightfall, aetherial rumours
> Revive for a moment a broken Coriolanus

Eliot himself appended to this passage a note from Dante's 'Inferno':

> ed io senti chiavar l'uscio di sotto
> all'orribile torre

But there was still room within that situation for Bacon to manoeuvre, and in so doing to give us one of the most haunting of all presentations of ambiguity. What is the ambition of that outstretched and Michelangelesque leg? Is it to turn the key a second time, or is it to open the door? In a century when so large a part of mankind has dreaded to hear the key turn in the lock from outside, this image reaffirms that painting has still something to say to us.

Bibliographical note

The complete bibliography of an artist who has been in the public eye for more than twenty-five years runs necessarily to many hundreds of items. Many of them are likely to be of a self-generating and repetitive nature: in Bacon's case, especially so. The catalogue of the Bacon retrospective at the Grand Palais in Paris (1971) includes a manful attempt to grapple with the material *in extenso*.

The general reader may however welcome a drastically abbreviated account of what, in all this, is of lasting interest. Bacon's own first-person statements are recorded most extensively in *Interviews with Francis Bacon* by David Sylvester (London, New York, 1975). His note on Matthew Smith in the catalogue of the Smith retrospective at the Tate Gallery (1953) is well worth getting out. *The Sunday Times Magazine* for 14 July 1963 gives the full text of an interview between Bacon and David Sylvester which had been made earlier for the BBC Third Programme. Among prefaces to exhibition catalogues I would single out the following: James Thrall Soby, 'Contemporary Painters' (Museum of Modern Art, New York, 1948); David Sylvester (Venice Biennale, 1958); Robert Melville (Marlborough Fine Art, London, 1960); Helen Lessore (Nottingham University, 1961); John Rothenstein (Tate Gallery, 1962); Thomas M. Messer and Lawrence Alloway (Guggenheim Museum, New York, 1963); Michel Leiris (Galerie Maeght, Paris, 1966; Marlborough Fine Art, London, 1967; Grand Palais, Paris, in collaboration with the Kunsthalle, Düsseldorf, 1971–72; Galerie Claude Bernard, Paris, 1977); Lawrence Gowing (Marlborough Gallery, New York, 1968); Henry Geldzahler (Metropolitan Museum, New York, 1975).

A *catalogue raisonné*, complete to the summer of 1963, was included in *Francis Bacon* by John Rothenstein and Ronald Alley (London, 1964). John Rothenstein also devoted an issue of 'The Masters' series (London, 1963) to Bacon; *Francis Bacon* by John Russell appeared in London, 1964. Lorenza Trucchi's *Francis Bacon* was published in London, 1976.

In 1961 the Arts Council sponsored a film by David Thompson, *Francis Bacon: Paintings 1944–1961*; in 1966 Michael Gill made a film for BBC Television which included an interview with David Sylvester.

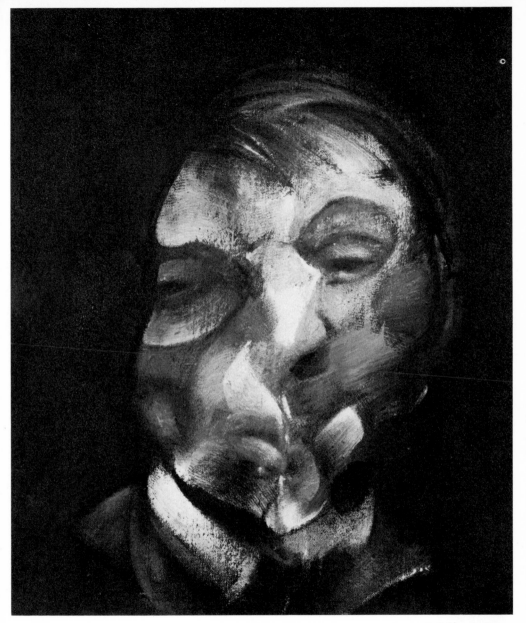

78 *Self-portrait* 1971

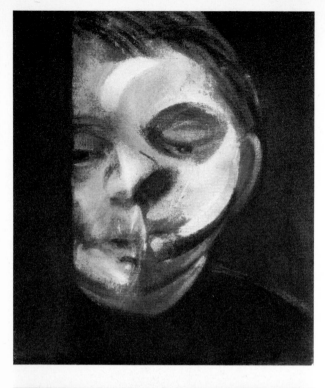

79 *Self-portrait* 1972

80 *Self-portrait* 1972

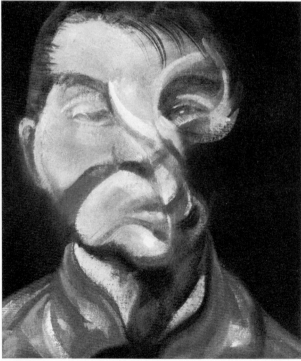

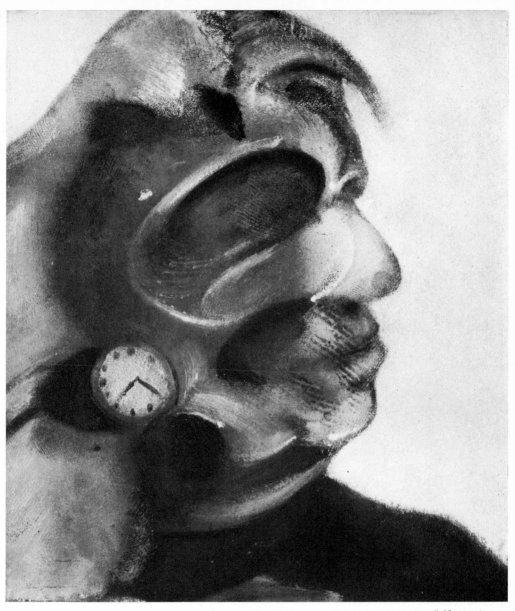

81 *Self-portrait* 1973

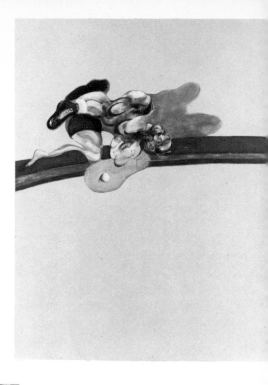

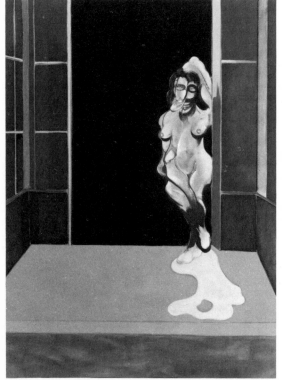

82 *Female Nude*
Standing in Doorway 1972

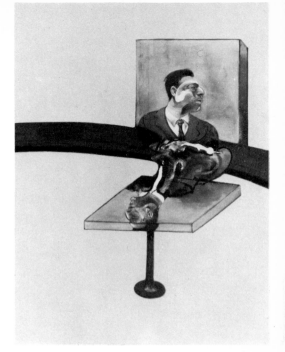

83 *Triptych 1971*

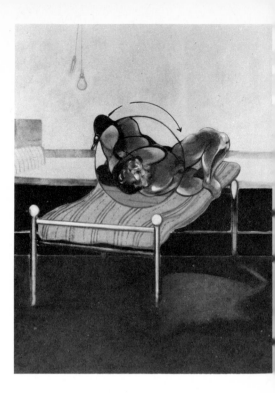

84 *Portrait of Man
Walking Down Steps* 1972

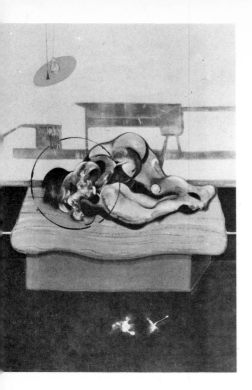
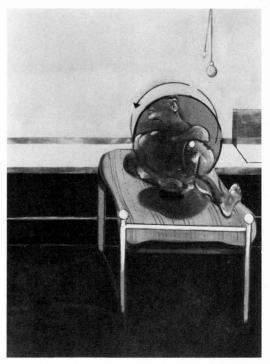

85 *Three Studies of Figures on Beds* 1972

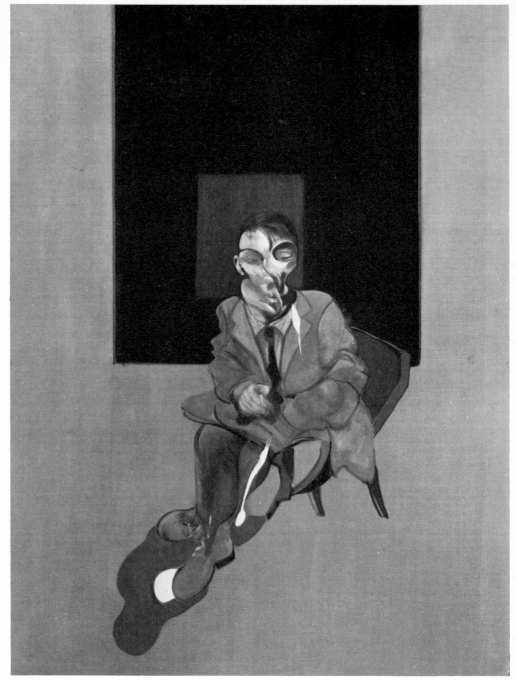

86 *Self-portrait* 1972

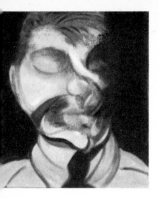
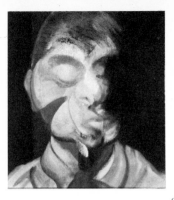
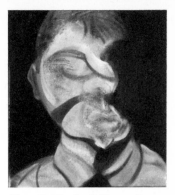

87 *Three Studies for Self-portrait* 1972

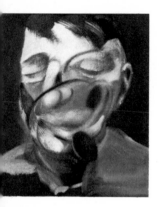
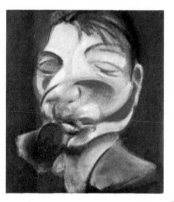
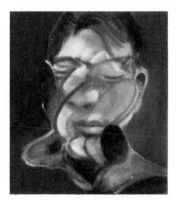

88 *Three Studies for Self-portrait* 1974

89 *Three Studies for Self-portrait* 1976

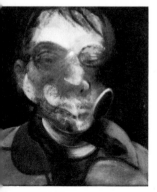
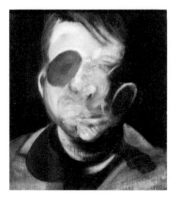
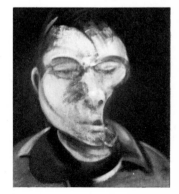

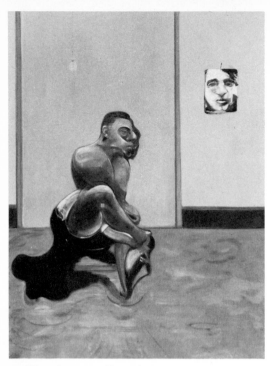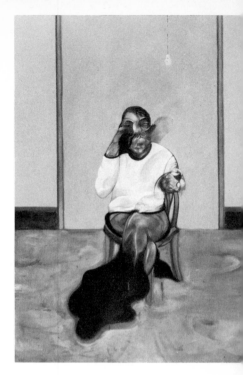

90 *Three Portraits – Triptych*
George Dyer, Self-portrait,
Lucian Freud 1973

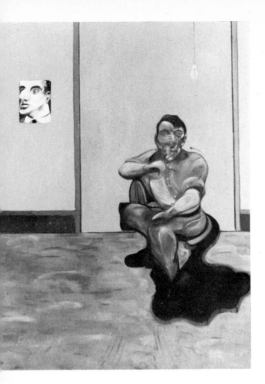

91 *Self-portrait* 1973

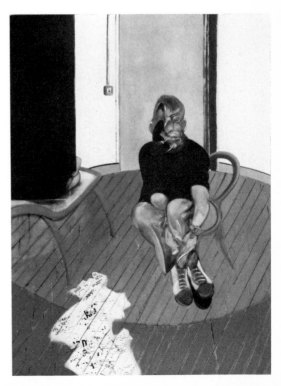

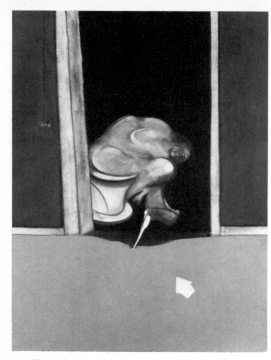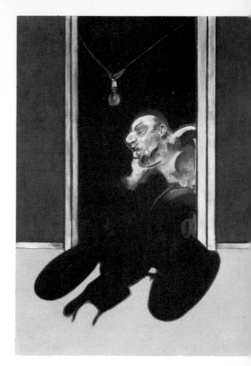

92 *Triptych May–June 1973*

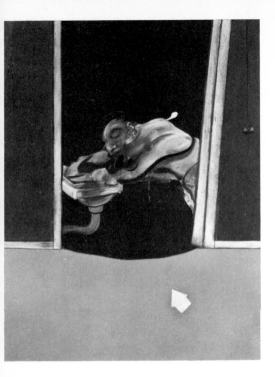

93 *Sleeping Figure* 1974

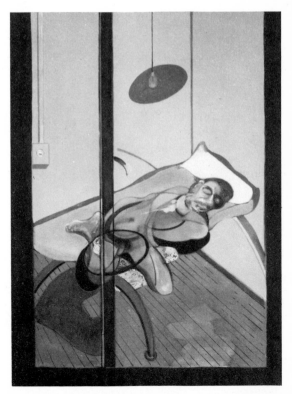

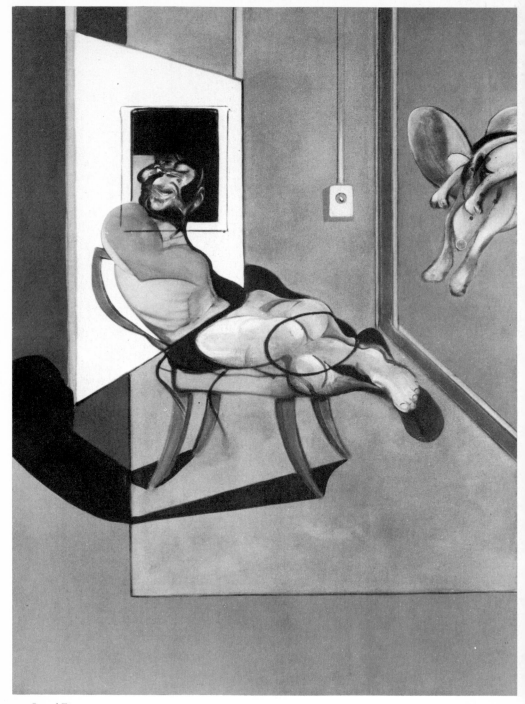

94 *Seated Figure* 1974

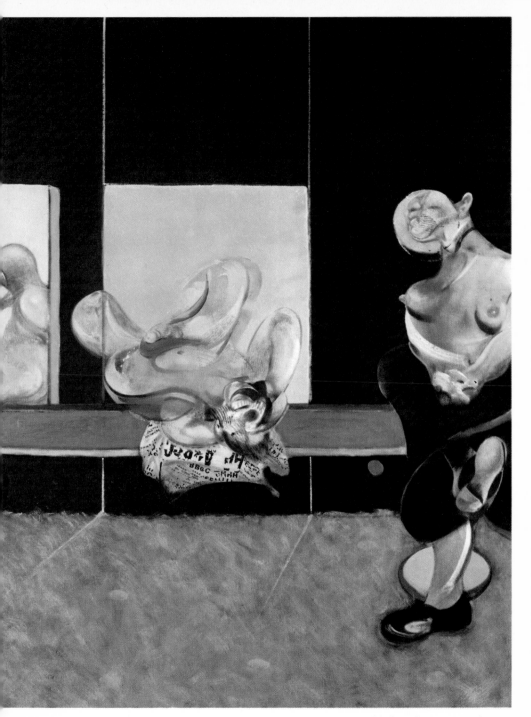

95 *Studies from the Human Body* 1975

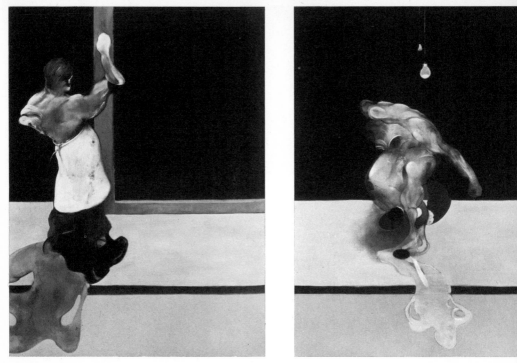

96 *Triptych March 1974*

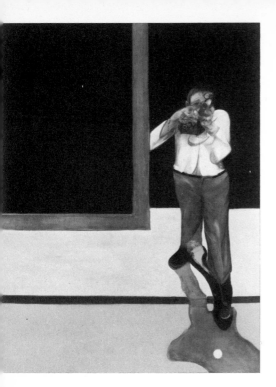

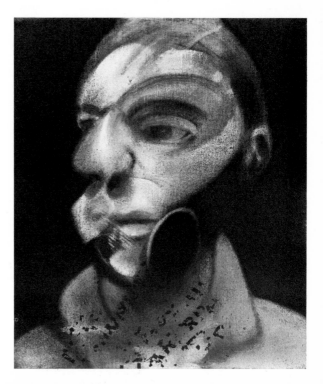

97 *Self-portrait* 1975

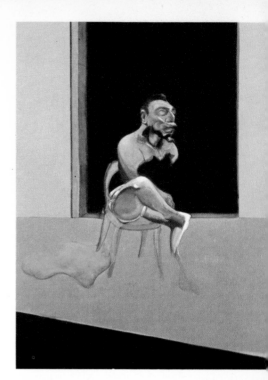

98 *Triptych August 1972*

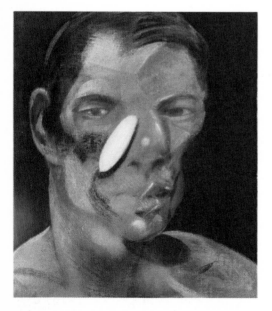

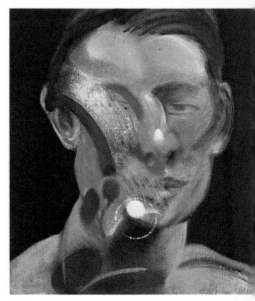

172

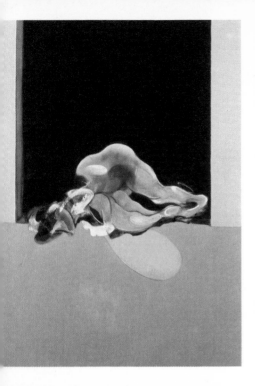

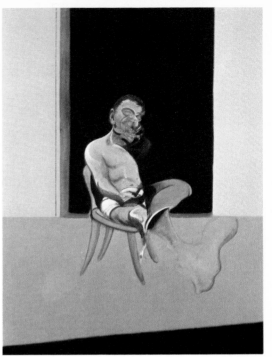

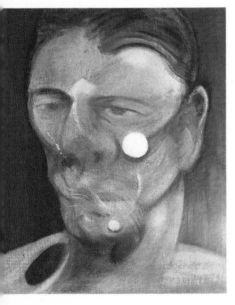

99 Three Studies for Portrait of Peter Beard 1975

173

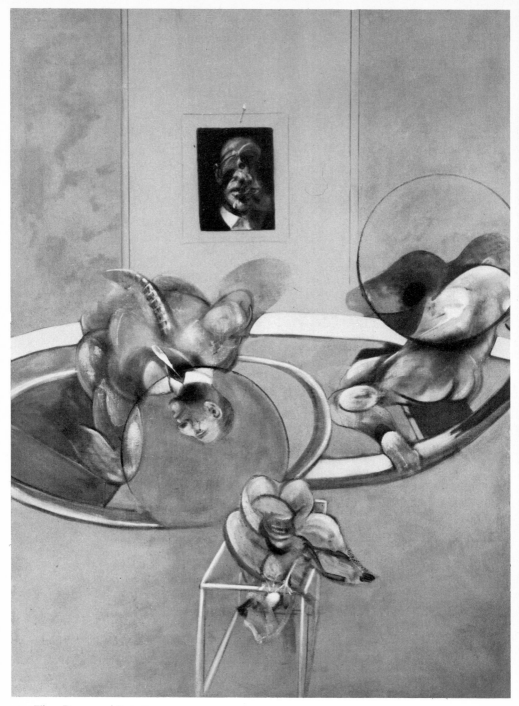

100 *Three Figures and Portrait* 1975

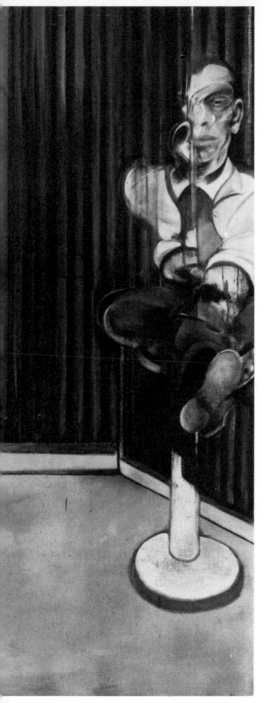

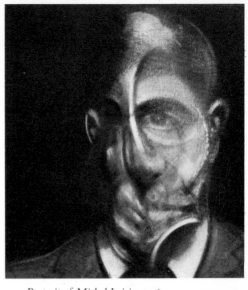

102 *Portrait of Michel Leiris* 1976

01 *Portrait of a Dwarf* 1975

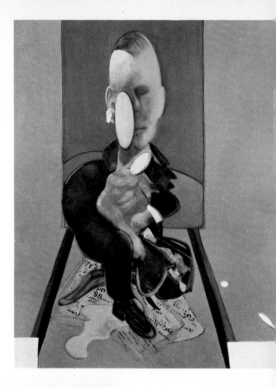

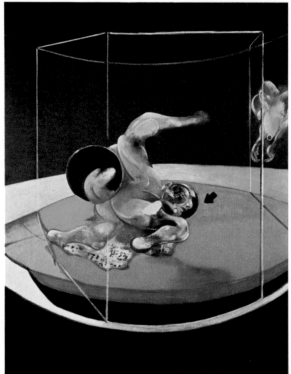

103
Figure in Movement 1976

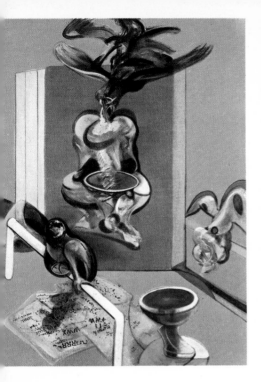

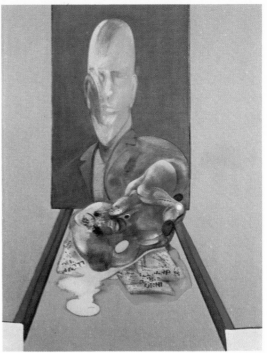

104 *Triptych 1976*

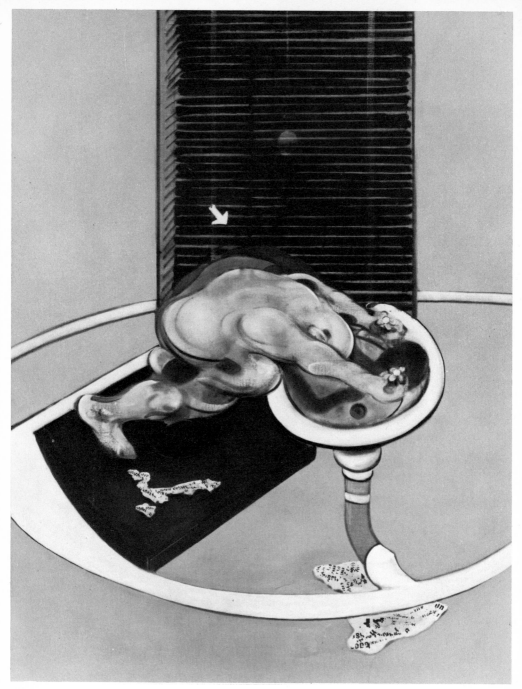

105 *Figure at a Washbasin* 1976

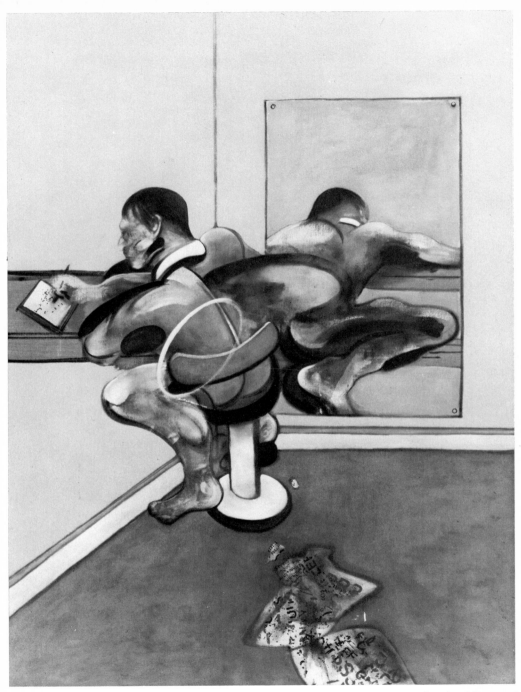

106 *Figure Writing Reflected in Mirror 1976*

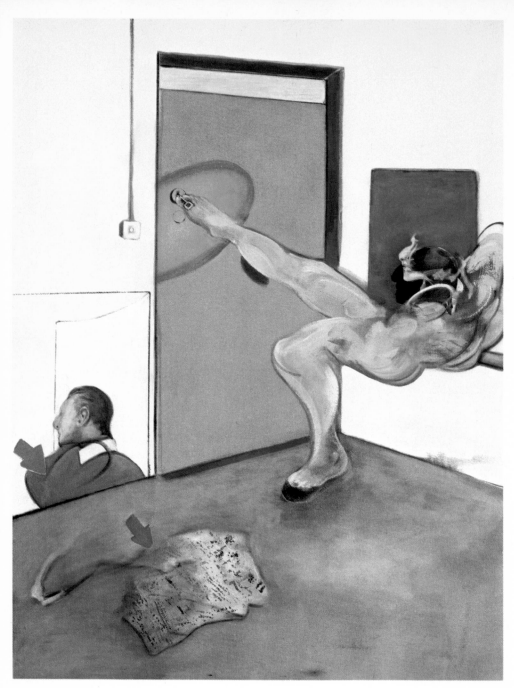

107 *Painting* 1978

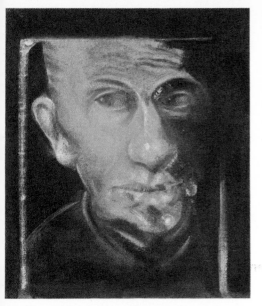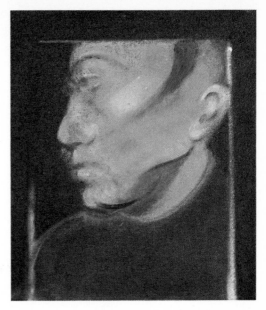

108 *Two Studies for Portrait of Richard Chopping* 1978

109 *Study for Self-portrait* 1978

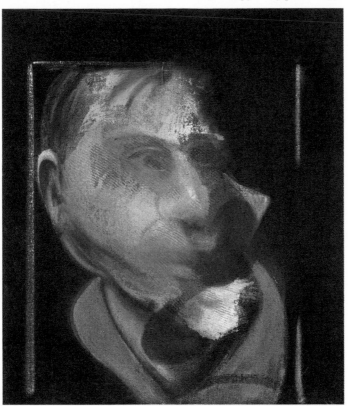

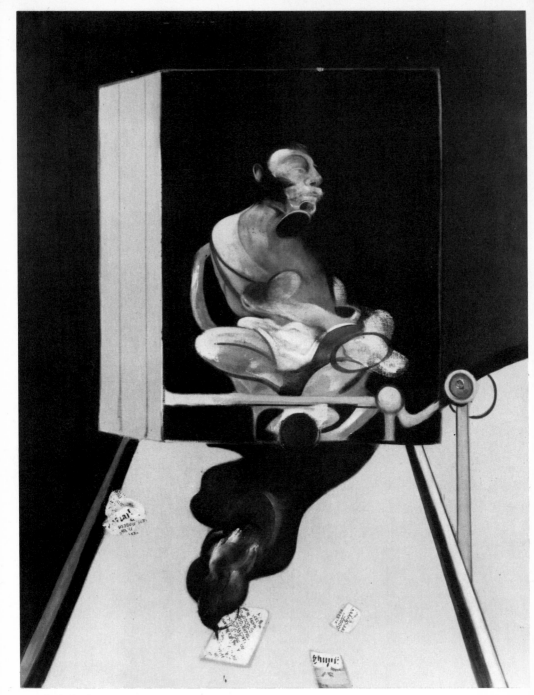

110 *Study for Portrait* 1977

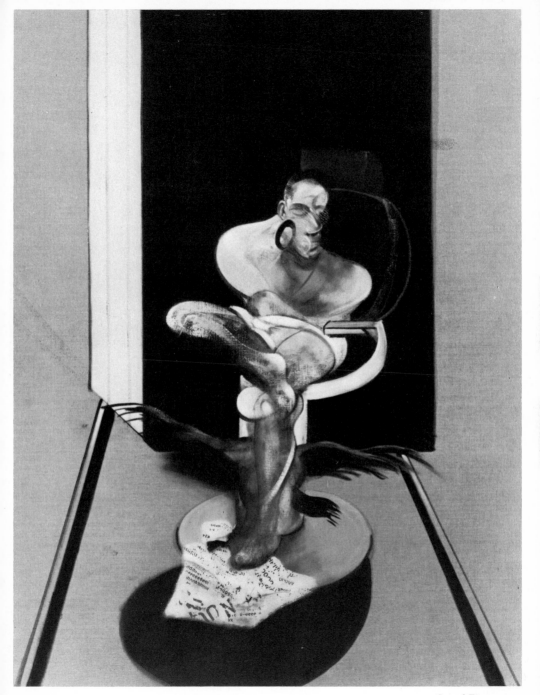

111 *Seated Figure* 1977

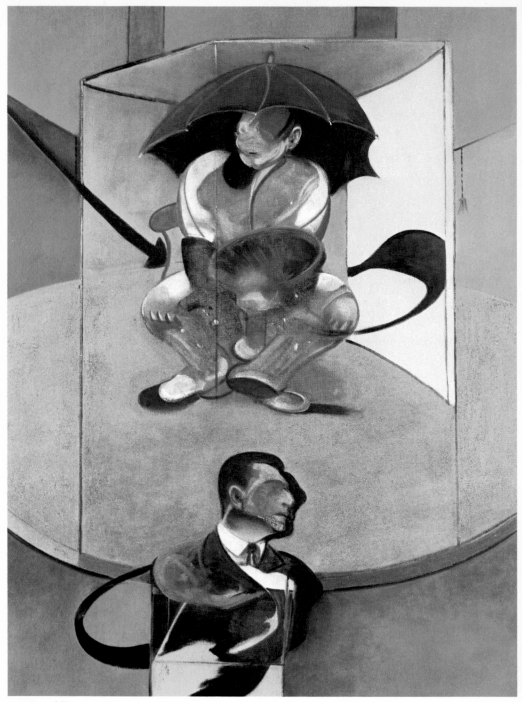

112 *Seated Figure* 1978

List of illustrations

The medium is oil on canvas except where specified. The measurements are given in inches and centimetres, height before width.

19 *Henrietta Moraes* 1966
$59\frac{3}{4} \times 51\frac{7}{8}$ (152 × 132)
Mr and Mrs Ian Stoutzker, London

20 *Portrait of Isabel Rawsthorne*
 Standing in a Street in Soho 1967
78 × 58 (198 × 147·5)
Nationalgalerie, Berlin

21 *Head of a Man – Study of*
 Drawing by van Gogh 1959
26 × 24 (66 × 61)
Private collection, USA

22 *Study for the Nurse in the Film*
 'Battleship Potemkin' 1957
78 × 56 (198 × 142)
Private collection, Paris

23 *Triptych (inspired by T. S. Eliot's*
 poem 'Sweeney Agonistes') 1967
Each 78 × 58 (198 × 147·5)
The Hirshhorn Museum and Sculpture
Garden, Smithsonian Institution, Wash-
ington, D.C.

24 *Triptych – Studies from the*
 Human Body 1970
Each 78 × 58 (198 × 147·5)
Museum of Modern Art, Teheran

25 *Study for Three Heads* 1962
Each 14 × 12 (35·5 × 30·5)
William S. Paley, New York

26 *Lying Figure* 1969
78 × 58 (198 × 147·5)
Private collection, Montreal

27 *Study for Portrait of Lucian Freud*
 (sideways) 1971
78 × 58 (198 × 147·5)
Private collection, Brussels

28 *Painting* 1950
78 × 52 (198 × 132)
City Art Galleries, Leeds

29 *Fragment of a Crucifixion* 1950
Oil and cotton wool on canvas
$55 \times 42\frac{3}{4}$ (140 × 108·5)
Stedelijk van Abbe Museum, Eindhoven

30 *Lying Figure with Hypodermic*
 Syringe 1963
78 × 57 (198 × 145)
University Art Museum, Berkeley, Califor-
nia. (Gift of Joachim Jean Aberbach, New
York)

31 *Portrait of Henrietta Moraes* 1963
65 × 56 (165 × 142·5)
Private collection, Germany

32 *Study for Portrait*
 (Isabel Rawsthorne) 1964
78 × 58 (198 × 147·5)
Private collection, Italy

33 *Portrait of George Dyer*
 Staring at Blind Cord 1966
78 × 58 (198 × 147·5)
Private collection, New York

34 *Study of Isabel Rawsthorne* 1966
14 × 12 (35·5 × 30·5)
Michel Leiris, Paris

35 *Study for a Portrait* 1966
$33\frac{1}{8} \times 27$ (84 × 68·5)
Mr and Mrs Walter Nelson Pharr, New York

36 *Three Studies of George Dyer (on light*
 ground) 1964
Each 14 × 12 (35·5 × 30·5)
Private collection, Italy

37 *Portrait of George Dyer on a Bicycle* 1966
78 × 58 (198 × 147·5)
Mr and Mrs Jerome L. Stern, New York

38 *Study for a Portrait* 1953
$60 \times 46\frac{1}{2}$ (152·5 × 118)
Hamburger Kunsthalle, Hamburg

39 *Three Studies of the Human Head* 1953
Each 24 × 20 (61 × 51)
Private collection, Switzerland

40 *Sphinx I* 1953
$78\frac{1}{2} \times 54$ (199·5 × 137)
Private collection, California

41 *Two Figures* 1953
$60 \times 45\frac{7}{8}$ (152 × 116·5)
Private collection, Great Britain

42 *Man with Dog* 1953
59⅞ × 46 (152 × 117)
Albright-Knox Art Gallery, Buffalo
(gift of Seymour H. Knox)

43 *Chimpanzee* 1955
60 × 46 (152·5 × 117)
Staatsgalerie, Stuttgart

44 *Study for Portrait III*
(after the life-mask of William Blake) 1955
24 × 20 (61 × 51)
Private collection, London

45 *Lying Figure* 1959
78 × 55¾ (198 × 141·5)
Private collection, New York

46 *Three Studies of Henrietta Moraes* 1969
Each 14 × 12 (35·5 × 30·5)
Galleria Galatea, Turin

47 *Triptych – Studies of the*
Human Body 1970
Each 78 × 50 (198 × 147·5)
Private collection, Paris

48 *Pope No. 2* 1960
60 × 47 (152·5 × 119·5)
Private collection, Great Britain

49 *Three Studies for Portrait of Isabel*
Rawsthorne 1965
Each 14 × 12 (35·5 × 30·5)
The Sainsbury Collection

50 *Portrait of Isabel Rawsthorne* 1966
33 × 27 (84 × 68·5)
Tate Gallery, London

51 *Head II* 1961
14¼ × 12¼ (36 × 31)
Private collection, London

52 *Head III* 1961
14 × 12 (35·5 × 30·5)
Private collection, London

53 *Man with Arm Raised* 1960
40 × 25 (101·5 × 63·5)
Private collection, New York

54 *Lying Figure* 1958
60½ × 47 (153·5 × 119·5)
Städtischegalerie, Bochum

55 *Miss Muriel Belcher* 1959
29 × 26½ (74 × 67·5)
Gilbert Halbers, Paris

56 *Triptych (Two Figures Lying on a Bed with*
Attendants) 1968
Each 78 × 58 (198 × 147)
Knoedler-Modarco, New York

57 *Three Figures in a Room* 1964
Each 78 × 57¾ (198 × 147)
Centre Pompidou, Beaubourg, Paris

58 *Seated Figure* 1961
65 × 56 (165 × 142)
Tate Gallery, London

59 *Three Studies for Portrait of*
Henrietta Moraes 1963
14 × 12 (35·5 × 30·5)
William S. Paley, New York

60 *Three Studies for Portrait*
of Lucian Freud 1966
Each 78 × 58 (198 × 147·5)
Private collection

61 *Crucifixion* 1965
Each 78 × 58 (198 × 147·5)
Bayerische Staatsgemäldesammlungen,
Munich

62 *Portrait of George Dyer Crouching* 1966
78 × 58 (198 × 147·5)
Private collection, Caracas

63 *Two Studies for a Portrait of*
George Dyer 1968
Each 78 × 58 (198 × 147·5)
Art Museum Ateneum, Helsinki
(Collection Sara Hildén)

64 *Portrait of George Dyer*
and Lucian Freud 1967
78 × 58 (198 × 147·5)
Klaus Hegewisch, Hamburg

65 *Three Studies of Isabel Rawsthorne* 1967
47 × 60 (119·5 × 152·5)
Nationalgalerie, Berlin

187

66 *Portrait of George Dyer in a Mirror* 1968
78 × 58 (198 × 147·5)
Thyssen-Bornemisza, Lugano

67 *Two Studies of George Dyer*
 with Dog 1968
78 × 58 (198 × 147·5)
Private collection, Rome

68 *Three Studies of the Male Back* 1970
Each 78 × 57⅝ (198 × 147)
Marlborough

69 *Three Studies from the Human Body* 1967
78 × 58 (198 × 147·5)
Galerie Claude Bernard, Paris

70 *Study for Bullfight No. 1* 1969
78 × 58 (198 × 147·5)
Private collection, Switzerland

71 *Study of Nude with Figure in a*
 Mirror 1969
78 × 58 (198 × 147·5)
Private collection, Belgium

72 *Three Studies of Lucian Freud* 1968–69
Each 78 × 58 (198 × 147·5)
Private collection, Rome

73 *Two Studies of George Dyer and Isabel*
 Rawsthorne 1970
Each 14 × 12 (35·5 × 30·5)
Private collection, Switzerland

74 *Three Studies for Portraits (including Self-*
 portrait) 1969
Each 14 × 12 (35·5 × 30·5)
Private collection, Italy

75 *Self-portrait* 1970
59⅛ × 58 (152 × 147·5)
Private collection, London

76 *Triptych* 1970
Each 78 × 58 (198 × 147·5)
National Gallery of Australia, Canberra

77 *Study for Portrait* 1970
78 × 58 (198 × 147·5)
Private collection

78 *Self-portrait* 1971
14 × 12 (35·5 × 30·5)
Michel Leiris, Paris

79 *Self-portrait* 1972
14 × 12 (35·5 × 30·5)
Private collection, Switzerland

80 *Self-portrait* 1972
14 × 12 (35·5 × 30·5)
Private collection, Switzerland

81 *Self-portrait* 1973
14 × 12 (35·5 × 30·5)
Private collection, London

82 *Female Nude Standing in Doorway* 1972
78 × 58 (198 × 147·5)
Private collection

83 *Triptych 1971*
Each 78 × 58 (198 × 147·5)
Private collection, New York

84 *Portrait of Man Walking*
 Down Steps 1972
78 × 58 (198 × 147·5)
Private collection, London

85 *Three Studies of Figures on Beds* 1972
Oil and pastel on canvas
Each 78 × 58 (198 × 147·5)
Private collection

86 *Self-portrait* 1972
78 × 58 (198 × 147·5)
Private collection, New York

87 *Three Studies for Self-portrait* 1972
Each 14 × 12 (35·5 × 30·5)
Basil P. Goulandris, Lausanne

88 *Three Studies for Self-portrait* 1974
Each 14 × 12 (35·5 × 30·5)
Private collection, Bogotá

89 *Three Studies for Self-portrait* 1976
Each 14 × 12 (35·5 × 30·5)
Private collection, Switzerland

90 *Three Portraits – Triptych*
 George Dyer, Self-portrait, Lucian Freud 1973
Each 78 × 58 (198 × 147·5)
Marlborough

91 *Self-portrait* 1973
78 × 58 (198 × 147·5)
Galerie Claude Bernard, Paris

92 *Triptych May–June 1973*
Each 78 × 58 (198 × 147·5)
The artist

93 *Sleeping Figure* 1974
78 × 58 (198 × 147·5)
The artist

94 *Seated Figure* 1974
Oil and pastel on canvas
78 × 58 (198 × 147·5)
Private collection, Switzerland

95 *Studies from the Human Body* 1975
78 × 58 (198 × 147·5)
The artist

96 *Triptych March 1974*
Each 78 × 58 (198 × 147·5)
Private collection

97 *Self-portrait* 1975
14 × 12 (35·5 × 30·5)
Private collection

98 *Triptych August 1972*
Each 78 × 58 (198 × 147·5)
The artist

99 *Three Studies for Portrait of*
 Peter Beard 1975
Each 14 × 12 (35·5 × 30·5)
Private collection, Paris

100 *Three Figures and Portrait* 1975
Oil and pastel on canvas
78 × 58 (198 × 147·5)
Tate Gallery, London

101 *Portrait of a Dwarf* 1975

$62\frac{1}{2}$ × 23 (158·5 × 58·5)
The artist

102 *Portrait of Michel Leiris* 1976
14 × 12 (35·5 × 30·5)
Michel Leiris, Paris

103 *Figure in Movement* 1976
78 × 58 (198 × 147·5)
Galerie Claude Bernard, Paris

104 *Triptych 1976*
Oil and pastel on canvas
Each 78 × 58 (198 × 147·5)
Private collection

105 *Figure at a Washbasin* 1976
78 × 58 (198 × 147·5)
The artist

106 *Figure Writing Reflected in Mirror* 1976
78 × 58 (198 × 147·5)
Private collection, Paris

107 *Painting* 1978
78 × 58 (198 × 147·5)
Magnus Konow, Monaco

108 *Two Studies for Portrait of*
 Richard Chopping 1978
Each 14 × 12 (35·5 × 30·5)
Private collection, Paris

109 *Study for Self-portrait* 1978
14 × 12 (35·5 × 30·5)
Private collection, New York

110 *Study for Portrait* 1977
78 × 58 (198 × 147·5)
Magnus Konow, Monaco

111 *Seated Figure* 1977
78 × 58 (198 × 147·5)
Private collection, Paris

112 *Seated Figure* 1978
78 × 58 (198 × 147·5)
The artist

Index